JOHN SLOAN

JOHN SLOAN

BY DAVID SCOTT

WATSON-GUPTILL PUBLICATIONS · NEW YORK

To the two Ediths and the two Tirsas who helped

Copyright © 1975 by Watson-Guptill Publications

First published 1975 in New York by Watson-Guptill Publications,
a division of Billboard Publications, Inc.,
One Astor Plaza, New York, N.Y. 10036

Manufactured in U.S.A.

Library of Congress Cataloging in Publication Data
Scott, David W. 1916–
 John Sloan.
 Bibliography: p.
 Includes index.
 1. Sloan, John, 1871–1951. I. Sloan, John, 1871–1951.
ND237.S57S36 759.13 75-6694
ISBN 0-8230-4869-1

First Printing, 1975

CONTENTS

COLOR PLATES

CHRONOLOGY

1871. *August 2:* born at Lock Haven, Pennsylvania, the son of James Dixon and Henrietta Ireland Sloan.

1876. Moved to Germantown, then to 1921 Camac Street, Philadelphia.

1884. *September:* entered Central High School in the same class with William Glackens and Albert C. Barnes. Enrolled in the College Preparatory Curriculum.

1888. *April:* left high school to go to work for Porter and Coates, booksellers and dealers in fine prints. Taught himself to etch by study of *The Etcher's Handbook* by Philip Gilbert Hamerton.

1890. Began work for A. Edward Newton, designing novelties and calendars and making etchings. Entered night freehand drawing class at the Spring Garden Institute.

1891. Late in the year, left Newton and took his own small studio as a freelance artist doing lettering, advertisements, calendars, etc.

1892. Began work in the art department of the Philadelphia *Inquirer. Fall:* entered Antique Class at the Pennsylvania Academy of the Fine Arts under Thomas Anshutz. Met Robert Henri through Charles Grafly.

1893. *March:* helped form Charcoal Club, a five months' breakaway from the Academy. Joined with Joe Laub in renting Henri's studio at 806 Walnut Street. Visit to Philadelphia of Beisen Kubota, who gave lessons in Japanese brush technique.

1894. Late in 1893 or early in 1894, left the Academy. First public recognition as an illustrator in the Poster style came from the Chicago magazines *Inland Printer* and *Chap Book.*

1895. Art editor of *Moods: a Journal Intime.* Left the *Inquirer* for the staff of the Philadelphia *Press.*

1896. Began two murals at the Pennsylvania Academy of the Fine Arts. First serious painting in oils, chiefly portraits, 1896 and 1897.

1897. In 1897 or 1898, undertook first city scenes. Finished murals for Pennsylvania Academy.

1898. *Summer:* went to New York to work on New York *Herald. October:* returned to Philadelphia *Press.* Met Anna M. (Dolly) Wall.

1899. *June 18:* first large colored poster drawing for the *Press.*

1900. Illustrated Stephen Crane's *Great Battles of the World. October:* exhibited *Walnut Street Theater* at the Art Institute of Chicago. *November:* exhibited *Independence Square* at the Carnegie Institute, Pittsburgh.

1901. *January:* three paintings in the Pennsylvania Academy Annual. *April:* three paintings at Allan Gallery, New York, in group show organized by Henri. *August 5:* married Anna M. Wall.

1902. worked on illustrations for a deluxe edition of Charles Paul de Kock's novels. (Fifty-four drawings and fifty-three etchings were completed by January, 1905.)

1903. *April:* exhibited *Violinist, Will Bradner* at the Society of American Artists. Received critical acclaim for the de Kock etchings. *December:* left Philadelphia *Press* art department but continued making "word charade" puzzles for the paper through 1910, his only regular source of income.

1904. *January:* exhibited with Henri group at the National Arts Club. *April:* moved to New York, to Sherwood Building. *September:* took apartment at 165 West Twenty-third Street, where he painted many of his best-known "City Life" paintings, and remained seven years.

1905. Did eight of the ten etchings of the New York "City Life" series. Received Honorable Mention for *The Coffee Line* at the Eighth International of the Carnegie Institute.

1906. *January 1:* began diary (continued till 1913). *February:* in group show at Sigmund Pisinger's Modern Gallery. *May:* of the ten New York etchings invited to the American Water Color Society Exhibition, four were returned as "too vulgar." *August:* began outdoor sketching in oil. *December:* received first enthusiastic review of a New York city scene painting, *Dust Storm, Fifth Avenue.*

1907. *May:* decision of The Eight to hold exhibition in 1908. *August 28:* Death of Sloan's mother. *Fall:* taught one day a week at Pittsburgh Art Students League. Discussion of Sloan's art in Charles H. Caffin's *Story of American Painting.*

1908. *February 3–15:* exhibition of The Eight at Macbeth Gallery. Subsequent traveling exhibi-

tion. *May:* experiments with lithographs. Growing interest in the Socialist party.

1909. *February:* article on Sloan in the *Craftsman. June:* introduced to the Maratta color system by Henri. *July:* met John Butler Yeats.

1910. *January:* joined Socialist party. *April:* exhibition of Independent Artists. *June:* major sale of prints to John Quinn. *November:* Socialist party candidate for N.Y. State Assembly (ran again in 1915).

1911. *March:* commissioned by Scribner's to illustrate six volumes by Emile Gaboriau. *May:* planning for MacDowell Club exhibitions. *June:* moved to apartment at 155 East Twenty-second Street. *December:* travelled to Omaha to paint portraits of Mr. and Mrs. Gottlieb Storz.

1912. Group exhibition at MacDowell Club. *May:* took studio at 35 Sixth Avenue (where he remained three years); began studies of the nude. Private pupils. *October:* moved to apartment at 61 Perry Street. *December:* became acting art editor of the *Masses.* Dolly became business manager (through May, 1913) and treasurer.

1913. *February:* moved to apartment at 240 West Fourth Street. *February 17–March 15:* International Exhibition of Modern Art (Armory Show); two paintings, five etchings included. Helped hang exhibition. First sale of a painting, *Nude, Green Scarf,* to Dr. Albert C. Barnes.

1914. Summer at Gloucester, Massachusetts (returned every summer through 1918). *December:* appeared as art editor on masthead of the *Masses,* but became inactive thereafter as contributor.

1915. Received Bronze Medal for etching at San Francisco Pan-Pacific Exposition. *October:* moved to 88 Washington Place, where he remained twelve years.

1916. *January:* first one-man exhibition at Mrs. H. P. Whitney's studio. *April:* resigned from the *Masses,* subsequently dropping membership in Socialist party. One-man exhibition sponsored by Dr. John Weischel's People's Art Guild at Hudson Guild Social Center. *Summer:* Gloucester, teaching private classes. *September:* began teaching at Art Students League in New York, continuing (with brief interruption) until 1938. Began lifelong association with Kraushaar Gallery.

1917. *March:* first one-man show at Kraushaar's. *April:* helped to hang the first exhibition of the Society of Independent Artists at the Grand Central Palace. Dolly Sloan raised money for Mooney-Billings defense.

1918. Became president of the Society of Independent Artists (held position for life). One of the original members of Whitney Studio Club.

1919. Trip to Santa Fe, New Mexico, with the Randall Daveys. (Returned every summer except 1933 and 1951.) Duncan Phillips purchased *Old Clown Making Up* for the recently incorporated Phillips Memorial Collection.

1920. Bought house in Santa Fe (314 E. García Street). Illustrated *Mitch Miller* by Edgar Lee Masters.

1921. Purchase of *Dust Storm, Fifth Avenue* by Metropolitan Museum of Art (first sale to a museum). Trip to Hopi Snake Dance.

1922. Death of John Butler Yeats. Surgery for hernia; Dolly underwent surgery.

1923. Sale of twenty oils to George Otis Hamlin (announced as $20,000, actually $5,000). *Fall:* visiting critic of art classes, Maryland Institute, Baltimore.

1924. *April:* member of jury of American section of Carnegie International.

1925. Surgery for hernia. Publication of A. E. Gallatin's *John Sloan.*

1926. Philadelphia Sesqui-Centennial Gold Medal awarded for etching *Hell Hole.* Mrs. Whitney presented a complete set of etchings to The Metropolitan Museum of Art.

1927. Moved to 53 Washington Square, his "first real studio," where he remained eight years.

1928. Adopted underpainting and glazing technique. Publicized sale of twenty paintings to Carl Hamilton falls through.

1929. Elected to National Institute of Arts and Letters. Beginning of superimposed linework over glazes. Death of Robert Henri.

1931. Received Carroll H. Beck Gold Medal for *Vagis, the Sculptor* at the Pennsylvania Academy. Elected president of Art Students League. Resigned teaching position at League.

President, Exposition of Indian Tribal Arts. Surgery, Pueblo, Colorado.

1932. Resigned as president of Art Students League. Joined staff of Archipenko's École d'Art (November and December). A founder of Washington Square Outdoor Show.

1933. Refused invitation to go to Moscow from American Section of the International Bureau of Revolutionary Artists. Elected head of George Luks School; taught there until May, 1935. Summer in New York City. Letter to sixty museums offering paintings at half price; made one sale, *Pigeons,* to Boston Museum of Fine Arts in 1935.

1934. Painted *Tammany Hall* and *Fourteenth Street, Snow.*

1935. Returned to Art Students League. Moved to Hotel Chelsea, 222 West Twenty-third Street. (Retained studio apartment until his death.)

1936. *March:* exhibition of one hundred etchings at Whitney Museum.

1937. *February:* Etching retrospective at Kraushaar's. Did sixteen prints illustrating Somerset Maugham's *Of Human Bondage.*

1938. Retrospective exhibition at Addison Gallery of American Art. Gall bladder operation. Death of William Glackens.

1939. Publication of *Gist of Art.* Treasury Department mural for Bronxville, N.Y., post office.

1940. Started to build "Sinagua," six miles from Santa Fe.

1941. Second operation for obstruction of gall duct, and double pneumonia. One-man exhibition at Museum of New Mexico.

1942. First prize ($500) for etching *Fifth Avenue, 1909,* in exhibition Artists for Victory. Elected to the Academy of Arts and Letters.

1943. *May 4:* death of Dolly (coronary). Went to Santa Fe as guest of Miss White. Third operation for obstruction of gall duct; successful. Convalescence in Santa Fe, fall and winter.

1944. *February 5:* married Helen Farr. Elected president Santa Fe Painters and Sculptors.

1945. Artists of the Philadelphia Press exhibition at the Philadelphia Museum of Art. Exhibition of etchings and Moody lecture at the University of Chicago. Operation to correct double vision.

1946. Seventy-fifth Anniversary Exhibition, Dartmouth College.

1948. Retrospective exhibition, Kraushaar Gallery.

1949. Illustrated *New Mexico Quarterly.* President of New Mexico Alliance for the Arts.

1950. Gold Medal for painting, American Academy of Arts and Letters. Elected to American Academy of Arts and Sciences.

1951. Summer in Hanover, New Hampshire. *September 7:* died following operation.

1952. Retrospective Exhibition at Whitney Museum of American Art (selected before his death).

FOREWORD

What, another book on John Sloan?

Yes, because Sloan and his work are important enough to justify a book of this format. And since the book was needed, I wanted to do it: I wished to come to know better the man under whom I had studied at the Art Students League in 1937. I had joined his class asking, as students do, only that he pay attention to *my* work; here at long last is my opportunity to give careful consideration to *his*.

A great deal has been published about Sloan, and a great deal more lies in the records that Helen Farr Sloan has deposited at the Delaware Art Museum. The story of his early career is best recounted in his diary, important parts of which have appeared in *John Sloan's New York Scene*. His mature thought is recorded in his *Gist of Art*. We are fortunate to possess accounts and interpretations by men who knew him well and wrote tellingly of his life and work—Van Wyck Brooks in *John Sloan* and Lloyd Goodrich in the Whitney Museum catalog of the retrospective exhibition held just after Sloan's death. Peter Morse's catalog raisonné of the prints is a model of its kind. Sloan's importance as a graphic artist and illustrator has been studied in theses by John Bullard and Merrill Rueppel. Accounts of the exhibitions of The Eight, the Independents, and the Armory Show have all been published in book or catalog form. Helen Sloan and Bruce St. John have made valuable recent contributions to the published material on our subject, and so has the National Gallery's catalog for the Sloan Centennial Exhibition. And yet another book on Sloan is not merely redundant.

For one thing, Sloan's art, like that of most American artists of his generation, has not been made available in reproductions of sufficient quality and scope to give an adequate impression of the color, texture, and "presence" of his total production as an artist. This situation can now be remedied. Moreover, the very abundance of publications, together with the increasing information being made available as new studies come forth and work is done on material in the John Sloan estate, has created a need for a new summary of the disparate sources. Finally, to round out the summary, there is need for a new analysis, a step-by-step ordering of the material, and a new synthesis—a fuller relation of Sloan's work to his underlying concerns and motivations.

THE EARLY YEARS
1871·1891

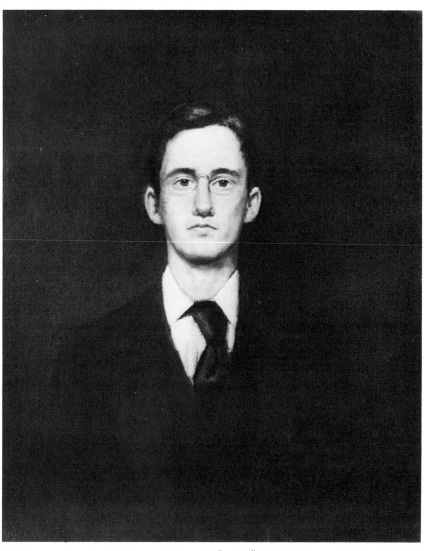

Self-Portrait. 1890. Oil on canvas, 14″ x 12″. The Delaware Art
Museum, Wilmington. Gift of Mrs. John Sloan.

PHILADELPHIA

The generation of Philadelphia artists growing up in the wake of the International Centennial Exhibition lived in a city astir with excitement. During the nineteenth century, however, Philadelphia had sunk from the glory of its early days, when it had been the uncontested American capital of the arts. The city had become a provincial center, indifferent to its most able painters, whether they remained at home like Thomas Eakins or moved abroad like Mary Cassatt.

In 1893, when Alexander Milne Calder's gigantic William Penn was finally hoisted atop the tower of City Hall and the first sightseers stepped on the hat brim, the scene began to change. Not that the events of 1876 had opened the eyes of Philadelphians to the merits of their own artists, but the glimpse of world culture had brought a new viewpoint. In the Centennial year, the venerable Pennsylvania Academy of Fine Arts moved into its elegant Victorian quarters on Cherry Street, where it enjoyed larger galleries and classrooms; at the same time a small wave of enthusiasm for collecting, exhibiting, and studying art began to mount in the city. The students on the Academy's roster during the eighties and nineties were a lively group and destined to have an immense influence on American art.

The more serious students regarded the Academy as a step on the road to Paris. Nevertheless, Philadelphia could still hold many of the young artists, before and after the inevitable European journey, because of the city's flourishing publishing business. The young artists found that there were ample opportunities for employment as newspaper illustrators during the early and mid-nineties.

Commercial printing techniques changed rapidly, and art styles and movements eddied across the Atlantic. The period was one of flux; it was also *fin de siècle*. But in Philadelphia it was a time for youth, with frontiers beckoning, when John Sloan and his friends entered the world of art.

THE BEGINNINGS

John Sloan liked to quip, "I'm Irish and agin the government," but in a more serious autobiographical vein he wrote that his father's "Scotch Presbyterian forbears had been cabinetmakers for many generations," and had settled in Pennsylvania early in the eighteenth century.[1] His great-grandfather had come to the lumber town of Lock Haven soon after 1800. It was there that grandfather John French Sloan carried on the family business as cabinetmaker and undertaker, and that his father, James Dixon Sloan, tried his hand at photography and bicycle repairing before moving to Philadelphia in 1876.

His mother's side of the family was widely connected in the paper-manufacturing and stationery business. Great-grandfather Samuel Priestley, by family tradition a cousin of Joseph Priestley, came to America from Leeds in 1816 and established a paper mill

The Home of Edgar Allan Poe. 1891. No. 4 of Homes of the Poets by A. Edward Newton. Etching, 5″ x 7″ (plate mark). The John Sloan Estate. Photo courtesy of the Smithsonian Institution, Washington, D. C.

in Delaware. Great-uncle Alexander Priestley "was a wonderful old scholar-inventor," with a library rich in prints and illustrations by Hogarth and Rowlandson, Cruikshank and Doré, Leech and Abbey. John spent hours of his boyhood pouring over these treasures.

John's mother, Henrietta Ireland Sloan, who had attended normal school, was teaching English in Lock Haven when she met her future husband. Her sisters, who had gone to finishing school in Switzerland, were narrowly pious High Church ladies. Aunt Emma married William H. Ward, son of the English publisher Marcus Ward and friend of the illustrators Kate Greenaway and Walter Crane. It was through these connections that John's father became involved with stationery, first as a salesman for Marcus Ward and then as proprietor of a small shop. John grew up in the world of fine papers, of printing and illustrating, of books and greeting cards.

Born in Lock Haven in 1871, John was the only son in a family which soon included two younger girls, Marianna and Bessie. He remembered that he and his parents shared the deepest affection. His mother, in contrast to her strait-laced sisters, "loved to make puns and was really a Dionysian at heart." His father's gifts, unfortunately never exploited, lay in the direction of the crafts and inventing. "My father was an artist, a skillful craftsman, painting in his spare time. A total wreck in business. My mother a humorful, gentle lady. My sisters and I all drew equally well."[2] Marianna, in fact, was to become a well-known Philadelphia painter in her own right. The Sloan household was short on funds but lively and long on spirit.

John read omnivorously, going through "all of Dickens and Shakespeare" before he was twelve, and then spending his free time in the library after entering Philadelphia's Central High School. His classmates there included William Glackens and Albert Barnes, who were engrossed in baseball. John did not engage actively in sports, partly because he was already suffering from a lifelong trouble with nearsightedness that caused him to stay out of school for a half term. He shared his mother's pleasure in words and so loved etymology, and he drew illustrations for his copy of *Treasure Island,* both of which prepared him well for his subsequent years of inventing pictorial charades and puzzle drawings.

When he was sixteen, his father's stationery store failed and he was forced to go to work. He later recalled, "I don't think that I was ever bitter about going without a college education, but I cannot bear to remember the look of melancholy defeat on my father's face when he had to tell me the family had decided I had to leave school."

The job that John Sloan found was the first of a series that led him progressively into a full-fledged career in art. In the bookstore of Porter and Coates, where he served as assistant cashier, he found time to read deeply in Balzac and Zola, developing his taste for realism. By good fortune, he was also given the opportunity to create greeting cards and valentines—doing both the verses and the decorations—after the manner of the Marcus Ward cards he knew so well. Porter and Coates handled original prints by such

artists as Dürer and Rembrandt, and John made copies in pen and ink, selling them for five and occasionally ten dollars. He was soon determined to learn etching himself. Studying Hamerton's *The Etcher's Handbook,* he did a drypoint after a Rembrandt self-portrait, then an etching after a print of a Turner landscape. Before long he was off on a series of portraits depicting English authors and calendars illustrating the homes of American poets. He set his sights on becoming an illustrator, and he experimented with a variety of mediums, doing watercolor sketches and even a self-portrait in oils.

His ability must have been impressive, because in 1890 A. Edward Newton, a clerk from Porter and Coates who was leaving to set up his own business, asked John to join the new establishment as a commercial artist at nine dollars a week. There Sloan designed a variety of "notions," while the flock of girls who worked with him teased him heartlessly. He recalled later "how frightened I used to think myself. There were about sixty girls employed—watercolorists, sewers, and pasters on boxes and calendars, etc. I was the only male in the painting room."[3] At night he attended a class in freehand drawing at the Spring Garden Institute, determined to train himself professionally. Newton offered to send him abroad to study, but Sloan already had firm ideas about independence, and he declined the offer.

In 1891, after working for Newton somewhat more than a year, he left to become a freelance artist, a daring step considering his youth and the family's continuing dependence on his earnings. He took a tiny studio at 703 Walnut Street and worked at lettering, letterheads, and streetcar advertisements (which called for a poster technique). He continued to produce etchings for Newton, making more than fifty over a period of several years and becoming widely experienced in the technique at a time when relatively few Americans knew the mysteries of the craft.

At the age of twenty, John Sloan already displayed the traits that were to distinguish him for life. A perceptive description was given by his uncle, William H. Ward, who wrote a letter of recommendation for the stubborn, struggling youngster to the manager of the Philadelphia Engraving Company:

<div align="right">

S.S. Teutonic
23rd Nov., 1891

</div>

. . . He is very assiduous in evening study at Art Classes, and I feel sure that he has decided talent and will get on. One good trait in his character is his independence. He has got along so far entirely unassisted, and is determined to rely upon his own labor in the future, and also to help his mother. This makes the earning of some steady sum, small though it may be for a time, a necessity; and may retard the rapidity of his progress in art —but with determination to get on he is sure to succeed in the long run. . . .[4]

THE NEWSPAPER DAYS
1891·1903

Self-Portrait. Crayon on paper, 6″ x 4″. The Kraushaar
Galleries, New York.

STAFF ARTIST

By the end of 1891, it was obvious that freelancing offered an uncertain livelihood. Sloan applied for work at the Philadelphia *Inquirer,* and he soon joined the art staff under the sympathetic direction of the youthful staff manager, Edward Wyatt Davis. Davis (who was to become the father of the artist Stuart Davis and Sloan's lifelong friend) had attended the Pennsylvania Academy with Robert Henri and Charles Grafly, and soon Sloan was caught up in the world of young Philadelphia artists.

A number of the painters were professional illustrators. They moved from paper to paper—the *Press,* the *Ledger,* the *Inquirer,* the *Bulletin*—but their social life revolved around the Academy and independent studios, especially Henri's. Thus it was that Sloan became close friends with his high school classmate William Glackens and with George Luks and young Everett Shinn, all of whom worked at one time or another on the *Press,* as Sloan was to, although they never worked together there as a group.

During the nineties there were great advances made in the photomechanical processes used in newspaper printing. The changes directly affected Sloan and his friends. The young men began as illustrators at a time when it was first becoming possible for artists to do their drawings freely on paper for photomechanical reproduction. "There was a kind of excitement in the air for those of us who were interested in drawing as a means of communicating ideas, when these new opportunities for mass production through publishing were opening up." Before long, however, another technical advance—the photomechanical reproduction of halftones and consequently of photographs—brought to a climax and eventually terminated the golden age of the artist-reporters.

When Sloan first joined the *Inquirer,* the routine jobs assigned to the art staff included making line drawings of photographs of people and places in the news. This was a hack job, but sufficiently demanding when done under pressure. It was far more lively to cover crimes, accidents, and catastrophes on the spot, but Sloan and his editors found that such artists as Glackens, Luks, and Shinn had more facility for offhand reportorial drawing. Sloan "was only sent out on news assignments when the staff was short-handed," but it was often enough so the emphasis on quick observation, memory, and capturing the essentials prepared him for his later depictions of the New York scene. He also appreciated the training in achieving factual accuracy and in judging the effect of his work objectively.

Because Sloan had a gift for decorative illustration in the newly fashionable "Poster Style," his usual assignments were for feature pages and the Sunday supplement. In December, 1895, Sloan moved to the *Press* art department to work on the Sunday supplement there. By this time, Shinn had gone to Sloan's old paper, the *Inquirer;* Luks had moved to the *Bulletin,* which sent him to Cuba; and Glackens was in Europe with Henri and Grafly. But the *Press* stood for their common experience as newspaper illustrators, and Sloan's memory of his years there remained warm and vivid:

On the Court at Wissahickon Heights. 1892. Brush, pen, and ink over pencil on board, 9¾″ x 6⅝″. The John Sloan Trust, Wilmington, Delaware.

Night on the Boardwalk.
Illustration in the July 8, 1894,
Philadelphia *Inquirer*. Brush,
pen, and ink, 12½″ x 6¾″. The
Delaware Art Museum, Wilming-
ton. The John Sloan Collection.

It is not hard to recall the *Press* "art department": a dusty room with windows on Chestnut and Seventh Streets—walls plastered with caricatures of our friends and ourselves, a worn board floor, old chairs and tables close together, "no smoking" signs and a heavy odor of tobacco, and Democrats (as the roaches were called in this Republican stronghold) crawling everywhere. But we were as happy a group as could be found and the fun we had there took the place of college for me. Like most newspaper men of those days we knew nothing of world troubles; a care-free life such as the birds lead.[5]

THE POSTERS

Sloan had been producing posters for the Bradley Coal Company as far back as his freelance days of 1891, and his etchings for Newton sometimes were done in a related decorative manner. It was his newspaper work, however, that especially encouraged the development of the style, calling as it did for "illustrations for serialized stories, headings for feature articles on the Women's Page, advertisements for such products as Lydia B. Pinkham's tonic, and decorative pictures for the sections on Sports, Vacations, etc."

It seems paradoxical that Sloan, who is associated above all with a school of art that rebelled against stylistic graces and who devoted his last twenty years to the pursuit of plastic realization, should have made his mark first and decisively in the Poster Style. A partial explanation lies in the early influence of such artists as Walter Crane, Randolph Caldecott, and Edwin Austin Abbey. Subsequently, he enjoyed specializing in the style because producing these illustrations and decorations allowed him a detached independence within the art staff "factory."

What remains inexplicable except in terms of sheer talent is the creative vitality that finally infused his Poster Style work. Sloan himself recognized that the style, as exemplified by Edward Penfield, Henry Carter, and Howard Pyle, had roots reaching back through Crane, Morris, and the Pre-Raphaelites to "Medieval and Japanese art, along with the study of Greek vase painting." As early as 1892, magazine and book illustrations were adapting ideas borrowed from Japanese woodcuts to the photoengraving process for making linecuts. The new photomechanical reproduction of original drawings allowed the artists increased freedom and assured them accurate results.

John Sloan took pains to point out that his first work in the Poster Style appeared in the *Inquirer* in 1892, and that a turning point in his style came with his study with Beisen Kubota in 1893. Kubota had gone to the World's Columbian Exposition in Chicago as a correspondent, subsequently traveling to Philadelphia to offer lessons in Japanese brush technique. Henri and Sloan were much intrigued by Kubota and carried brush and ink about with them, making sketches.

Hard on the heels of this, in the first part of 1894, came the fully definitive expression of what was then formally termed the "Japanese or Poster Style." John Sloan and Will H. Bradley (whom Sloan was to know years later in New York) were the

Miner Poet. c. 1894. Relief linecut, photomechanical, 3¾″ x ¾″. The John Sloan Estate. Photo courtesy of the Smithsonian Institution, Washington, D.C.

acknowledged pioneers in America. Simultaneously, an international craze was developing, and Sloan seized on Beardsley's *Yellow Book* as soon as it reached Philadelphia. Nationwide interest in the Poster Style was immensely stimulated by Beardsley's sensational success, but the first wave of the poster period moved on as rapidly as it had come. "When the scandal about Oscar Wilde (1895) cast a cloud on Beardsley, our uneven little efforts in the United States suffered." Some ten years later, Sloan referred in his dairy to "the Poster Period of 1894 –95–96."[6]

The enthusiasm for the style had an immense effect on Sloan's professional growth, both in terms of his work and the recognition he began to receive. In 1894 the first published notices of his work appeared in two Chicago magazines, *Inland Printer* and *Chap Book*. His composition and drawing ability with figures became increasingly sure. By the next year, his posters and drawings were mature and vigorous, and he found himself established as a leading figure in the movement. He was mentioned in papers in Chicago and Pittsburgh, and a New York critic wrote of "Chéret, Hardey, Beardsley, Bradley, Sloan, Vallotton, and the whole school who have, by their Japanesque work in France, England, and this country, excited so much recent comment."[7] He began to do illustrations for a number of magazines (mostly the small literary journals of the moment). He was shown and well received at the Seventh Annual Black and White Exhibition of the Chicago Society of Artists and it was announced that he had been appointed art editor of *Moods*—"the pretentious effort of Bloomingdale and Lewis in Philadelphia"[8]—an honor that proved to be as shortlived as the magazine.

By the end of the nineties the little publications that had appeared everywhere were succumbing to financial pressures, but the Poster Style merged into Art Nouveau and continued in that form into the present century. Sloan's Sunday supplement illustrations are an example of this later phase of the style.

His early work emphasized clarity by using a limited number of flat, carefully arranged and contrasted areas, a manner that reached its climax in 1895 and 1896. His later decorative drawings became much more complex in line, pattern, texture, color, and spatial order. He was conscious throughout the period, however, of keeping somewhat closer to real life than Beardsley and avoiding the latter's "kind of decadent and bizarre quality." He preferred "the wholesome kind of humor that comes out in ribaldry."

At first Sloan worked within the limitations of a process usually restricted to one or two flat colors. (It was occasion for comment when the second issue of *Moods* was adorned by a Sloan cover printed in four colors.) When the techniques of printing advanced to the point where the artist could use color flexibly and expressively for the newspaper, the results were exhilarating. For Sloan, this opportunity came as a result of his decision in 1898 to try a job in New York City.

By then, most of his close friends had left Philadelphia for New York. Glackens and Luks had gone in 1896, Shinn the next year,

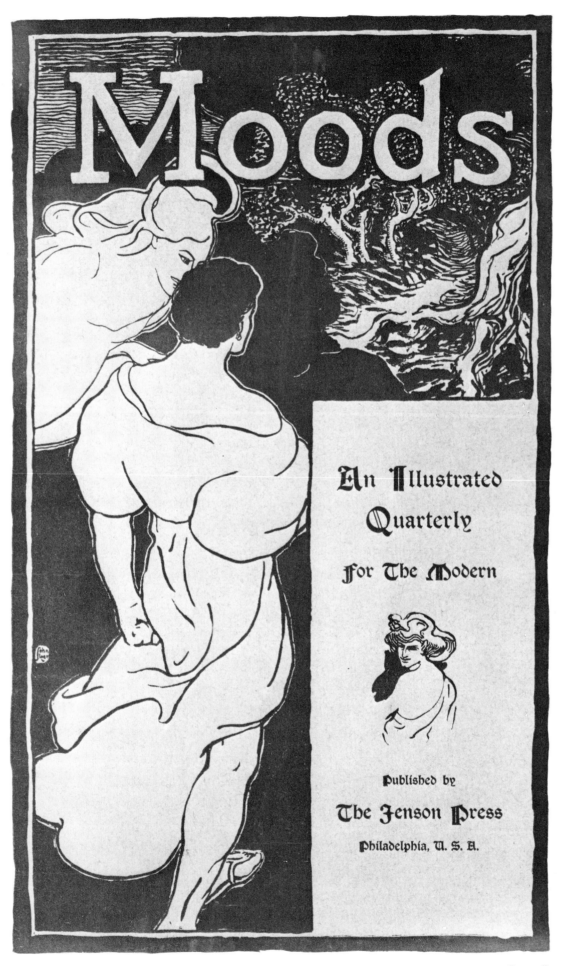

Moods. Poster announcing the July, 1895, issue of *Moods*. Chalk-plate in green ink, 19″ x 11″. The Smithsonian Institution, Washington, D. C.

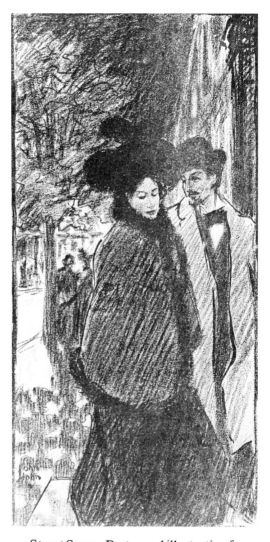

Street Scene. Poster and illustration for "Loves Kalendar" in November 9, 1895, *Gil Blas*. Black chalk and ink, 15¾" x 7¾". The John Sloan Estate. Photo courtesy of the Smithsonian Institution, Washington, D.C.

and Henri returned from Paris temporarily to take a studio there in 1898. Sloan was offered a position, with an increase in salary, by the New York *Herald*. He soon found he was not happy with the editors' desire to have him "tickle up" his drawings, and he returned to Philadelphia after two or three months. He had learned, however, about the Benday process for printing watercolor drawings in newspapers, and he soon began producing colorful full-page puzzles for the *Press*'s Sunday supplement.

A remarkable series of some eighty large watercolor drawings appeared in the *Press* between 1899 and 1903. Sloan thoroughly enjoyed the work, and he poured ingenuity and imagination into the games he played with words, shapes, and colors. Characteristic of Art Nouveau, Sloan's line ran into spirited fantasy when it had the freedom to take off on rhythmic excursions depicting plant forms, flowing hair, billowing or patterned drapery, or swirling water. Decorative passages were carried exuberantly to the verge of independent abstractions.

The large puzzle drawings represent the last phase of Sloan's poster period, and of his full-time newspaper work. They are a credit to his technical as well as artistic inventiveness, for he did much to develop the process used in printing the reproductions. But by 1903 the heyday of the newspaper artist was well past and Sunday supplements were being syndicated, so he left the staff of the *Press* and limited his work for the paper to a weekly line drawing of a "charade."

By this time Sloan was deeply immersed in magazine and book illustration, and he was becoming known for a style of drawing much closer to that of his paintings, which in turn had begun to attract attention as examples of the new Realist movement.

CINDER-PATH TALES
WILLIAM LINDSEY

BOSTON: COPELAND AND
DAY ❀ ❀ ❀ PRICE $1.00

Cinder-Path Tales (poster and book-cover design). 1896. Lithograph, photomechanical, in black and white ink on brown paper, 22¾″ x 13⅞″ (paper), 17¼″ x 11¼″ (picture). The Smithsonian Institution, Washington, D. C.

THE YOUNG ARTIST
1892·1904

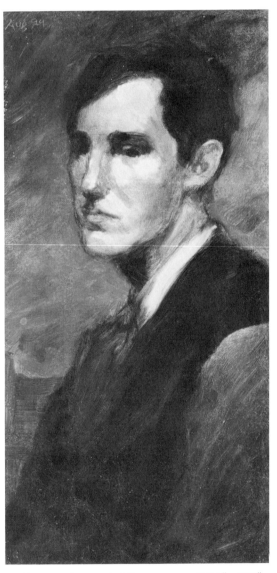

Self-Portrait. 1894. Oil on canvas, 15¾″ x 8¼″.
The Delaware Art Museum, Wilmington. The
John Sloan Collection.

STUDENT OF ART

In the summer of 1892, Sloan and Glackens began to go on sketching trips in the Philadelphia countryside, painting watercolors of the fields, hills, and scattered factory buildings near the city outskirts. That fall Sloan entered night class at the Academy, where the influence of the uncompromising Thomas Eakins was transmitted through the strict but kindly Thomas Anshutz, master of anatomy and painter of factory laborers. Sloan confessed that his group "felt that Eakins, while a thoroughly fine man, lacked a sense of humor and made too much fuss about posing nude models," and although he had consummate respect for Eakins's painting and critical judgment, he never studied with him.

Sloan found it hard to take instruction with docility. Late in 1893, after two semesters with Anshutz, he had just been advanced to life class when he flared up at a criticism and walked out. Nevertheless, his friendship for Anshutz continued to grow, along with respect for his dedicated teaching. Sloan's diary often records their meetings in later years, and the etching of a lecture class that he made from memory in 1912, *Anshutz on Anatomy* (page 91), is a heartfelt tribute.

In December of 1892 Sloan had been introduced to Robert Henri by Charles Grafly, the young Philadelphia sculptor who was to acquire an outstanding reputation, and who was just then commencing a long, distinguished teaching career at the Academy. The following March found Henri and Sloan working together along with the principal instigators of the Charcoal Club, a five-month experiment in running a night school on a more liberal and economical basis than the Academy's. Instruction was somewhat informal, but Henri offered criticism in drawing, while Sloan served as bookkeeper and criticized the compositions. (This was to be his only opportunity to work from the nude model during his student days.) The class coincided with Thomas Anshutz's temporary absence from the Academy, and at first it attracted more students than the Academy night class, "but cooperation schemes at $2.00 per month won't stand hot weather,"[9] and the project did not survive the summer. On the other hand, it brought together the nucleus of a group that was to continue meeting on Thursday nights for nearly two years at the open house Henri conducted in his studio, where he held forth eloquently on the nature of art and life before the younger painters.

Henri, who was six years older than Sloan, had studied under Anshutz, continued his education in France, and then returned to Philadelphia to establish his studio there and to teach. He quickly became the strongest influence Sloan was to know during his formative period. Dynamic, restless, gifted, magnetic, Henri enjoyed teaching, gathered disciples, and was the center of attention wherever he went. He expounded "the art spirit," calling for dedicated work and a wholehearted embracing of life. He was generous in encouraging and championing the younger artists in their struggles to create and exhibit a more vital art. He urged them to paint spontaneously, using the everyday subject matter about them, and to strive for the directness and immediacy of

subject and technique that characterized the work of Frans Hals and Manet.

Henri was especially friendly to Sloan, who in turn was swept into a mounting enthusiasm for art. Sloan never ceased paying him generous tributes: "I don't think I would have become a painter if Henri had not kept at me to become started. When I met him, I was only interested in becoming a good illustrator. He was my father in art."

The group that went to Henri's on Thursday nights included not only Sloan, Glackens, Shinn, and sometimes Luks, but other illustrators, among them James Preston and F. R. Gruger, and on occasion artists such as Grafly, Sterling Calder (son of Alexander Milne Calder and father of Alexander Calder), E. W. Redfield, Hunter C. Breckenridge, and Elmer Schofield.

Sloan was never an actual student of Henri's, but he joined Joe Laub in renting Henri's studio at 806 Walnut Street when Henri was away, and when Henri returned to town and used the studio for classes, Sloan sometimes remained in the room to observe and listen. In addition, Henri would look over Sloan's work and offer criticisms. Henri was full of enthusiasm for the work of Manet and talked about "the need to paint the everyday world in America just as it had been done in France." Sloan, steeped as he was in Rembrandt, Hogarth, and the realism of Dickens, was immensely influenced by Henri's philosophy of art and his approach to painting. Listening to Henri expound on George Moore, Ruskin, Emerson, and Whitman struck responsive chords in Sloan, who at the same time remained skeptical when Henri went on to champion the theories of Bakunin and philosophical anarchism.

For more than a dozen years Sloan's paintings reflected Henri's manner and spirit to a greater or lesser degree. Increasingly, however, Sloan's own stubborn and earthy independence asserted itself, and eventually the two men began to drift apart. But at the outset of Sloan's career, Henri was his closest friend, and this he never forgot.

The studio at 806 Walnut Street was the scene of much talk about art and much teaching, but there were also many lighter moments. The artists were fun-loving, lively, and natural actors. George Luks threw himself in and out of character at a moment's notice—portraying a senator, prize fighter, Canadian Mountie, or Uncle Tom: Sloan regarded Luks as a wonderful entertainer, but sometimes wondered whether he had read Baron Munchausen to the point of losing some of his footing in reality. Everett Shinn's involvement in all aspects of the theater was to develop into a lifelong passion. What with Henri's and Sloan's histrionic flair, it was inevitable that "the gang" (Henri sometimes called them "the old stock company") would engage in amateur theatricals. The results were such presentations as *The Poison Gum-Drop* or *The Apple Woman's Revenge,* and *The Widow Cloonon's Curse.* The climax was a satire on *Trilby,* George du Maurier's colorful elaboration on the bohemian background of Whistler. *Twillbe* was performed during the Christmas season of 1894 at the Academy, with Henri playing Svengali and Sloan, fitted with a wig, a dress, and huge false feet, portraying the heroine.

A START AT PAINTING

During the same year that he was carrying his decorative style to a climax, Sloan was working toward the realization of a very different artistic concept. He later recalled that he had begun to paint seriously in 1896, doing some portraits and two large murals for the Pennsylvania Academy. If Puvis de Chavannes appears to have been a guiding influence in the murals, the portraits (and the city scenes that began to follow very shortly) owed much to Henri and Glackens.

It is difficult to determine the exact dates of most of Sloan's paintings from the nineties. He did self-portraits in 1890 and 1894. Some twenty more surviving oils date from this decade, and the majority of them are portraits or figure studies. He painted a few of his friends (including William Glackens and Jimmy Preston) and twice, in 1898 and 1899, he attempted portrayals of his bride-to-be, Anna M. Wall, or Dolly. He had met this diminutive, spirited Irish-American through his friend Edward Davis. She was constantly encouraging him to paint, and in 1898 she saved enough from her wages as a department-store bookkeeper to buy him an easel.

As might be expected, the canvases of these years reveal the struggles of a young artist to achieve technical proficiency and find a personally congenial style. He liked to model his forms carefully, reflecting the earnestness of Anshutz and Eakins, but at times, egged on by Henri, he attempted to work with a broad, flowing brush. Henri often scolded Sloan for his laborious approach. "I paint until I get solidity," Sloan said doggedly, while Henri jibed, "*Sloan* is the past participle of *Slow*!"[10]

Glackens and Henri shared a mutual enthusiasm for Whistler and Manet. Both of Sloan's friends favored a style of muted colors, with strong darks and occasional gleaming whites arranged in striking, simplified shapes. Sloan usually echoed this mode, painting "in darkest Henri," although on two or three occasions he experimented with sinuous compositions, (such as in his Art Nouveau drawings) and once he toyed with the high-keyed palette of Impressionism. At times—and this was significant for the more distant future—he tried glazes, heavy impasto, and freely linear graphic accents.

The painters of the group could be diverted by the play of pattern and brushwork, but they abhorred the pallid, sweetish, derivative, conformist "good taste" that dominated academic art of the day. In contrast, they sought a vigorous, direct, original art—erring on the side of roughness if need be. They were determined to seize the immediate impression of life and put it down vividly: "scenes and people presented with . . . studied nervous energy and direct means of expression," as Sloan said later of Henri's canvases.[11]

The group reverted to the darker manners of Manet and Hals because, in their minds, American Impressionism was associated with prettiness and superficiality. For Henri, this meant abandoning the Impressionist manner he had cultivated in France and still reflected in 1893; but he, Glackens, and Sloan adopted and

retained relatively muted palettes until about 1909, when fresh experiments brought them into a new phase of heightened color.

Realism after the manner of Hals and Manet (with a dash of Courbet and Whistler, and memories of Eakins and Anshutz) led less directly to city scenes than to figure and portrait painting. From the beginning, Henri and Sloan worked long and hard on such subjects—Henri with an eye on portrait commissions and Sloan struggling for a sense of substance. Figure painting provided a particular challenge because the artist worked from the model, trying to capture form, character, and expression with a technique that appeared fresh enough to give the sensation of spontaneity and life. Sloan's portraits involved a more painful and protracted struggle for realization than did his memory-derived city scenes. If the fluent city view was to make his reputation as a painter, the figure study, with its basic problem of realization of form, increasingly concerned him until in later years it became his main preoccupation.

The determined vigor of his portrayal of form is increasingly evident in portraits done after 1900, such as *Miss Shoemaker* and *The Sewing Woman*. *George Sotter* (Plate 6) and *Stein in Profile* (Plate 7), which he painted soon after moving to New York in 1904, attest to a growing power. Eugenie Stein, whom Sloan admired for her earthy humanity, remained a favorite model for years. Henri also painted her in 1904, and his *Young Woman in White* (page 47) affords us an excellent opportunity to compare the work of the two friends. Sloan's utter lack of idealization stands in sharp contrast to Henri's stylish handling.

Sloan always credited Henri with stirring his interest in painting scenes of city life. To be sure, Henri had experimented with the genre fairly early, some years before his *La Neige* went to Luxembourg in 1899. In 1900, Henri announced that he was establishing his home in New York City, taking a house on East Fifty-eighth Street overlooking the East River, and "making some interesting studies of the neighborhood, which seems to have passed unnoticed by other artists."[12] He stated that he was about to do a series of New York street scenes, and several views of the East River and New York streets followed during the next couple of years. William Glackens kept in close touch with Henri, and he produced notable portrayals of New York life and the East River during the same period.

Meanwhile, Everett Shinn, the youngest member of the group, had in his own way made the greatest mark as a portrayer of city scenes. While working on the staff of *Ainslee's* in 1899, he had received a commission to illustrate a book projected by William Dean Howells that was to deal at length with life in New York. Shinn prepared thirty-six pastels, and these (though never published) led to a commission for a center spread in the February 17, 1900, issue of *Harper's Weekly, A Winter's Night on Broadway*. From this Shinn went on to other similar illustrations for *Harper's Weekly* and to one-man shows (first at the Boussod and Valadon galleries, later at Knoedler's) where his "New York and Paris types" were featured. His wide variety of subjects, usually in pastel, ranged from the sleepy passengers of *The Sixth Avenue*

After the Duel. Illustration for Charles Paul de Kock's *Andre the Savoyard,* Vol 2. 1904. Watercolor and charcoal, 10½″ x 14″. The John Sloan Trust, Wilmington, Delaware.

Elevated after Midnight (1899) to the ragpicker of *Early Morning, Paris* (1901). Although the figures fail to strike a deep chord of human sympathy, the scenes were often handled with striking cleverness, and the pictures found admiring purchasers among Shinn's friends in the theatrical world.

Sloan's first city scenes seem to have begun about 1897 with one or two low-keyed paintings. He continued in this vein throughout the next several years with increasing assurance, painting such works as *Walnut Street Theater* (ca. 1899), *Independence Square, Philadelphia* (1900), *East Entrance, City Hall, Philadelphia* (1901), and *The Rathskeller, Philadelphia* (1901). Meanwhile Sloan, like Henri, announced a "program": the *New York Times* of September 7, 1901, in the column "Philadelphia Art Notes," stated that Sloan "is at work upon a series of studies of city scenes which will appear in the Fall exhibitions. Mr. Sloan is a believer in the capabilities of the modern American city for artistic work, a theory which he shares with his friend Everett Shinn."

The city scenes were thus publicly launched, and Sloan at the same time was beginning to launch himself as an exhibiting painter. As a first venture, in October of 1900, he exhibited his oil *Walnut Street Theater* at the Art Institute of Chicago. In November he showed *Independence Square* at the Carnegie International in Pittsburgh. In April, 1901, *Independence Square* was included in the annual exhibition of the Society of American Artists in New York; during that month he exhibited with Henri and his friends at New York's Allan Gallery. Also in 1901 he displayed three oils at the Pennsylvania Academy, and thereafter he exhibited regularly in several shows every year.

At first, he had reasonable success in getting past the juries, in spite of the fact that (or perhaps because) his work had not yet reached its full strength. He was the slowest to "arrive" of the Henri group, and when they showed together, the critical attention tended to fasten on Henri, Glackens, or Luks. Only after he moved to New York in 1904, and was able to thoroughly immerse himself in the city's "human comedy," did his city scenes begin to take on complete freedom and fullness of movement. In the meantime, his work in illustration and etching had leaped to maturity, and his experiences with these mediums were to have a strong effect, in their turn, on his oils.

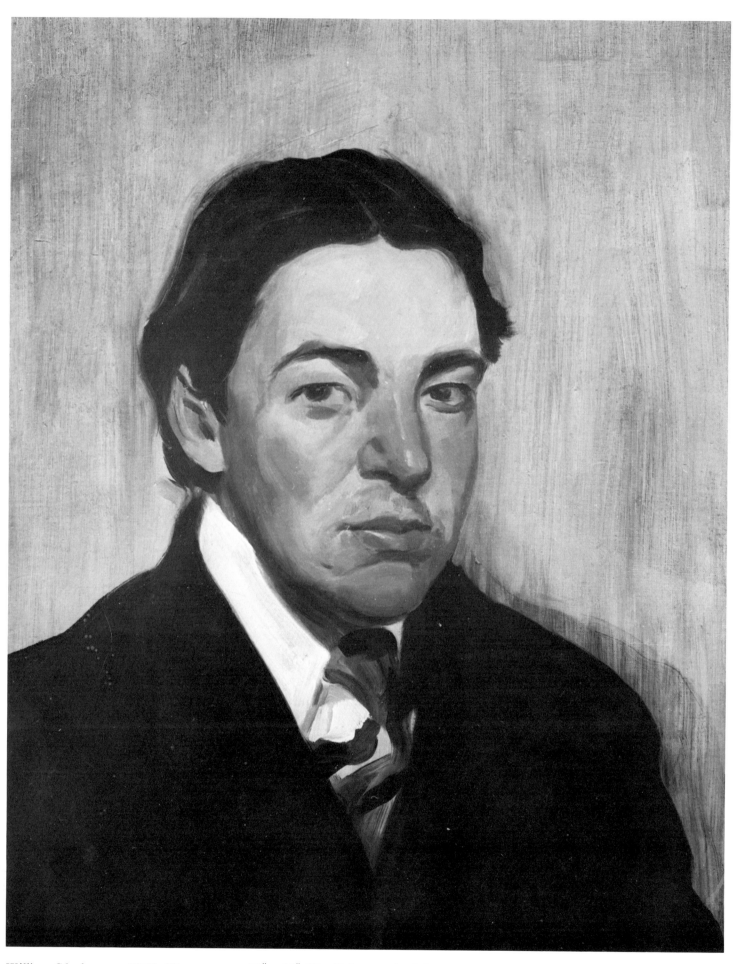

William Glackens. c. 1895. Oil on canvas, 20″ x 16″. The Delaware Art Museum, Wilmington. Gift of Mrs. John Sloan.

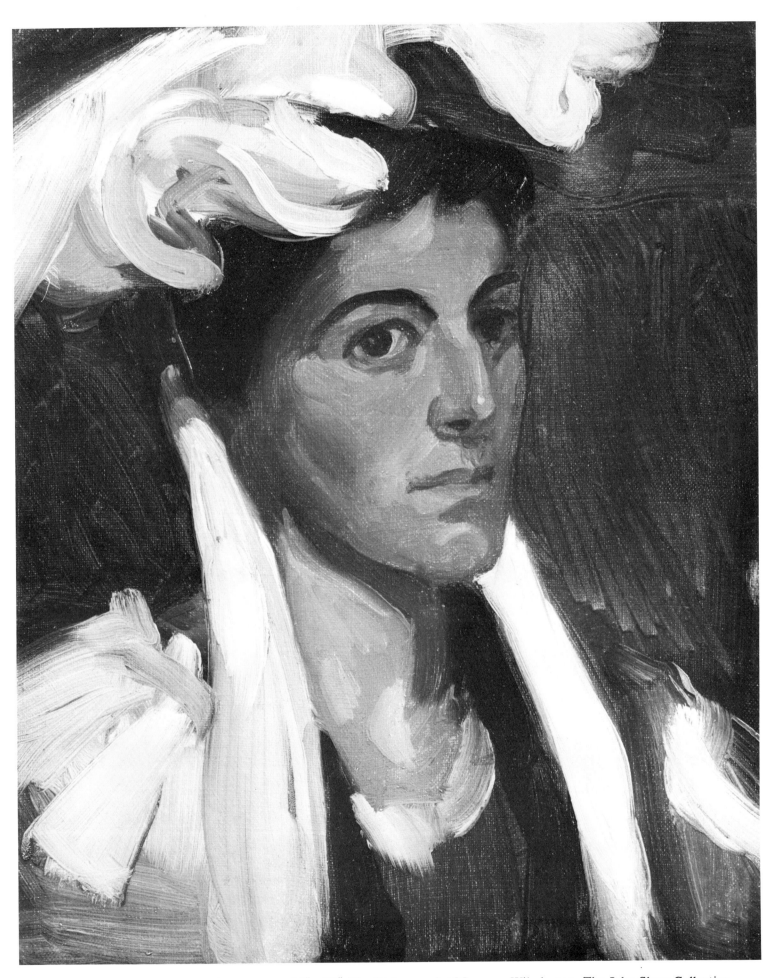

Girl in Feather Hat. c. 1896. Oil on canvas, 28″ x 20″. The Delaware Art Museum, Wilmington. The John Sloan Collection.

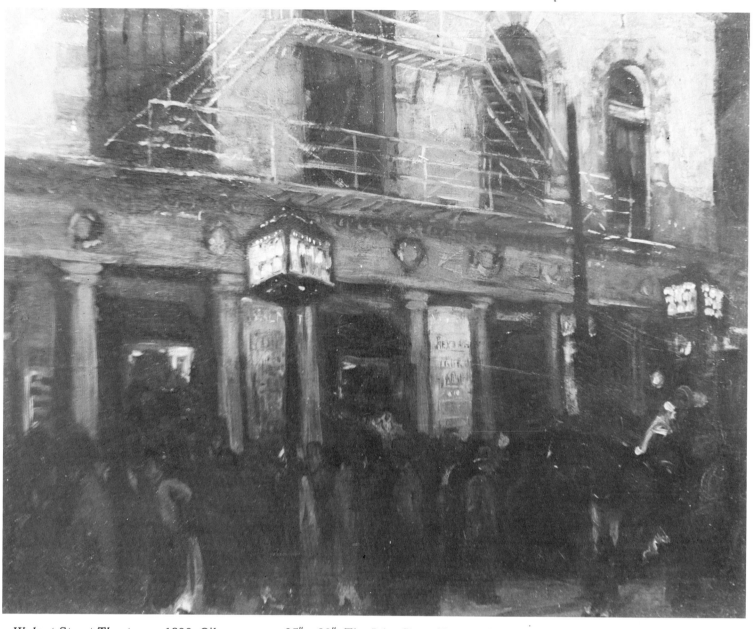

Walnut Street Theater. c. 1899. Oil on canvas, 25″ x 32″. The John Sloan Trust, Wilmington, Delaware.

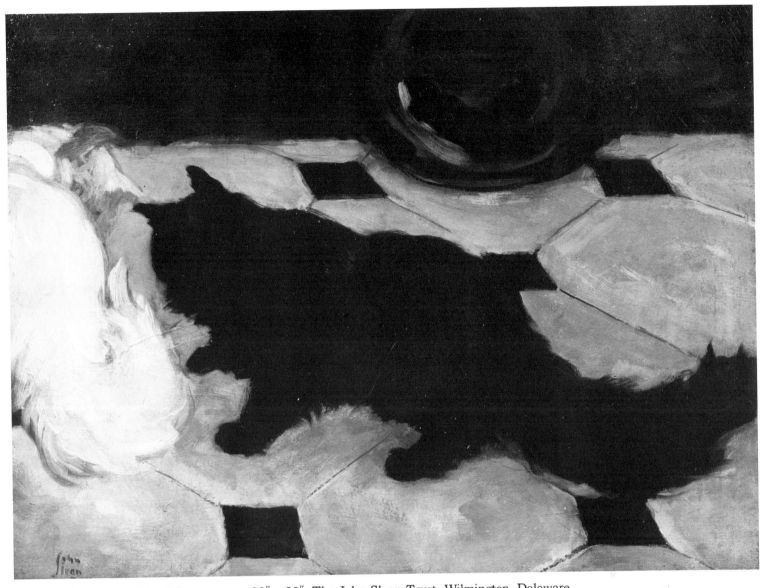

Green's Cats. c. 1899. Oil on canvas, 22″ x 30″. The John Sloan Trust, Wilmington, Delaware.

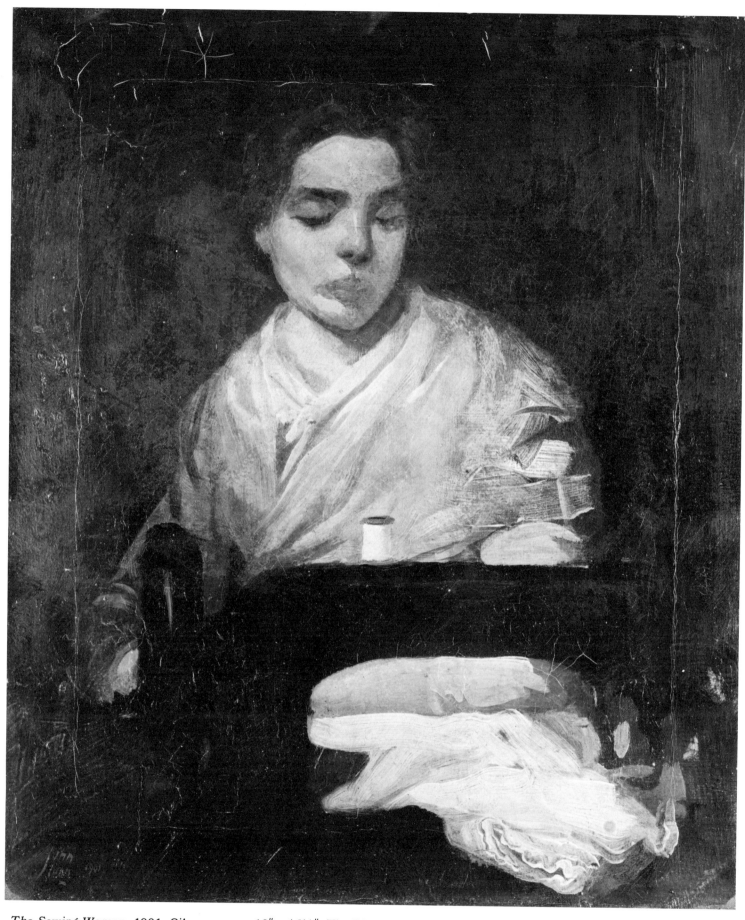

The Sewing Woman. 1901. Oil on canvas, 19″ x 16⅛″. The Metropolitan Museum of Art, New York. Gift of Margaret S. Lewisohn.

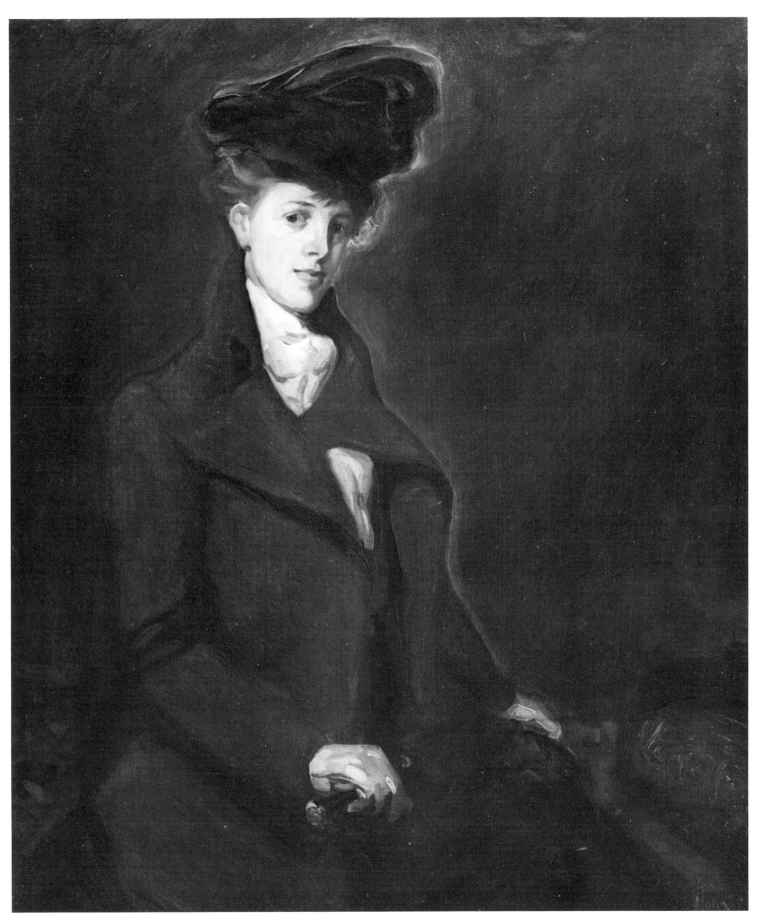

Miss Shoemaker. 1901. Oil on canvas, 27″ x 23″. The Kraushaar Galleries, New York.

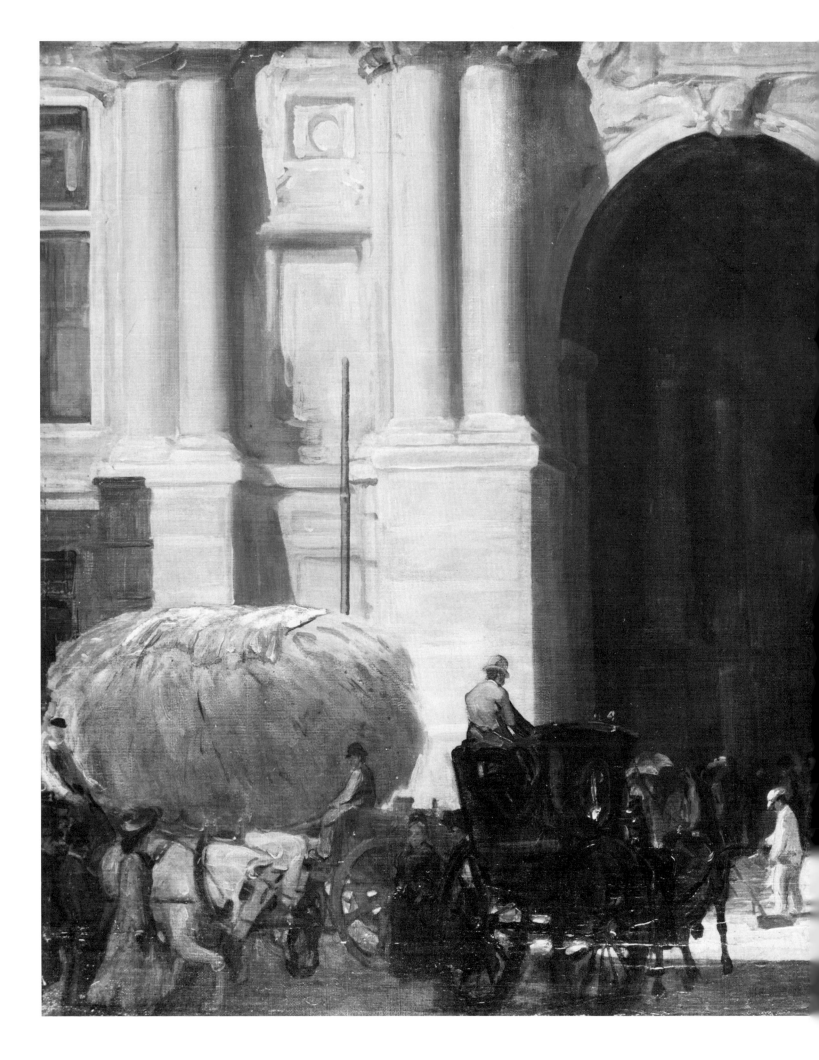

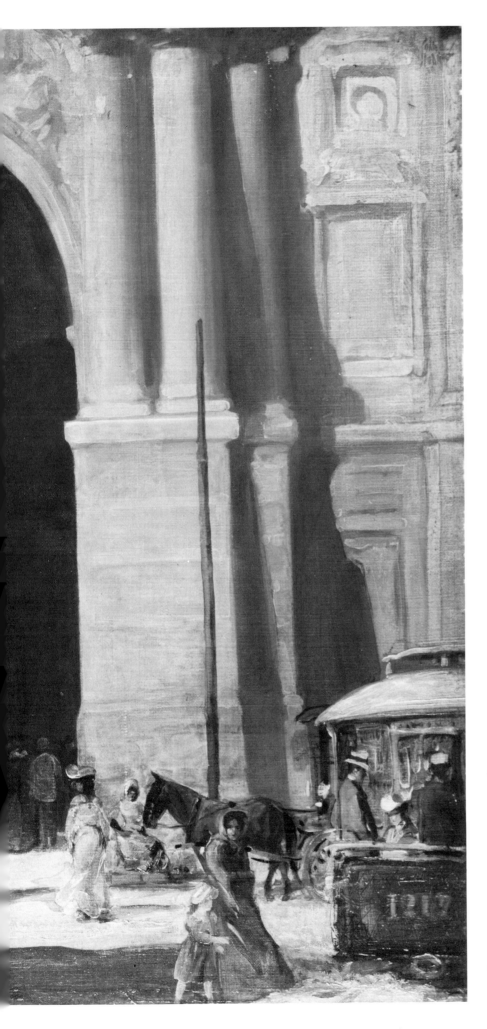

East Entrance, City Hall, Philadelphia. 1901.
Oil on canvas, 27″ x 36″. The Columbus Gallery
of Fine Arts, Columbus, Ohio. F. Howald Fund.

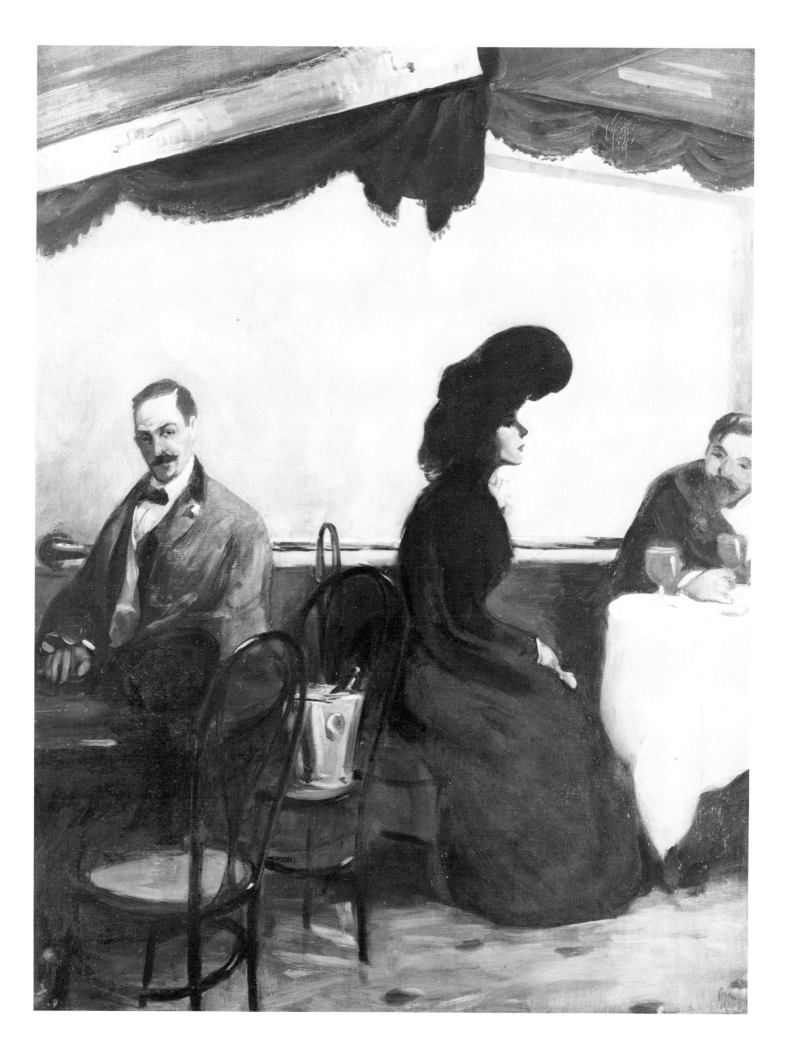

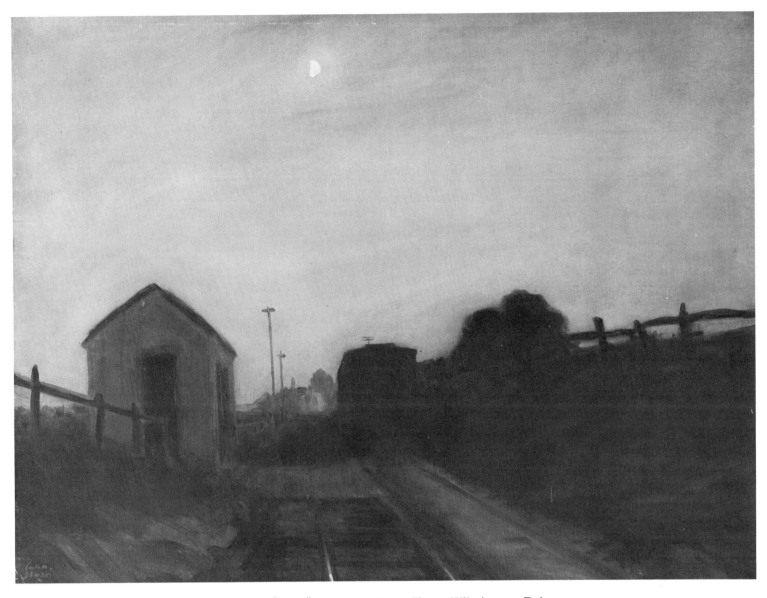

Wayside Station. 1902. Oil on canvas, 26″ x 32″. The John Sloan Trust, Wilmington, Delaware.

The Rathskeller, Philadelphia. 1901.
Oil on canvas, 35½″ x 27¼″.
The Cleveland Museum of Art.
Gift of Hanna Fund.

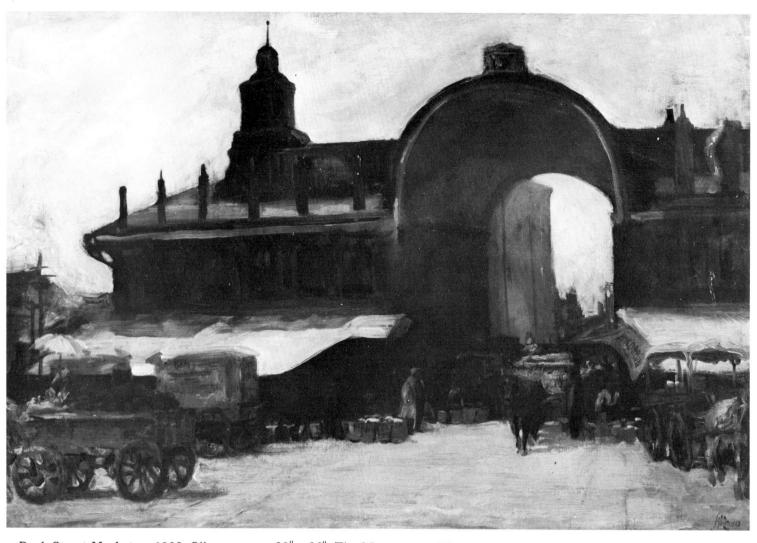

Dock Street Market. c. 1902. Oil on canvas, 29″ x 36″. The Montgomery Museum of Fine Art, Alabama.

Robert Henri. *Young Woman in White.* 1904.
Oil on canvas, 78¼″ x 38⅛″.
The National Gallery of Art, Washington, D. C.
Gift of Violet Organ.

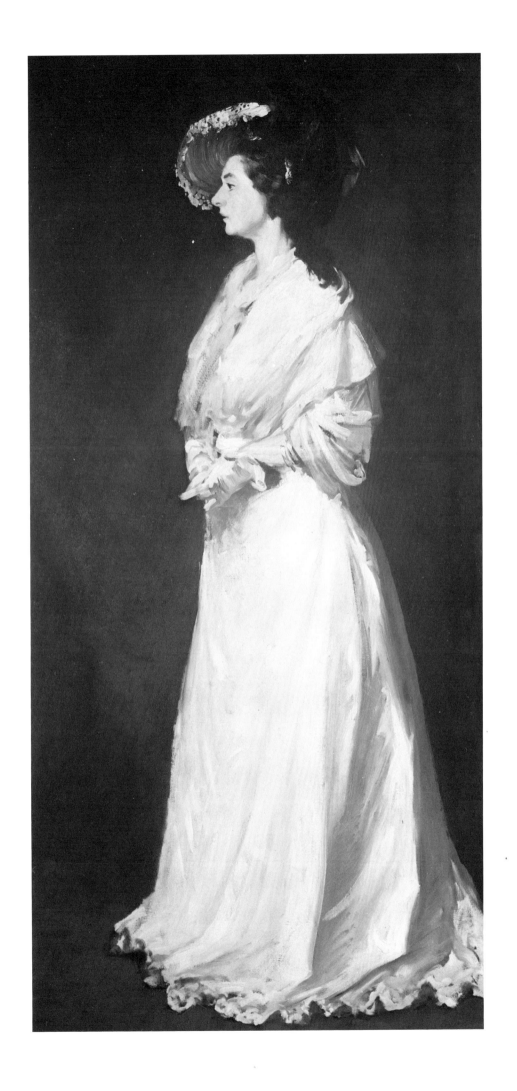

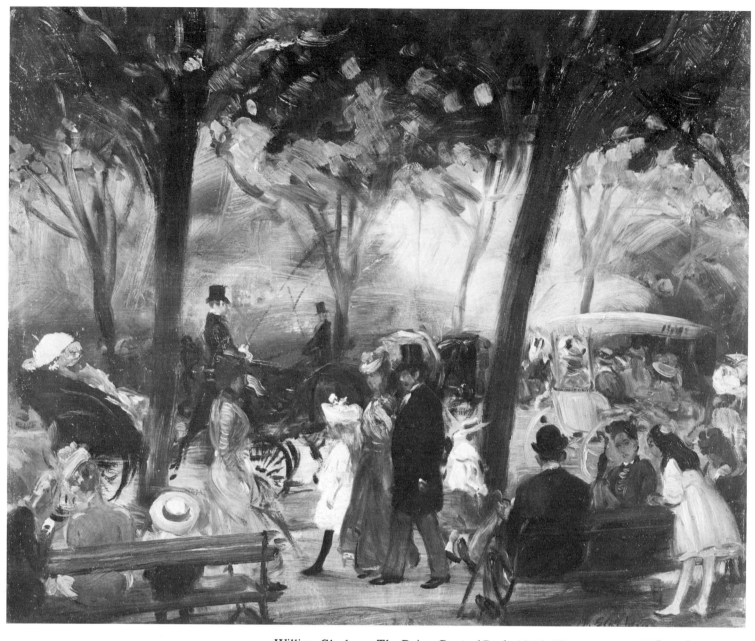

William Glackens. *The Drive, Central Park*. 1905. Oil on canvas, 25¾" x 32". The Cleveland Museum of Art, Ohio. Gift of J. H. Wade.

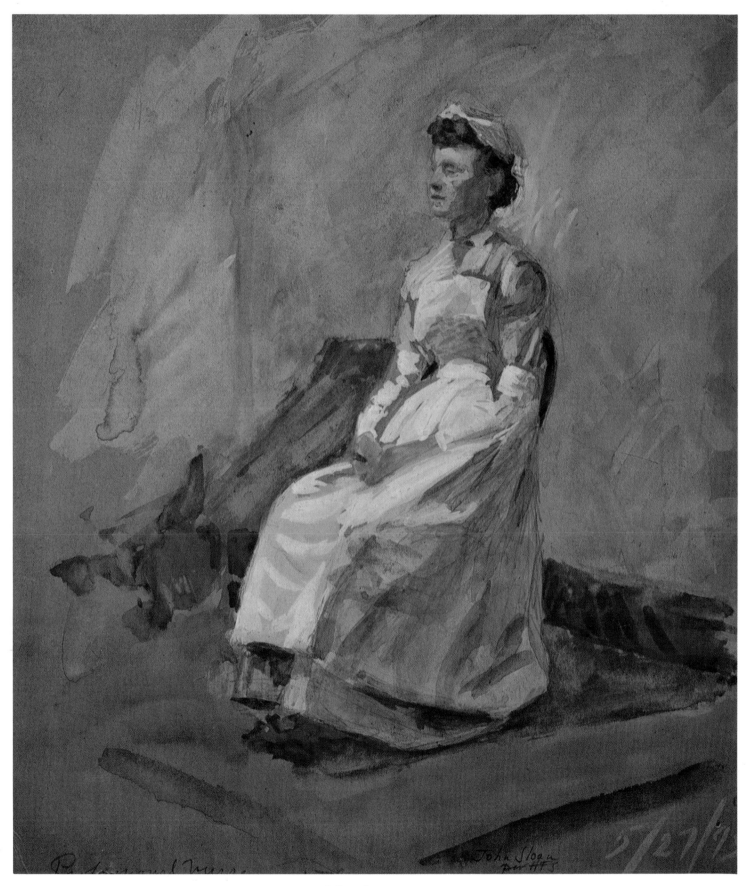

Plate 1. *Professional Nurse*. 1893. Watercolor, 10 3/4″ x 9″.
The Delaware Art Museum, Wilmington. The John Sloan Collection.

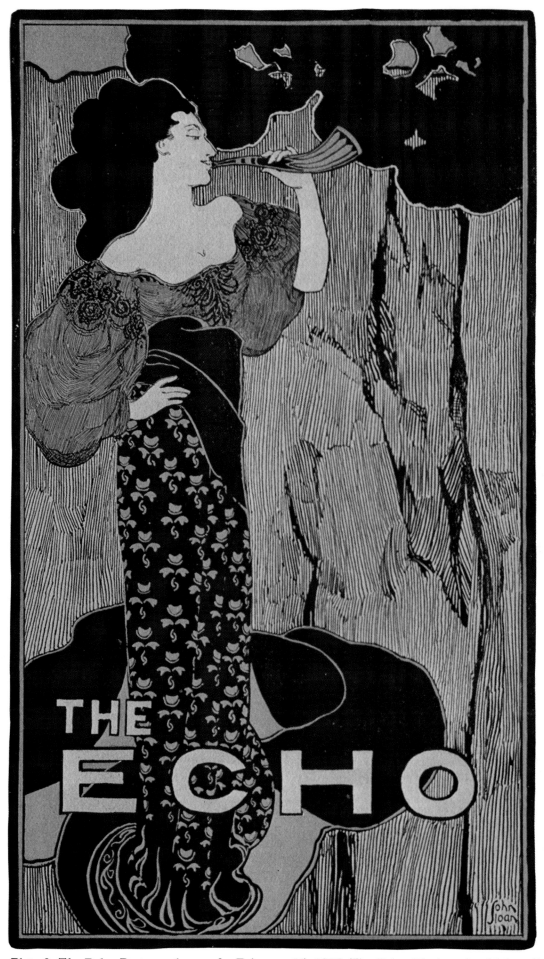

Plate 2. *The Echo*. Poster and cover for February 15, 1896, The Echo. Black and red ink, relief linecut, photomechanical, 9 7/8″ x 5 3/4″. The John Sloan Trust, Wilmington, Delaware.

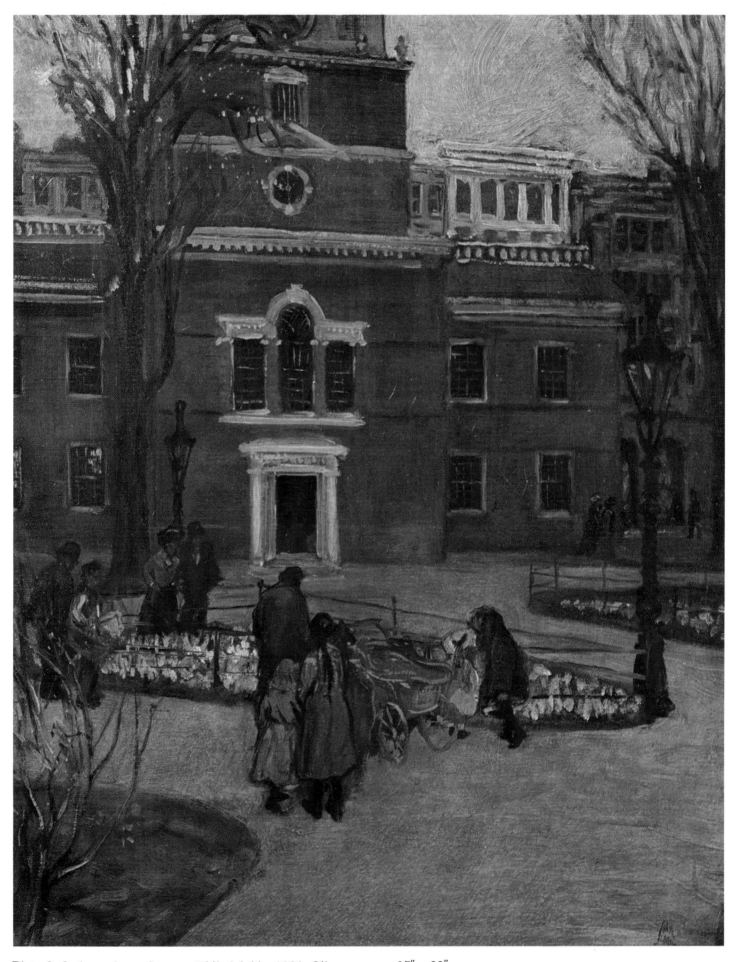

Plate 3. *Independence Square, Philadelphia*. 1900. Oil on canvas, 27″ x 22″.
The John Sloan Trust, Wilmington, Delaware.

Plate 4. *Hot Wave Puzzle*. Illustration for August 26, 1900, Philadelphia Press. Ink and watercolor, color linecut reproduction, 21 1/2″ x 17 1/2″. The Delaware Art Museum, Wilmington. The John Sloan Collection.

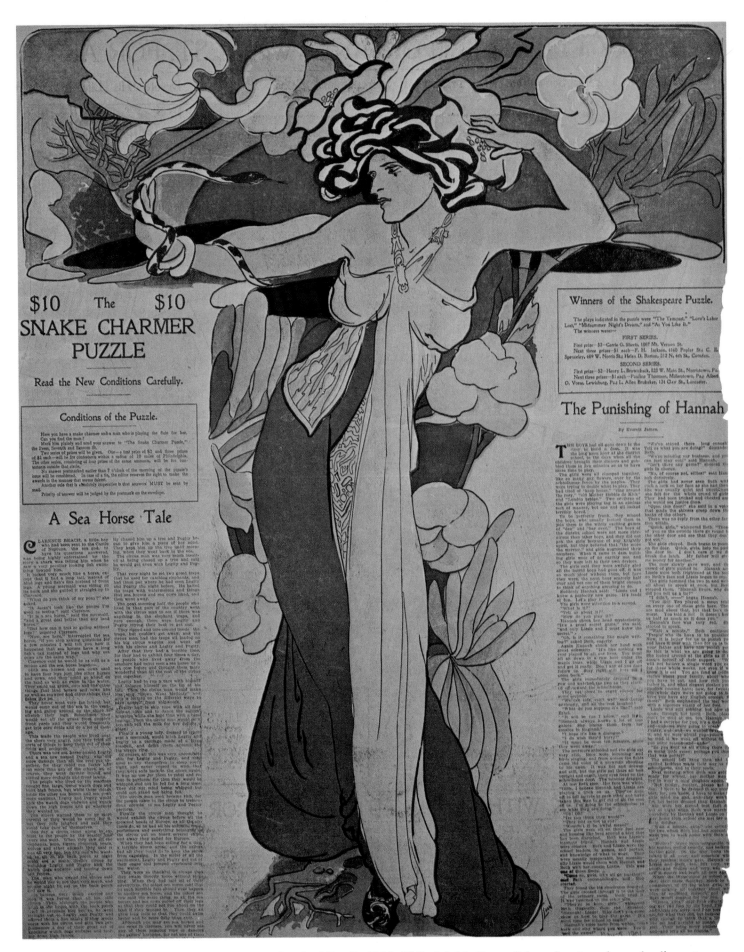

Plate 5. *Snake Charmer Puzzle*. Illustration for the May 5, 1901, Philadelphia Press. Ink and watercolor, color linecut reproduction, 21 1/2″ x 17 1/2″. Delaware Art Museum, Wilmington. The John Sloan Collection.

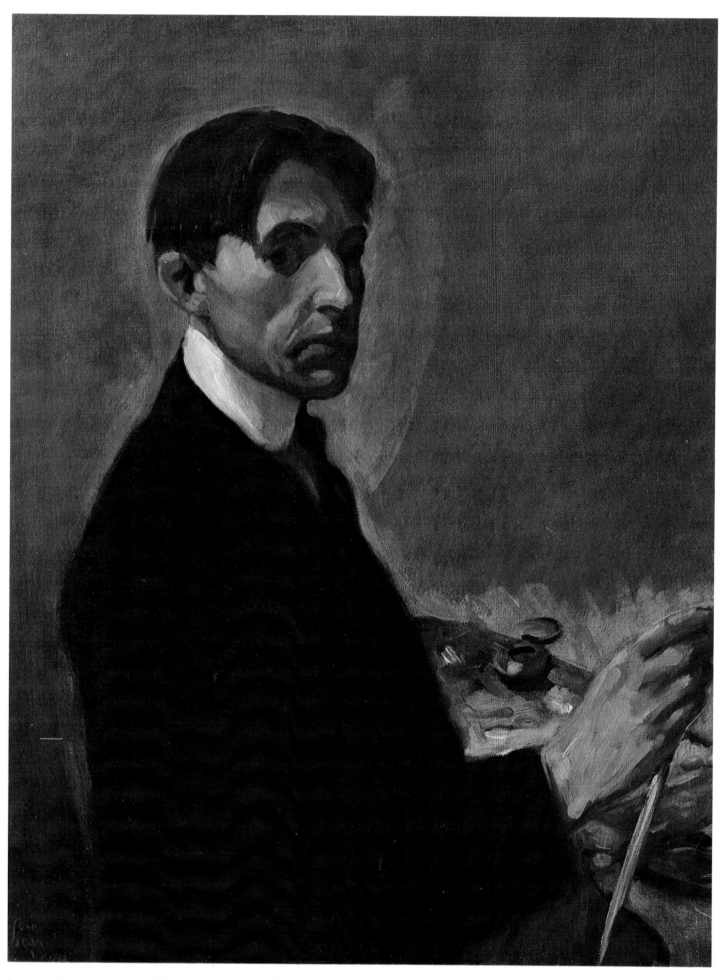

Plate 6. *George Sotter.* 1902. Oil on canvas, 30″ x 24″. The Kraushaar Galleries, New York.

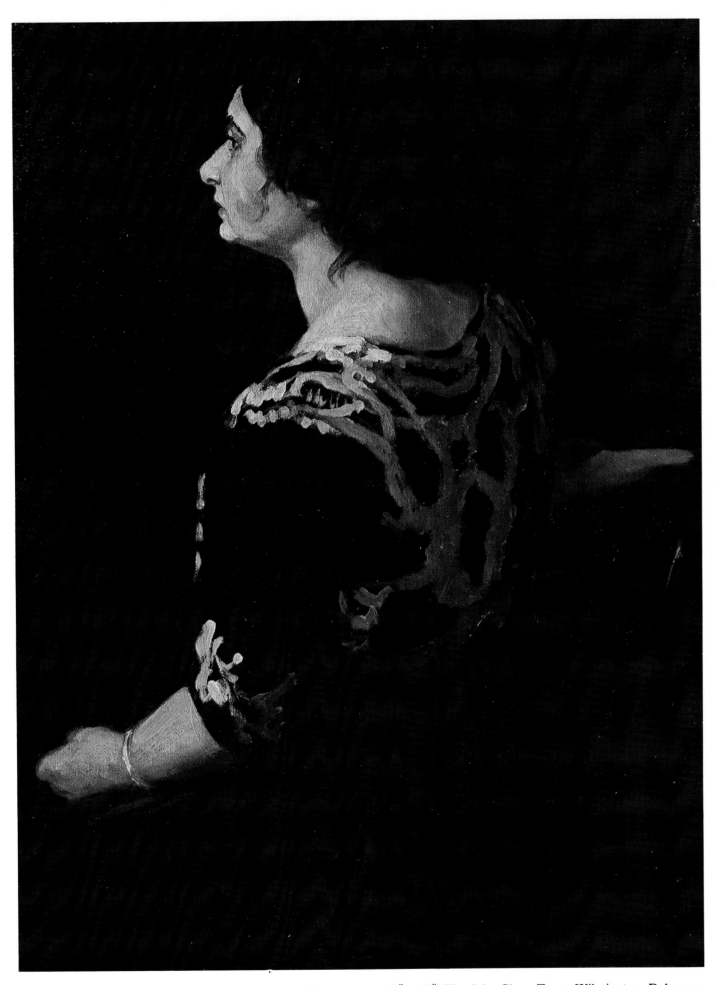

Plate 7. *Stein, Profile (Foreign Girl).* 1904 – 05. Oil on canvas, 36″ x 27″. The John Sloan Trust, Wilmington, Delaware.

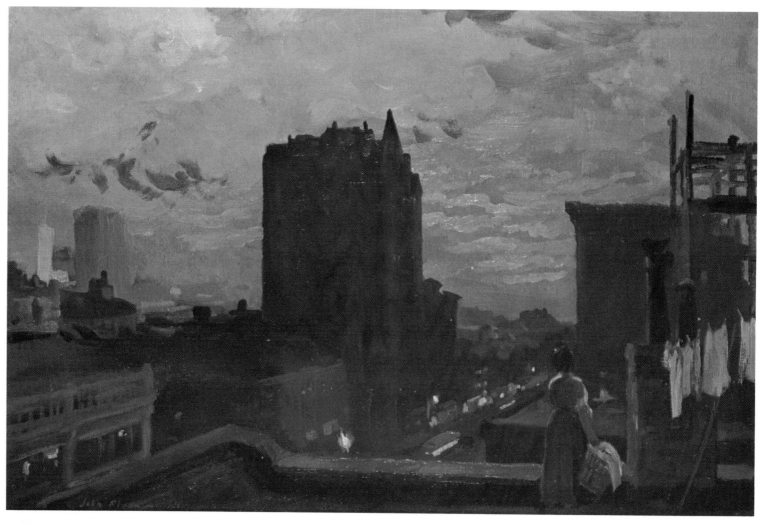

Plate 8. *Sunset, West Twenty-Third Street.* 1905 – 06. Oil on canvas, 24″ x 36″.
The Joslyn Art Museum, Omaha, Nebraska.

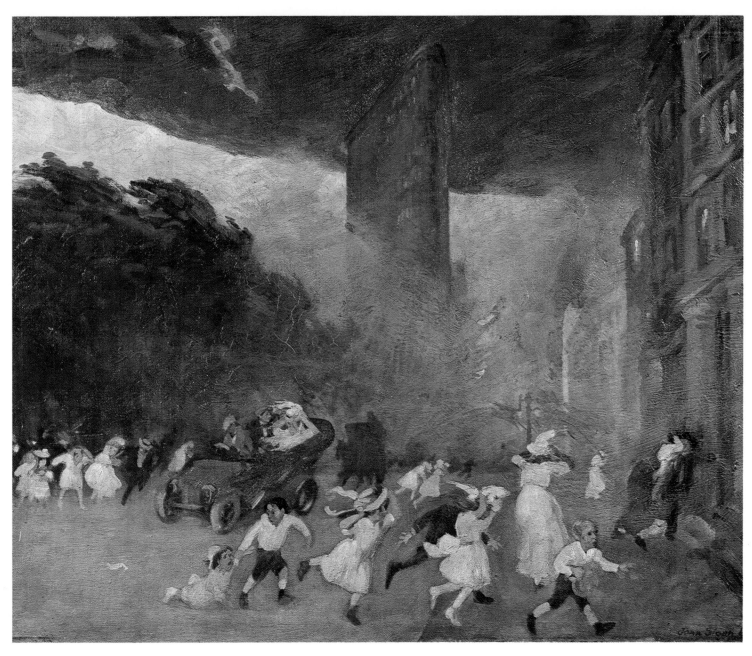

Plate 9. *Dust Storm, Fifth Avenue*. 1906. Oil on canvas, 22″ x 27″.
The Metropolitan Museum of Art, New York. George A. Hearn Fund.

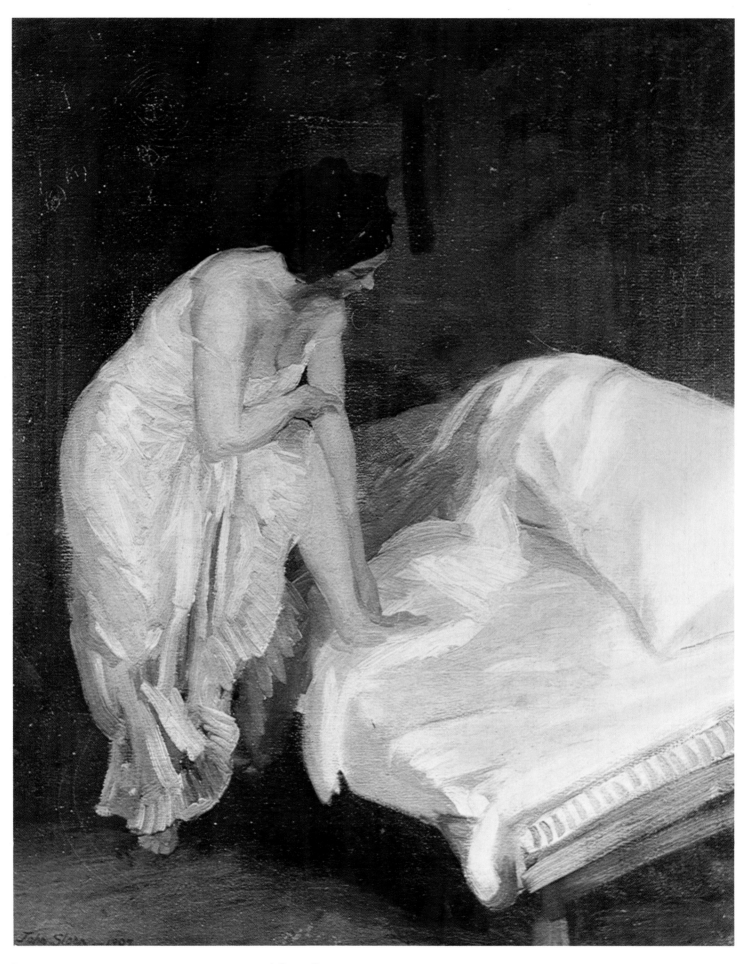

Plate 10. *The Cot*. 1907. Oil on canvas, 36 1/4″ x 30″. The Bowdoin
College Museum of Art, Brunswick, Maine. Hamlin Collection.

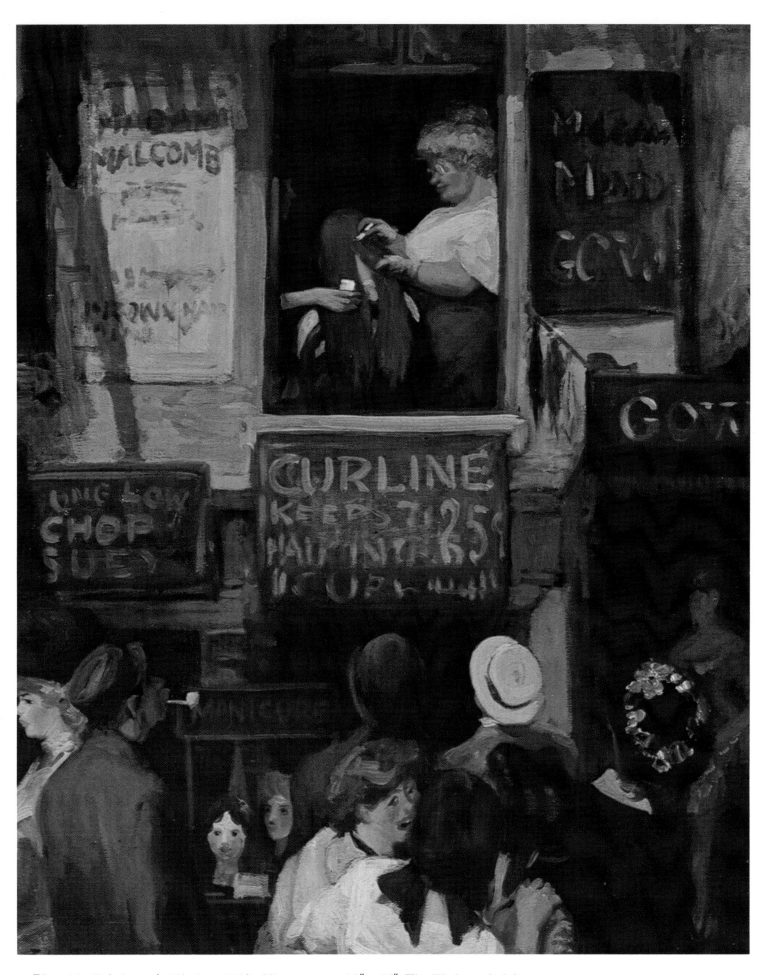

Plate 11. *Hairdresser's Window*. 1907. Oil on canvas, 32″ x 26″. The Wadsworth Atheneum,
Hartford, Connecticut. Ella Gallup Sumner and Mary Catlin Sumner Collection.

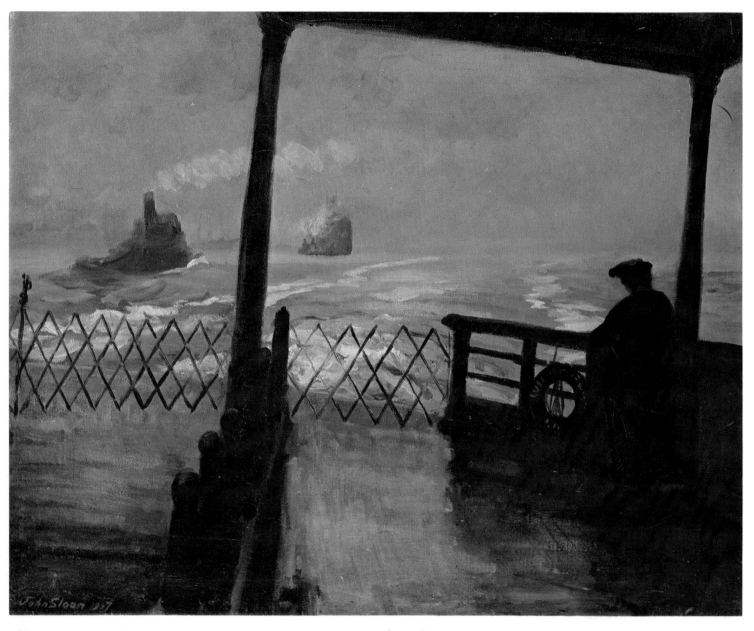

Plate 12. *The Wake of the Ferry* (no. 2). 1907. Oil on canvas, 26″ x 32″.
The Phillips Collection, Washington, D. C.

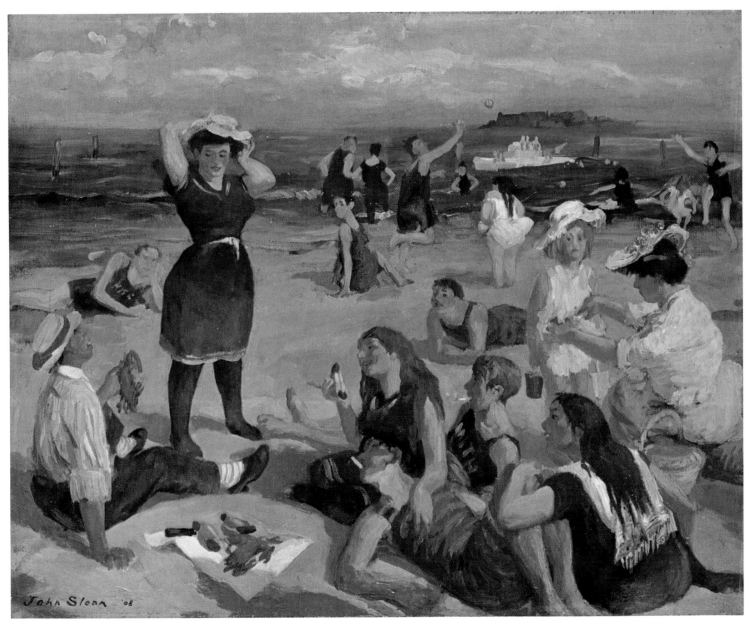

Plate 13. *South Beach Bathers*. 1907 – 08. Oil on canvas, 27″ x 32″.
The Walker Art Center, Minneapolis, Minnesota.

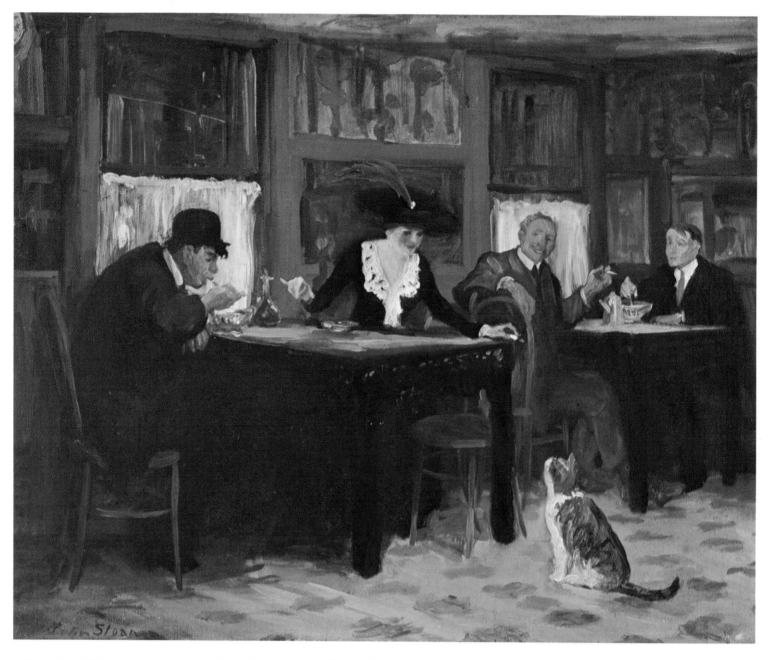

Plate 14. *Chinese Restaurant*. 1909. Oil on canvas, 26″ x 32″. The Memorial Art Gallery of the University of Rochester, New York. Marion Stratton Gould Fund.

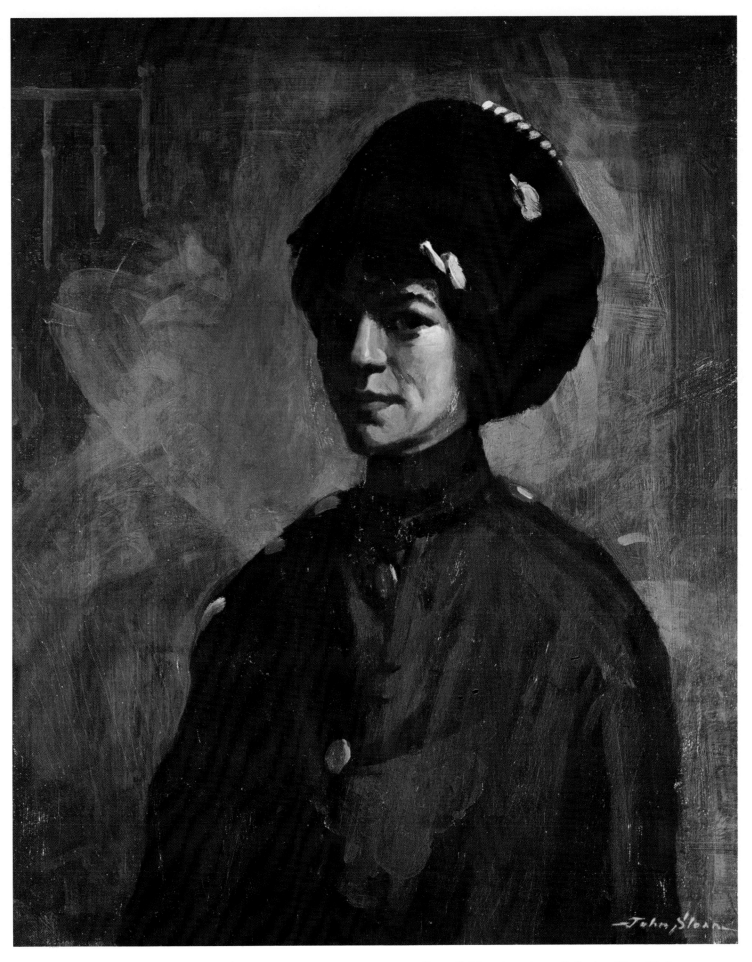

Plate 15. *Spanish Girl (Fur Hat, Red Coat)*. 1909. Oil on canvas, 32″ x 26″. The Kraushaar Galleries, New York.

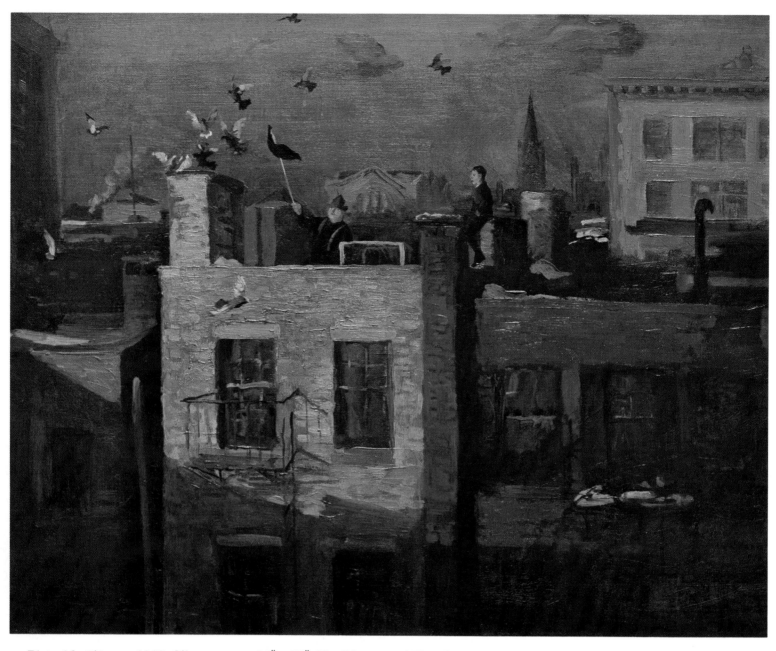

Plate 16. *Pigeons*. 1910. Oil on canvas, 26″ x 32″. The Museum of Fine Arts, Boston. Charles Henry Hayden Fund.

ILLUSTRATOR AND ETCHER

1894·1907

Memory. 1906. Etching, 7½″ x 9″ (plate). The John Sloan Estate. Photo courtesy of the Smithsonian Institution, Washington, D. C.

ILLUSTRATIONS AND ETCHINGS

John Sloan's etching and illustrating had advanced side by side after he taught himself to etch in 1888 in order to make greeting cards and calendars. By 1894, Sloan had produced fifty or more etchings for Newton, and it was as an experienced craftsman that he introduced Glackens to the mysteries of etching techniques that year.

The Poster Style interlude, however, interrupted Sloan's activities as an etcher. No plates survive from the years between 1895 and 1902. Work for the little magazines and the *Press* occupied most of his time, but he also moved into other branches of illustration.

In 1899 Everett Shinn, then on the art staff of *Ainslee's* in New York, helped Sloan obtain a commission from that magazine, the first important national periodical to give him a job. Another new enterprise came for Sloan in 1900 when he undertook a complete set of illustrations for a book. In his drawings for Stephen Crane's *Great Battles of the World* (page 67) he completely abandoned the Art Nouveau manner of his usual Sunday supplement color puzzles. The illustrations are, in fact, reminiscent in manner of the drawings Glackens had sent back from Cuba in 1898 during the Spanish-American War. A friendly appraisal of Crane's book by the *Press* called attention to the fact that "the volume is illustrated by John Sloan, who has made eight full-page drawings of extraordinary strength, remarkably alike for the effectiveness of the general design and the completeness of the detail. They are bold and dramatic in conception and witness the advent of a book illustrator, whose work in the higher branches of graphic art has lately attracted a good deal of admiring attention."[13]

The original drawings were indeed quite strong, though they lost much in reproduction. It is curious to observe Sloan, who was to become such a fervent pacifist, in the act of dramatizing war.

Two years later, William Glackens helped Sloan obtain a commission as one of the illustrators for a deluxe English edition of the novels of Paul de Kock. That prolific but minor author, whose stories dealt with Parisian city life of the early nineteenth century, hardly merited the attention lavished on him by the Frederick J. Quinby Company, publishers of the series. The entire venture finally fell on hard times, but not until Sloan and some of his friends had had the opportunity to show what they could do under promising conditions. Sloan contributed fifty-three etchings and fifty-four drawings, his first really major undertaking of the kind.

The etchings that he did for Quinby from 1902 to 1904 brought his work in that medium to a new height and prepared him for the New York city-life etchings. With the appearance of the first de Kock volumes in 1903, it became apparent to the more discerning critics that Sloan was producing work that was both forceful and original in concept and that placed him in the front rank of American printmakers. Arthur B. Davies asserted that "nothing better has ever been done," and Robert Henri, who was in South Carolina at the time, wrote to Sloan: "I wish you could know on what a plane these etchings of yours have placed you in the minds

Battle of Bunker Hill. Illustration for Stephen Crane's *Great Battles of the World.* 1901. Watercolor, ink, and crayon, 20″ x 13″. The Delaware Art Museum, Wilmington. The John Sloan Collection.

The Hungry Cat. Illustration for John Kendrick Bang's "The Genial Idiot" in the Philadelphia *Press.* 1903. Crayon and pencil, 18½″ x 22″. Collection of Mr. and Mrs. Harold Levy, New York.

Charles Paul De Kock. 1904. Etching, 16″ x 13″ (plate). Commissioned by Frederick J. Quinby Co. The John Sloan Estate. Photo courtesy of the Smithsonian Institution, Washington, D. C.

of many, very many, who know."[14] A perceptive criticism appeared in the New York *Evening Sun* for April 25, 1903:

> Mr. Sloane's [*sic*] etchings are among the most remarkable we have seen in many years. Some interesting paintings by the same hand were shown in an out-of-the-way gallery a few years ago, but his work as an illustrator had hitherto escaped our notice. The illustrations in these volumes place him at once among the most original draughtsmen in the country. There can be no doubt about the intensity, force and vivid imagination shown in this work. It is quite free from anything in the nature of cleverness; indeed, we should rather be inclined to describe his manner as clumsy, if that were not a misleading term for the rude vigor with which he drives home his meaning. What we mean to suggest is an absence of fluency and grace . . . he has given Paul de Kock's characters a quality of intense vitality that the originals themselves can hardly pretend to.

The de Kock etchings represent a marked development for Sloan both as an illustrator and etcher; "he trained himself to invent figures in action, and also perfected a line system for rendering forms and textures with needle and acid."[15] As illustrations, they shared a direct vigor with Glackens' work that sometimes discon-

Chicotin Visits Violette. Illustration for Charles Paul de Kock's *Flower Girl,* Vol. 2. 1904. Etching, 6″ x 4″ (plate mark). The John Sloan Estate. Photo courtesy of the Smithsonian Institution, Washington, D. C.

certed the public of the day, and both artists were well aware of the penalties of adhering to such a manner. As far back as 1899, Glackens had stated in an interview printed in *The Art Interchange* that "if one goes boldly and directly to express an idea he is at once assailed as clumsy." Sloan, in 1903, was at the point of leaving the *Press,* and as he launched into the career of a freelance illustrator, he must have welcomed the praise of his friends but known that he would face long struggles ahead.

In April, 1904, John Sloan moved to New York with Dolly, whom he had married in 1901. He soon began making the rounds of publishers whom he thought might be interested in his work. For regular income, the Sloans could count only on the weekly puzzle that continued to appear in the *Press.* The de Kock venture was uncertain as to payments and future commissions. Sloan did some illustrations for *Century Magazine,* and before long he found enough other customers to earn a living, but not without continuing effort. A typical entry in his diary (January 16, 1907) reads, "went to see Russell at McClure's. He said that now and then is all the public will stand of me." Sloan was associated with depictions of "common life," generally a liability, but occasionally the cause of his being sought after, as when he was asked to illustrate T. A. Daly's *Canzoni.*

By dint of repeated calls, he obtained orders from *Bookman, Scribner's, Everybody's, Harper's Weekly, Times Magazine, Collier's, The Saturday Evening Post, Munsey's,* and a half-dozen other periodicals,[16] picking up enough to lead an uncertain but convivial existence at a time when it was possible to go "to a little 8th Avenue bakery for dinner" and have "very nice food for the sum of twenty cents."[17]

The graphic solidity and direct earthiness of the de Kock etchings prepared the way for the prints of 1905 and 1906. These included both personal subjects and city-life scenes. Among the former were several portraits, and two—*Mother* and *Memory,* showing the Sloans and Henris together as a family group—were masterpieces of characterization. The city views grew to a set of ten (later extended to thirteen). Their importance can hardly be exaggerated.

The etching series drew its inspiration from the intense impact that the New York scene made upon Sloan. Soon after coming to the city, he chose a "garret," a fifth-floor apartment at 165 West Twenty-third Street, where he and Dolly were to remain for seven years. The sights of his surroundings—"the outskirts of the seething Tenderloin"[18]—absorbed him completely: glimpses caught from the front and rear windows, from the roof, from the streets that he explored eagerly and at all hours of the day and night. Sloan progressively developed his concept of the city-life print. At first he thought of doing a "connoisseur" series (in the nineteenth-century tradition of mirroring an aspect of society), but soon decided upon a more direct response to the scenes that struck him on every side. He dropped the literary frame of reference as he moved from *Connoisseurs of Prints* and *Fifth Avenue Critics* to *Fun, One Cent* (the first "low-life" print), *The Man Monkey, Man, Wife, and Child, The Show Case, Turning out the Light,* and *The*

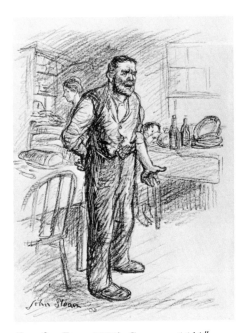

Eye for Eye. 1905. Crayon, 11¼" x 8½". The John Sloan Trust, Wilmington, Delaware.

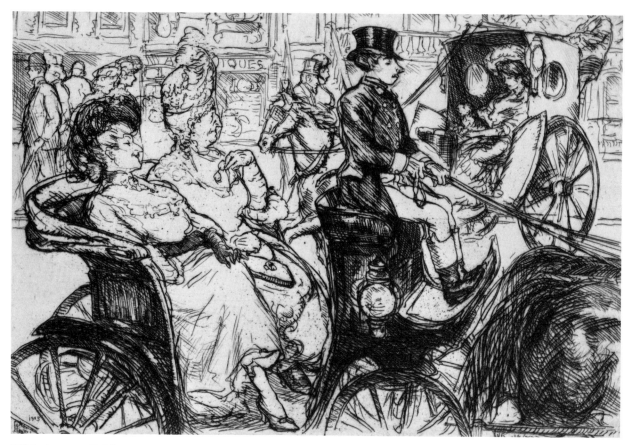

Fifth Avenue Critics. From the "New York City Life" series. 1905. Etching, 5″ x 7″ (plate). The John Sloan Estate. Photo courtesy of the Smithsonian Institution, Washington, D. C.

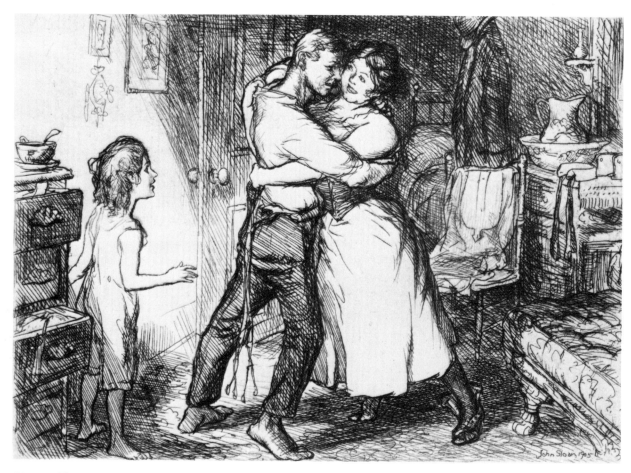

Man, Wife, and Child. From the "New York City Life" series. 1905. Etching, 5″ x 7″ (plate). The John Sloan Estate. Photo courtesy of the Smithsonian Institution, Washington, D. C.

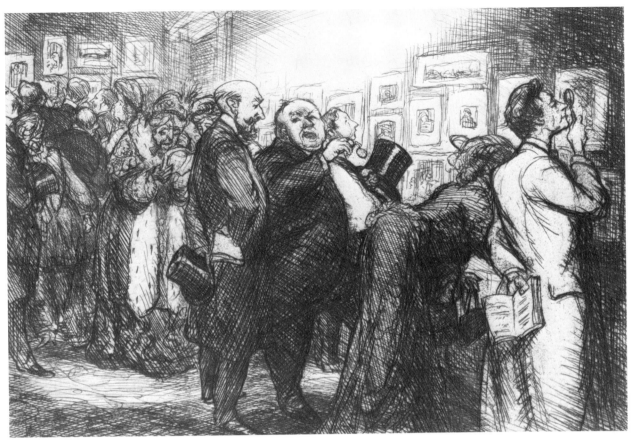

Connoisseurs of Prints. From the "New York City Life" series. 1905. Etching, 5″ x 7″ (plate). The John Sloan Estate. Photo courtesy of the Smithsonian Institution, Washington, D. C.

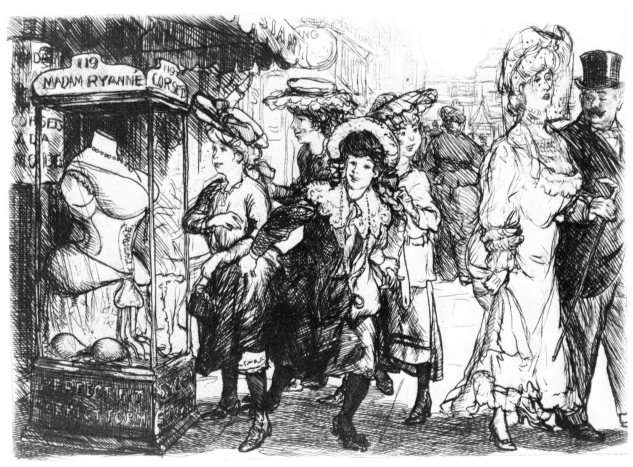

The Show Case. From the "New York City Life" series. 1905. Etching, 5″ x 7″ (plate). The John Sloan Estate. Photo courtesy of the Smithsonian Institution, Washington, D. C.

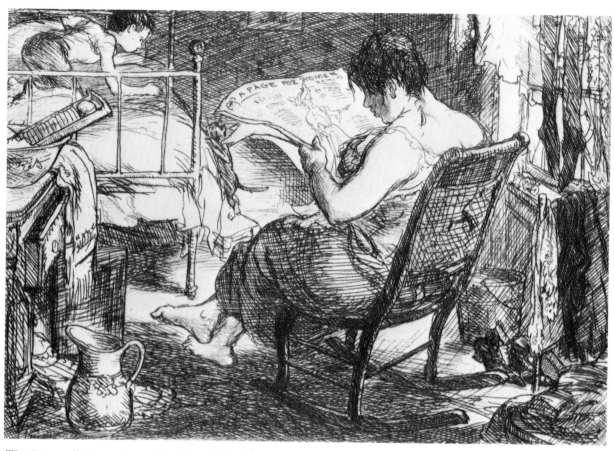

The Woman's Page. From the "New York City Life" series. 1905. Etching, 5″ x 7″ (plate). The John Sloan Estate. Photo courtesy of the Smithsonian Institution, Washington, D.C.

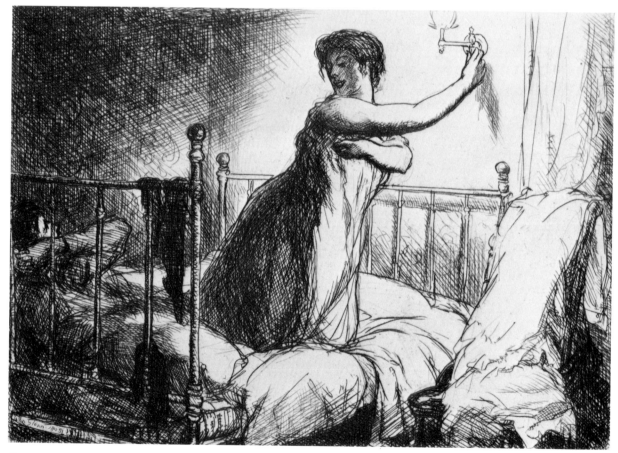

Turning Out the Light. From the "New York City Life" series. 1905. Etching, 5″ x 7″ (plate). The John Sloan Estate. Photo courtesy of the Smithsonian Institution, Washington, D. C.

Woman's Page. Early in 1906, as he added a ninth and tenth etching (*The Little Bride* and *Roofs, Summer Night*), he decided to offer the group to dealers for sale as a set. Sloan was understandably excited at the prospect: he had created something unique in American art of the day, capturing the immediate pulse of the life around him with a sure touch and in an art form that could be made available to the public readily, at low cost. Such a set of etchings was original in concept and execution. The prints were amusing and warmly human, showing an increasingly incisive grasp of form and modeling as the actors and the settings became more fully realized. In such works as *Man, Wife, and Child* and *Turning out the Light* he achieved a sculptural vigor and sense of sure mastery that he hardly surpassed later.

Charles Fitzgerald spotted the etchings at once and praised them in *The Evening Sun* as "astonishing and unequalled by any work of the kind that had been exhibited here."[19] Henry Ward Ranger bought a set, and the American Water Color Society invited Sloan to exhibit the entire group, but this early encouragement was short-lived. He wrote in his diary on May 2:

> In the afternoon four etchings of the set which has been invited by Mr. Mielatz of the committee on etchings of the Water Color Society Exhibition were returned to me. Great surprise as he had even furnished the frames. In the evening I attended the "stag" Private View, saw Mielatz and asked for an explanation. He said other members of the committee had thought these four were rather "too vulgar" for a public exhibition. I asked to be introduced to some of these sensitive souls but he would not comply. I was madder than I can describe. Asked to have the remaining six taken down but that is against the rules. . . .

For weeks Sloan tried to place the prints, but the dealers either declined to accept them or displayed them with little success. Eventually he was greatly disheartened. He turned more intensively to painting during the next winter and throughout 1907, carrying to his canvases the pictorial concepts that had so intrigued him in his etchings. His subjects came from life as a whole, as he saw it, and after his experience at the Water Color Society Exhibition, the stubbornly independent John Sloan was in no mood to eschew the "vulgar."

NEW YORK
AND THE EIGHT

1904·1917

Four of the Eight. Pencil, 12″ x 8″. The Chapellier Galleries,
New York.

THE NEW YORK SCENE

When Sloan first exhibited at the Allan Gallery's group show in 1901, he joined Henri, Glackens, Alfred Maurer, Ernest Fuhr, Willard Price, and Van Deering Perrine. Critical attention centered on Henri, Maurer, and Glackens, who were recognized not as shocking Realists but as "younger men whose work is encouraging."[20] Sloan's own contribution included two figure studies, which were given a mixed reception, and "a clever sketch of a crowd outside the doors of a theatre."[21] This was *Walnut Street Theater* (page 38), painted in Philadelphia in 1899 or 1900, and its informal glimpse of city life anticipated his characteristic scenes of New York.

The Allan Gallery show was followed three years later by another exhibition of the emerging Henri group that caused considerably more stir in the press. On this occasion, Henri, Luks, Glackens, Davies, Prendergast, and Sloan displayed works at the National Arts Club in New York. The *Commercial Advertiser* found the result "a most lugubrious show," with Sloan's *The Sewing Woman* suggesting "an animated corpse."[22] The painting was, indeed, representative of the disconcertingly homely realism that Sloan employed on occasion. Charles de Kay of the *New York Times,* in an article subtitled "Startling Works by Red-Hot American Painters," played up the controversial nature of the exhibition, the lack of finish resulting from "trying to get the objects on the canvas before the enthusiasm that caused their selection had had time to evaporate and the red-hot impression time to cool."[23] By and large, it was the offhand technique rather than the subject matter that provoked shock, though George Luks depicted a world that lay beyond the accepted limits of good taste. This was Luks' first public showing on such a scale, and his *Whiskey Bill, The Prize Fighter, Winter* (depicting the dumping of snow into the East River), *Boy with Shovel,* and *Gansevoort Dock, New York City* were the first collection of harshly powerful Realist paintings exhibited by any of the group. De Kay perceived this power, and he also perceived that Sloan "had much to expect in the way of success, not perhaps the success of sales, but the 'success of esteem.'"

It was three months after the National Arts Club exhibition that John and Dolly Sloan went to New York to settle. At the time he was finishing the de Kock illustrations and taking on occasional freelance jobs. His independent work was centered on etching rather than painting, though he managed to do some four or five canvases a year, mainly portraits. A notable exception was *The Coffee Line,* painted in 1905 in the style of the dark-toned city views he had begun in Philadelphia, but with stronger social overtones. Sloan was heartened when it received an Honorable Mention at the Carnegie International in November of that year, though he realized that his success was not unconnected with Henri's being on the jury. Aside from the award, Sloan drew deep satisfaction from a reported word of praise from Thomas Eakins, and Charles Wisner Barrell wrote later that the painting "was the most talked about picture in the exhibition."[24]

Prior to 1905 it would seem that for all of Henri's long-continued exhortations to paint city life, neither he nor his followers had really mingled with the people of the streets in order to portray them sympathetically in their environment. They had painted the docks, children playing in city parks, and streets made picturesque by falling snow, but it was something else again to enter life with the immediacy of the series of etchings Sloan had begun about June of 1905 and which had brought on an unexpected crisis of taste when exhibited the following year.

It was surely no coincidence that Henri urged his class to take to the streets at about the time Sloan was working on his city-life series. In June, 1906, a feature article in the New York *World* by Izola Forrester was entitled "New York Art Anarchists" and reported on the "revolutionary creed" of Henri and his class, describing work done by students during the past year. "It takes more than love of art to see character and meaning and even beauty in a crowd of east side children tagging after a street piano or hanging over garbage cans. There must be a knowledge of human nature, human motives, and, above all, sympathy." Here, in essence, is the philosophy of what was later termed the Ash Can School.[25]

The year 1906, Sloan's thirty-fifth, was a turning point in his career as a painter. In January, as he noted in his diary, he was "at a loss to show much work" when a reporter called to see his paintings. In February he joined Henri, Luks, Lawson, and Glackens in a group show at the short-lived Modern Gallery launched by a dealer named Sigmund Pisinger. Sloan sent the then relatively old canvases, *Independence Square* and *The Sewing Woman,* as well as a Henri-influenced figure study of 1903, *The Look of a Woman.* It was his set of ten recent etchings, however that elicited the greatest praise, especially from Fitzgerald of the *Evening Sun.* Though Sloan's excitement over the etching series was to turn to keen disappointment at their reception by the American Water

Roofs, Summer Night. From the "New York City Life" series. 1906. Etching, 5¼" x 7" (plate). The John Sloan Estate. Photo courtesy of the Smithsonian Institution, Washington, D. C.

Mother. 1906. Etching, 9″ x 7½″ (plate). The John Sloan Estate. Photo courtesy of the Smithsonian Institution, Washington, D. C.

Color Society in May, the new pictorial vision he had developed stirred him and generated a new, epoch-making series of paintings.

On June 2 he started *The Picnic Grounds,* a vigorous picture somewhat like a rude Glackens. Nine days later he began *Dust Storm, Fifth Avenue* (Plate 9), and with it, the main series of New York "Sloans." Now for the first time his paintings caught the city setting, the atmosphere, and the people from a fresh viewpoint as a total living entity. The episodic quality—the illustrator's approach, as broadened through the New York etchings—was fused with the city theme that Sloan had worked on sporadically for nearly ten years.

Again he had the luck to attract the attention of a perceptive critic, for just as Fitzgerald had spotted the novel achievement of the etchings in February, James Huneker acclaimed *Dust Storm* when it was displayed at the National Academy of Design's annual exhibition in December.

Treasure Trove. 1907. Etching, 4″ x 5½″ (plate). The John Sloan Estate. Photo courtesy of the Smithsonian Institution, Washington, D. C.

...Ah! There's a picture for you, which the jury wisely hung beside the celebrities. It is called *Dust Storm on Fifth Avenue,* No. 291, and is the most original picture on view, both in design and execution. Fancy a sudden summer gust sweeping up Fifth Avenue on a hot afternoon. The Flatiron Building, its prow cleaving the dust that eddies about its top and side, comes swimming toward you; its head is threatened by a stormy blackness; sharply outlined white clouds are driven eastward by the gale. All living and inanimate things are bending or running. Children from Madison Square charge wildly across the avenue for shelter. You hear them buzzing, giggling, and bustling in the hallways of Martin's or overflowing into the drug store at Twenty-sixth street. Here is your much talked about "human document" in the mass, with the physiology of the mob expressed in a summary yet conclusive fashion. To describe verbally the picture is to labor with a medium foreign to color and gesture. Mr. Sloan has accomplished in an impressionistic though none-the-less carefully painted work, the transcription of a summer afternoon's episode, and has interested us amazingly. To suggest air that whiplashes the tree tops and sends the blinding dust whistling through the panicky streets is of itself a pictorial feat. Mr. Sloan has done this. The tiny notes of white, the garbs of the flying youngsters, are a bright relief in the sombre hurly-burly. A very strong and very modern picture this.[26]

In the course of 1906 Sloan not only finished two works begun the previous year, *Spring, Madison Square* and *Sunset, West Twenty-third Street* (Plate 8), but produced several other "scenes" and a group of figure pieces. In addition, he fitted up a sketch box and began painting small studies directly from nature—a practice he continued every summer until 1911.

Sloan had seldom turned out more than a half-dozen pictures in any of the ten years that he had been seriously interested in painting, so this sudden full involvement in painterly activity was a new departure. It was carried full tilt into 1907, when he painted no less than fourteen "scenes," four or five pieces, and a number of landscape sketches. In works that ranged from the stark monumentality of *The Cot* (Plate 10) and the poetry of *The Wake of the Ferry* (Plate 12) to the throbbing city pulse of *Election Night* and the warm-hearted satire of *The Haymarket* and *Hairdresser's Window* (Plate 11), Sloan explored a gamut of themes and pictorial approaches that were to occupy him more or less intensively for some years to follow. The quality of this work

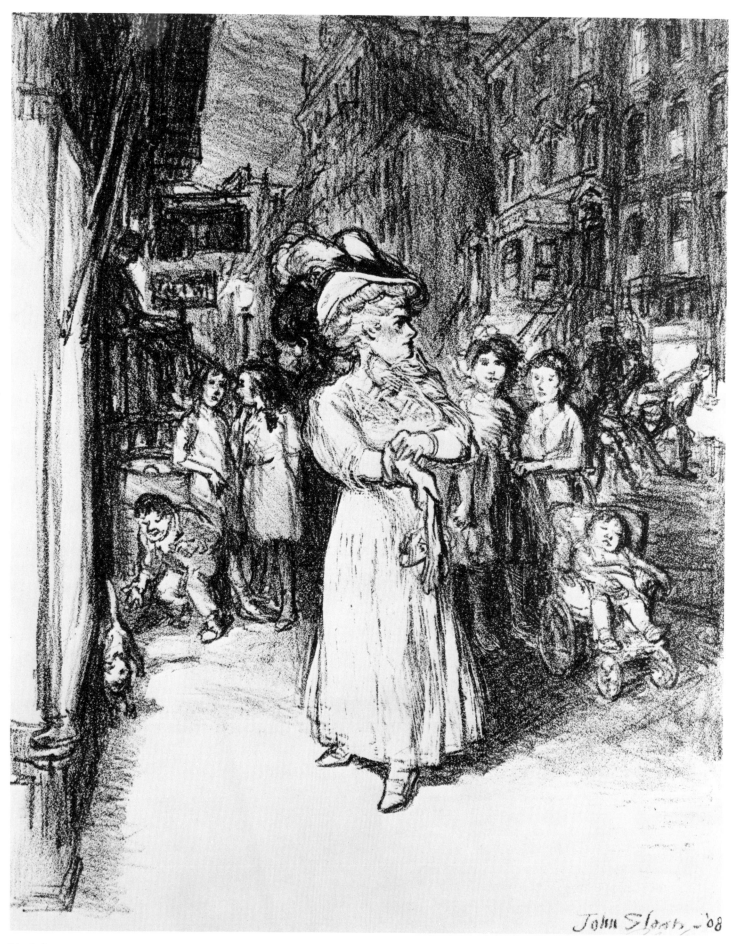

Sixth Avenue and Thirtieth Street. 1908. Lithograph with crayon additions, 14″ x 11″ (design). The National Gallery of Art, Washington, D. C. Lessing Rosenwald Collection.

of 1907, whether loose in composition and brushwork (*Sixth Avenue and Thirtieth Street*) or architecturally built up (*Throbbing Fountain, Madison Square*) was vital and compelling, buoyed up by Sloan's new gusto for painting.

Part of the excitement that carried him along came from the anticipation of a major exhibition project that had been under discussion for some time. Since the history of the exhibitions of this period is so important to an understanding of Sloan's career, it should be recounted in some detail.

THE EIGHT, THE INDEPENDENTS, AND THE ARMORY SHOW

The story of the exhibition of The Eight at the Macbeth Gallery in February 1908 is merely one chapter in the long history of the Henri group's struggle to find a way of assuring adequate exposure for their paintings and those of other independent artists. It involved the tenacious efforts of Henri, Sloan, eventually Arthur B. Davies, and many others; it was motivated by a mixture of lofty principle and self-interest; and it climaxed in several exhibitions that had a lasting effect on American art.

The setting for the struggle lay in a progressive narrowing of "official" exhibition opportunities during the first years of the century, at a time when the space available at private galleries was severely limited and the appearance of any unconventional work brought bitter denunciation from academic painters and critics alike. The conflict came out most sharply in jury sessions and the newspapers. The friction was considerable, leading ultimately to a war of concepts that was but half-understood at the time. The problem was not that the "younger men" (who were, in fact, mature artists, since the average age of The Eight was over forty in 1908) could not exhibit their work and had no support: they showed their work frequently and had eloquent champions among their close associates in the press. Nevertheless, they could not count on regular and effectively broad exposure, or on impartial treatment. Their work was repeatedly rejected or "skied" (hung above the line of vision) or placed in dark corners, and the prejudice of the academicians and conservative critics was made bitterly evident.

In 1904 the Henri group began to take shape in the exhibition at the National Arts Club. Six of the eventual Eight displayed their work. Only Shinn (who was preparing for a one-man show elsewhere) was missing from the old Philadelphia gang, which by this time had been joined by Davies and Prendergast. Charles de Kay of the *New York Times* explained that juries could not accept such work because of its lack of finish, so it had to be shown privately. However, even de Kay had some kind words to offer, and the *Evening Sun* was explicit in stating that, "with one or two exceptions the names of the painters . . . are rarely seen in the catalogues of the big annual shows, and this symptom of their independence should prepare us for the hostility of those brought

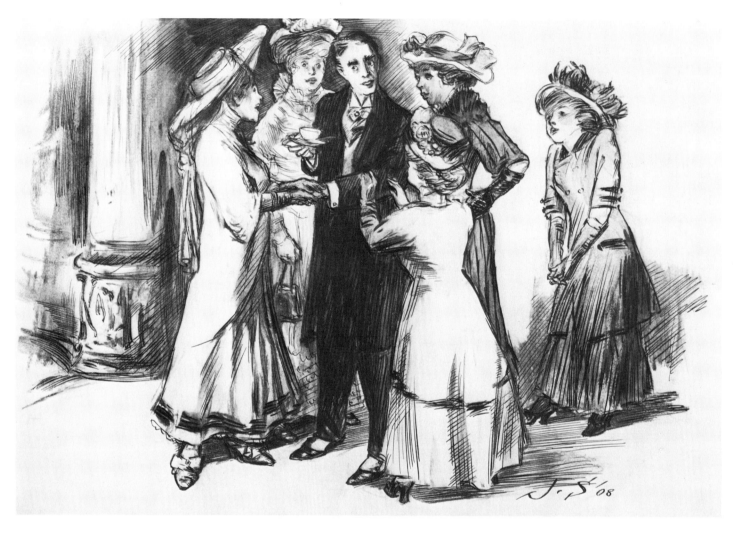

Thursday Afternoons. Illustration for Gelett Burgess's "Making of an Actress" in June 6, 1908, *Collier's.* Pen and wash, 12½″ x 18¼″. Collection of Dr. and Mrs. Leslie Pensler, Southfield, Michigan.

up on the pabulum of the Academy and the Society of American Artists."[27]

Sloan commenced his diary on January 1, 1906, and a week later wrote, "This evening George B. Fox and Ernest Lawson to dinner. Talk of the exhibition next year—each of say some seven of the 'crowd' puts in $10 per month for a year—makes a fund of $840."[28] Such schemes, in endless variations, were to be discussed for the next four years, until they finally bore fruit in both The Eight and Independent exhibitions. A show at Sigmund Pisinger's Modern Art Gallery offered a short-lived hope that a private dealer might succeed in alleviating the situation, but when it folded the group was left with the limited support of Macbeth (who handled Henri and Davies) and the occasional inclusion of a painting in a Knoedler Gallery show.

On March 8, 1906, Henri stopped in to warn Sloan that his two entries would probably be rejected by the hanging committee of the Society of American Artists, and to discuss the newly effected amalgamation of the Society and the National Academy of Design. Sloan justly observed, "it narrows things down," and although he was referring chiefly to space, he might have included viewpoint as well, for he was soon to find out how sharply the conservatives rejected his realism. It was two months later that four of the ten etchings that the Water Color Society had invited him to exhibit were returned.

The following December there were signs that the squeeze was

beginning at the National Academy, for Glackens, Luks, and Shinn were all rejected from the Academy's winter show, and only two of five Sloans survived, both hung above the line. In March, 1907, Henri, now a member of the Academy jury, became determined to obtain a fair showing for his friends and students. In the heat of the ensuing struggle, feeling himself rebuffed, he withdrew two of his own works. "The puny, puppy minds of the jury were considering his work for #2, handing out #1 to selves and friends and inane work," Sloan exploded in his diary.[29] When the show opened, Sloan had one painting in it (again above the line), but a strong Luks that Henri had fought for was missing, and when Henri and Luks dropped in on the Sloans three days later, there was "some talk after dinner of an exhibition of certain men's work. The time seems to be quite ripe for such a show."[30]

The planning went ahead actively. Six of The Eight met at Henri's on April 4, Sloan noted, observing that "the spirit to push the thing through seems strong. I am to take charge of the moneys for the purpose." A week later he recounted that a reporter from the *New York Times* called to talk about recent elections at the Academy in which Davies and Lawson were defeated, suggesting there was a feeling against the "younger" element. Sloan retorted, "it was resentment of good work; . . . a young man with 'fossilized' ideas had no trouble getting in."[31]

On May 2, 1907, all the members of the group but Prendergast met and assessed themselves fifty dollars each toward the expense of a show to be held at Macbeth's the following February, and the next day Davies reported that Macbeth was willing to let them have both galleries if guaranteed five hundred dollars and twenty-five percent of the sales. By May 14 and 15, the papers were full of the news of the proposed exhibition, and Prendergast had written that he was "in for it strong."

Sloan's immediate reaction was that there was "no lack of incentive for plenty of hard work,"[32] and he plunged into a period of intensive painting.

The following November, Henri was still raw-nerved from the spring jurying, and he debated with Sloan whether to submit to the Academy's winter show. Sloan decided to try one painting, but it was promptly rejected.

Active planning for the Macbeth exhibition resumed in December. Material was prepared for a feature article in *The Craftsman,* and costs began to mount. Macbeth was asked to reduce his guarantee to four hundred dollars, which he agreed to do. On January 2, 1908, there was a meeting at Henri's studio, the catalog was planned, and thereafter Sloan began photographing paintings for the publication. The bills continued to grow and the group decided upon a further assessment to meet the expenses. On the twenty-sixth, Henri left to paint portraits at Wilkes-Barre, and Sloan took over his classes on the twenty-ninth and thirty-first. When Henri returned at the last minute and complained about the quality of his reproduction in the catalog, Sloan observed in his diary, "as usual in these affairs, one or two do the work and the rest criticize."[33]

On the first of February, Sloan, Luks, Lawson, Henri, Prender-

Salve. 1909. Crayon, 7½" x 5¾". The John Sloan Trust, Wilmington, Delaware.

gast, and Glackens hung the paintings, decided they looked well enough, and went to top off the evening at a nearby café. The formal opening took place on the third, but Sloan stayed home and missed the historic event, feeling that his "clothes were not of the prosperous aspect necessary in this city." He came out later, however, to join his friends in a celebration so bibulous that even Prendergast "lost track of things."[34]

The sense of excitement was built up by the press. The *Post*, the *Herald*, the *American*, the *Literary Digest*, the *Tribune*, the *Sun*, the *World Magazine*, and the Philadelphia *Press* all carried the story—one eye-catching headline read "New York's Art War and the Eight Rebels"—and by February 8, Sloan could report, "The thing is a splendid success. . . . They tell me that 300 people were coming in every hour, about 85 people constantly in those two small galleries." And as the show closed on February 17, Sloan wrote jubilantly, "We've made a success—Davies says an *epoch*. The sales at the exhibition amount to near $4000. Macbeth is 'pleased as punch.' It's fine. Had this been a normal financial year, he says there would have been a landslide our way. I feel almost as glad as though I had sold some myself."

Although a few sensational journalists described the exhibition as shocking or vulgar, the more responsible critics gave understanding and favorable reviews. The New York *Evening Post* made the intentions of the Eight more explicit: "They are simply eight painters—some of whom have failed to receive recognition for their work, while others have received it tardily, from what they consider 'the old grannies of art in New York'—who thought it would be a good idea to let art lovers see that there is a group of men in the city that, to quote one of their number, are 'doing something.' "[35] De Kay of the *New York Times* commended the show for its liveliness; the Philadelphia *Press* found it noteworthy for "independence of viewpoint";[36] the New York *World* saw in it "a new and distinctive movement toward Americanism," with its dominant note "New York scenes, New York types."[37] The critics observed that it was John Sloan, particularly, who stuck to this theme and explored it. Thus he became widely identified as a city-scene painter and as the embodiment of the New York Realist movement.

The first reaction on the part of the National Academy of Design was a tribute to the success of The Eight. The arbitrary hanging committee was abolished and a one-man organizer (Harrison S. Morris, formerly director of the Pennsylvania Academy) was appointed. A more liberalized hanging policy followed, and when the Academy's spring show opened on March 13, Sloan observed, "This very crowding and variety that the increased acceptance has brought in, give the place a more interesting look than usual. . . . Still the National Academy should not be given any more money. My portrait of W. S. Walsh is on the line, though *The Haymarket* is 'skied'—still I'm lucky." When Lawson received the first Hallgarten Award and George Bellows, a Henri student, received the second, and when both were elected Associates, it seemed that a new era of tolerance had indeed dawned.

Meanwhile, the Macbeth exhibition had attracted national at-

tention, and museums across the country were expressing interest in showing the paintings. The show, with substitutions for sold works, went to Philadelphia in March, and on its return Sloan and his friend C. B. Lichtenstein arranged a nine-month tour through eight cities, beginning at the Chicago Art Institute in September. Traveling to Toledo, Detroit, Indianapolis, Pittsburgh, and Bridgeport, the paintings wound up in Newark in May 1909 and were returned home at the beginning of June.

John Sloan was now a national figure. Charles Caffin's *Story of American Painting,* which appeared shortly before the Macbeth exhibition, devoted a long paragraph to his work, giving him "almost too much prominence in the 'impressionist' movement,"[38] while stressing his underlying preoccupation with "the humanity of the scene."[39] In 1908 and 1909 his work was not only featured in the Macbeth exhibition tour, but invitations to exhibit came from Boston, Washington, Cincinnati, Texas, and the Kansas-Nebraska Art Association.

In spite of this, the need for more extensive and liberal exhibition facilities still existed. In the fall of 1908, Henri and his friends were too preoccupied to start the mechanism for a second Macbeth show, though Luks wrote to Sloan hoping to stir one up.

Rejections by the National Academy in December and the Pennsylvania Academy in January of 1909 kept Sloan well aware that the struggle was not over. He vented his feelings in his diary: "Academy (definition), an organization of Cads and Demi-Cads, with soft brains and pointed beards."[40] By March he was deep in discussions with Henri on schemes for establishing an independent gallery for a year. All through the spring the talk continued, and some likely locations were spotted, but again the summer exodus and fall distractions interrupted planning.

In December, 1909, the National Academy returned three of Sloan's four entries, and the fourth was "certainly hung in an outrageously bad place, the worst treatment" in his experience.[41] He began again to explore schemes for an independent exhibition. The problem remained one of finances, which was dramatized when his friend Albert E. Ullman suggested renting Madison Square Garden for a week at nine thousand dollars. Sloan and Henri, more practical, returned to considering a space they had seen in May at 29–31 West Thirty-Fifth Street, and debated whether they should aim at one exhibition or a year-long series.

Discussions early in January of 1910 resulted in Henri's proposing the title "Independent American Artists" and Davies coming out strongly for helping younger men, but a "powwow" on January 10 seemed to get nowhere, and at the end of the month Sloan determined *"to go at this thing* with Ullman." He designed a monogram for the "Associated American Artists" and gave Ullman one hundred dollars as a starter.[42]

Nevertheless, things remained at a stalemate until March 9, when the National Academy's spring jury slapped Henri and Sloan with fresh rejections. Though Sloan admitted that sending *Three A.M.* to the Academy was "like slipping a pair of men's drawers into an old maid's laundry,"[43] his *Pigeons* (Plate 16) was not only inoffensive but delightful. At this point Walt Kuhn went

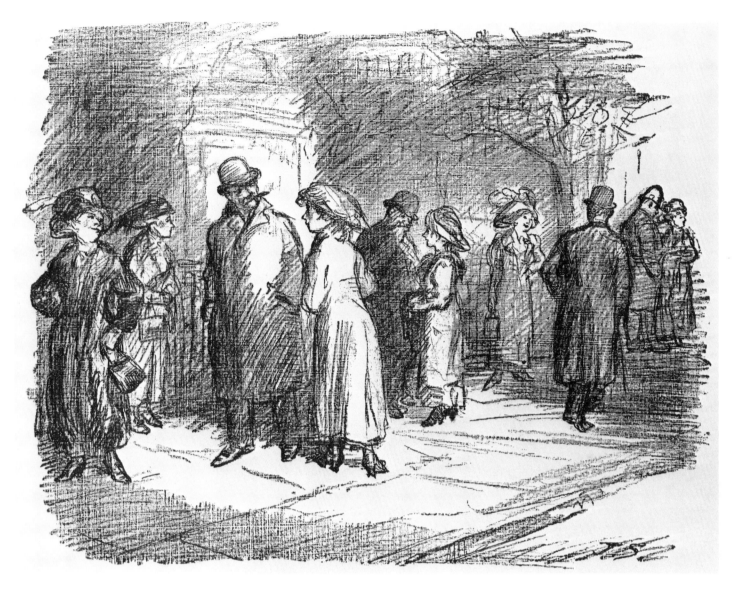

Picketing the Police Permit.
Illustration for "Pickets on the Outposts of Capitalism," in the January 23, 1910, New York *Sunday Call.* Relief linecut, photomechanical, 8¼″ x 11″. The Smithsonian Institution, Washington, D. C.

to Henri with a proposal that Henri passed on to Sloan, and within two days the three had developed a plan to open the Exhibition of Independent Artists in the Thirty-fifth Street building on April 1. It was to be an unrestricted show with no jury and no prizes. They assessed themselves two hundred dollars each toward expenses (which included one thousand dollars ´rent, plus wiring, lights, catalog, mailing, wall coverings, and so forth) and set about to raise the rest. Davies added another two hundred dollars, but Luks declared he would not participate since he was saving his work for an exhibition at Macbeth's.

Sloan, as treasurer and general factotum, plunged into a round of activity. A March 17 entry in his diary noted, "Up early after a short night's rest and troubled sleep on account of the Exhibition excitement." On March 23 he wrote, "I am putting down from Dolly's memory and my own what I can of these days up to April 3. I was too much occupied in business to get to my daily diary writing. We have done a great thing in planning and executing this project and are showing now (April 3rd) the New York public such an exhibition of American art as has never been seen before. The best exhibition ever held on this continent (that is, composed of American art exclusively)."

Some 624 works (paintings, sculpture, and drawings) had been

delivered by 103 artists to the gallery on March 25 and 26. Fees ranged from ten dollars for one picture to thirty dollars for four. The hanging committee met on the twenty-seventh, but no paintings could go in place until all walls had been frantically recovered; the next day, the pictures went up in strictly democratic fashion. Sloan worked the entire night of the twenty-ninth on the catalog and then went to the gallery to review the entries. On April 1 "the writers from the newspapers looked over the show, at a loss for the big stand-by names they were, and so they had to fall back on *us* as the big men. Henri, Glack, Davies, Prendergast, and even Sloan."[44]

The opening that evening was a sensation. "The three large floors were crowded to suffocation, absolutely jammed. At 9 o'clock the crowd packed the sidewalk outside waiting to get in. A small squad of police came on the run. It was terrible but wonderful to think that an art show could be so jammed."[45]

The press coverage was lively, if controversial, and the attendance continued to be encouraging all month. Although sales were poor, exhibitors' fees helped considerably in defraying expenses, and the $200 backers received a rebate of 33.8 cents on the dollar. Altogether, the project was clearly a success. Henri and Sloan proposed that it should be repeated the following year and that the Exhibition of Independent Artists should be incorporated.

Once again, plans languished through the summer and fall. In January of 1911, Sloan was reminded of the continuing hostility that faced the "Realists" when a committee of censors sequestered a group of his etchings in a private room at the Columbus Gallery together with oils by Davies, Bellows, and Kent. "Think of the vulgar indecency of ignorance!" he snorted.[46]

Early in February, 1911, Rockwell Kent proposed to Sloan that they organize a show (to include The Eight) of men who would sign an agreement not to exhibit at the National Academy that year. Henri, who had himself favored a boycott of the Academy in April of 1910, now rejected the idea, and Sloan decided to stand by him. On March 17 they met with a few of their older friends and planned a small exhibit of some fifteen painters to open at the Union League Club in April. Meanwhile, Kent had gone ahead with his project, and together with Davies, Prendergast, Maurer, Hartley, Marin, Luks, and several others opened an independent exhibition on March 24. Henri was no longer the leader of the more progressive artists.

The continuing problem of finding regular exhibition facilities was still unsolved, Henri proposed that the MacDowell Club on Thirty-ninth Street sponsor group exhibitions the following winter, and late in May Sloan wrote Davies, Luks, Shinn, and Prendergast asking them to join with him and Henri in one of the groups. Davies and Luks declined, and when Schofield and Kuhn were invited, they also declined. Sloan was elected to membership in the club in October, but it was not until November that he set his exhibition dates (January 24 to February 6). By the time his show opened, Shinn had dropped out, and Prendergast, Fuhr, Reuterdahl, and Boss were Sloan's companions. The exhibition was quiet but important in terms of continuing exposure. As Sloan con-

cluded, "There was not a very large attendance, I'm afraid, but the scheme is being displayed and if only four or five public galleries were open on this same plan the results would be great for the artists and public."[47] Limited as they were, the club's exhibitions of that winter had the considerable merit of initiating a series that was continued and imitated over the years, becoming widely known as "the MacDowell plan."

Henri had been the fomenter, Sloan the mainstay, of the exhibitions of The Eight and the Independents. In the case of the last and greatest of the three major progressive exhibitions, the Armory Show of 1913, the leadership was in other hands, and Sloan played a subordinate role.

The concept of the Armory Show mushroomed from the discussions of Walt Kuhn, Jerome Myers, and Elmer MacRae in early December of 1911, concerning the need for greater opportunities to exhibit the work of progressive painters, both American and foreign. By December 19, the group had designated itself the "American Painters and Sculptors"; Davies, Glackens, Lawson, and Luks were members, and Henri had been invited to join. By the second of January, 1912, the remaining three of The Eight were elected to membership. Sloan was absent from New York City on a trip to paint portraits in Nebraska from December 9, 1911, to January 19, 1912, and so missed the first meetings.

The organizers at first hoped that Academicians and the most progressive of the younger artists could work harmoniously, but lines of cleavage soon formed, and eventually direction was assumed by an inner circle headed by Davies. Henri, who could never accept a secondary position with grace, had little sympathy for the more advanced painters or for the concept of inviting a large foreign contingent. As a consequence, he remained to one side, and Sloan (who was actually far more liberal in his sympathies) shared his distaste for at least certain aspects of the operation. In the last flurry of activities, Davies designated Sloan as a member of the "Reception and Publicity" and the "Catalogue and General Printing" committees, but Sloan (who was deeply involved in *The Masses*) confided in his diary, "I can't feel interested enough to attend meetings lately."

The International Exhibition of Modern Art was held in the Sixty-ninth Regiment Armory from February 17 to March 15, 1913. It made history, changing the course of American Art. All of The Eight but Shinn were represented, Sloan by two paintings and five etchings.[48]

It was well over a year later (May 18, 1914) that Davies, after much prodding, held a membership meeting and presented the still incomplete books. They showed a favorable balance, but they left questions unanswered. The result was dissension, and Henri, Sloan, Luks, and Bellows resigned, together with Myers, du Bois, Lie, and Dabo. The Eight was split nearly down the middle, and neither that group nor the Association of American Painters and Sculptors effectively survived. But in the aftermath of the Armory Show there were positive developments as well. John Sloan, like other American painters now fully exposed to the impact of the new art of Europe, began to reexamine his own approach to

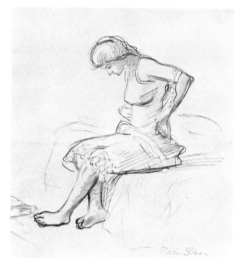

Seated Girl Undressing (Bachelor Girl). 1912. Sanguine, 8½" x 8½". The Kraushaar Galleries, New York.

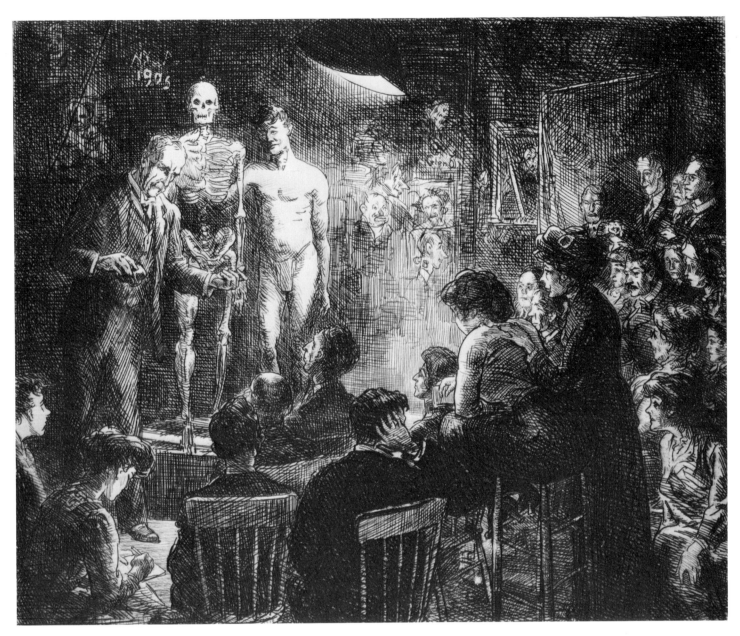

painting. Shortly thereafter, in 1917, the long-sought completely liberalized form of exhibition was established on a continuing basis by the Society of Independent Artists. This organization, though patterned after the Paris *Indépendants* rather than the 1910 Exhibition of Independent Artists, fully embodied the democratic "no jury, no prizes" principle that Sloan had fought for. Glackens was the first president, and though Sloan was not a party to the initial planning, he was soon deeply involved and gave his energetic support. In 1918 he was elected president, an office he held for the rest of his life.

Anshutz Talking on Anatomy. 1912. Etching, 7½″ x 9″. The John Sloan Estate. Photo courtesy of the Smithsonian Institution, Washington, D. C.

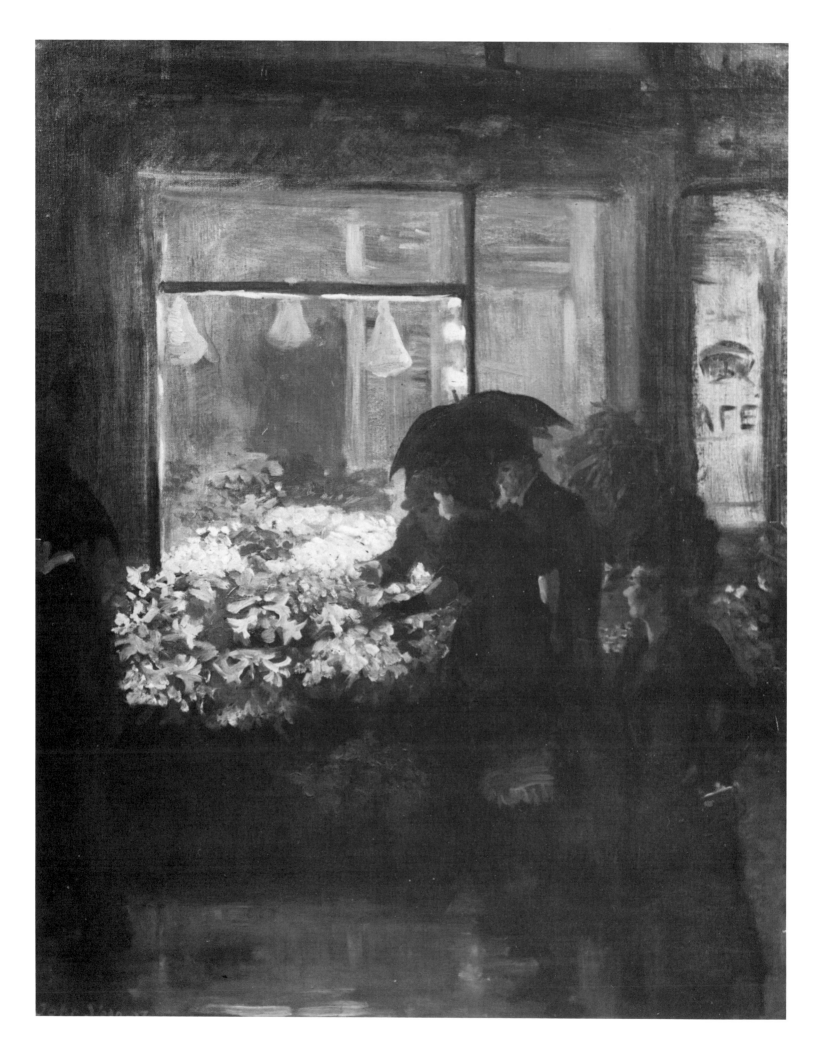

The Coffee Line. 1905. Oil on canvas, 21½″ x 31½″. The John Sloan Trust, Wilmington, Delaware.

Easter Eve. 1907. Oil on canvas, 32″ x 26″.
Collection of Miss Ruth Martin, New York.

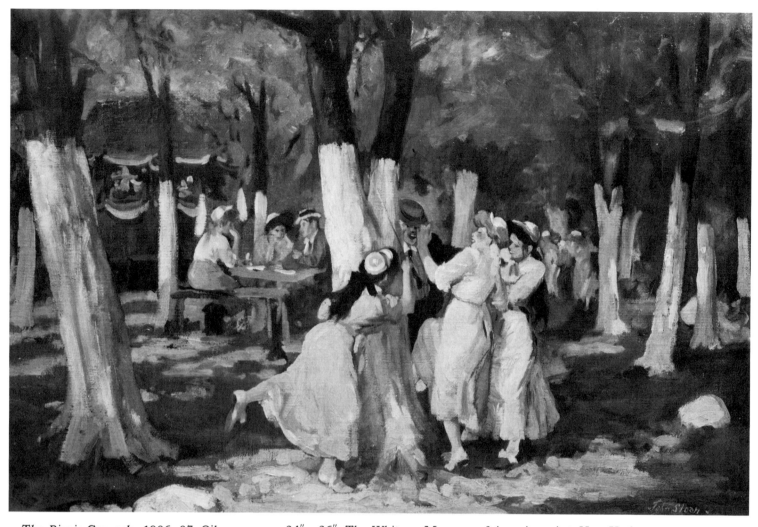

The Picnic Grounds. 1906–07. Oil on canvas, 24″ x 36″. The Whitney Museum of American Art, New York.

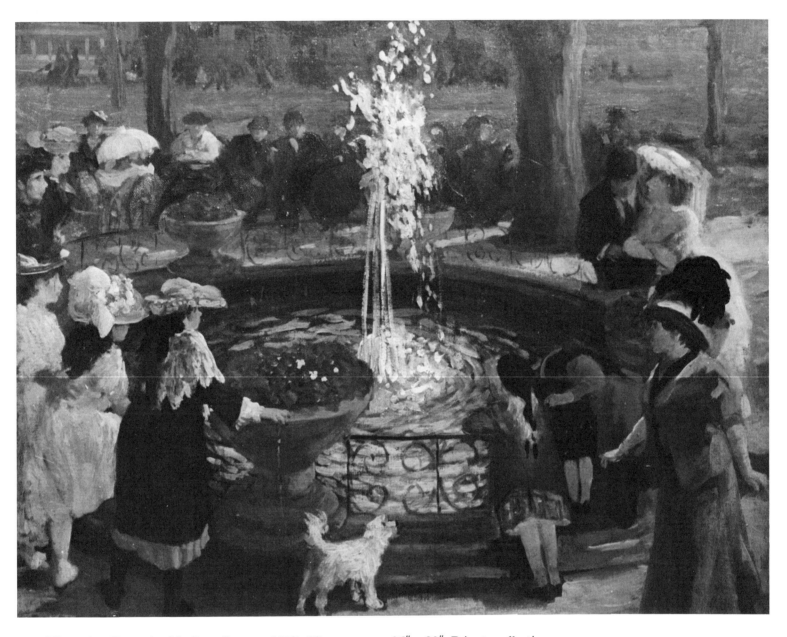

Throbbing Fountain, Madison Square. 1907. Oil on canvas, 26″ x 32″. Private collection.

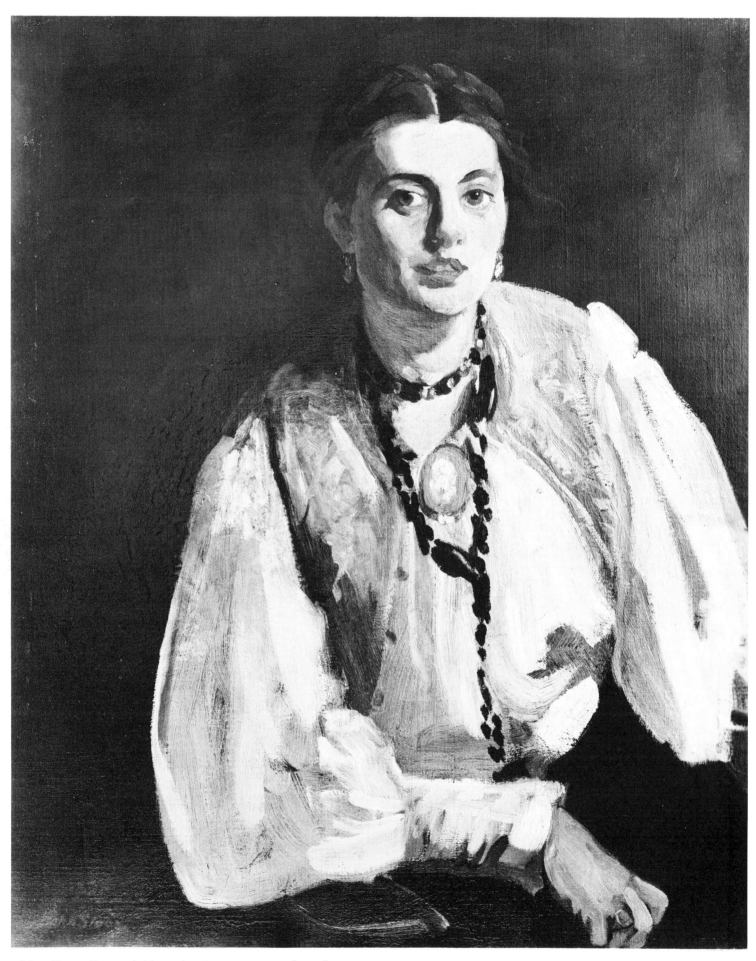

Mrs. Henry Reuterdahl. 1907. Oil on canvas, 32″ x 26″. Collection of Philip and Muriel Berman, Allentown, Pennsylvania.

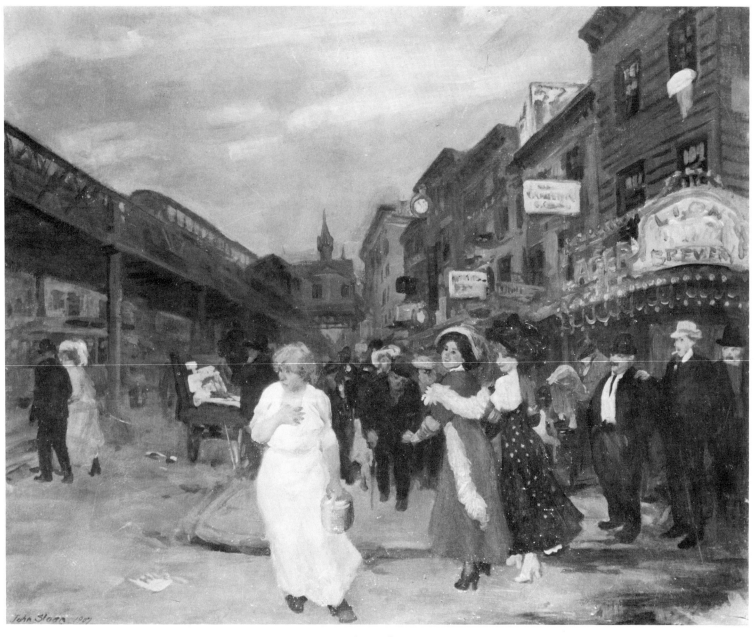

Sixth Avenue and Thirtieth Street. 1907. Oil on canvas. 26″ x 32″. Collection of Mr. and Mrs. Meyer P. Potamkin, Philadelphia.

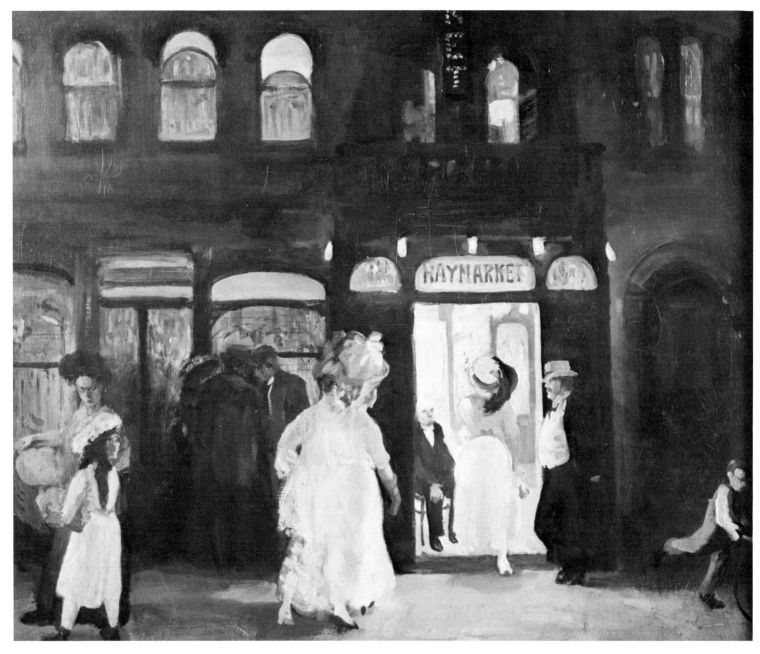

The Haymarket. 1907. Oil on canvas, 26″ x 32″. The Brooklyn Museum, New York. Gift of Mrs. Harry Payne Whitney.

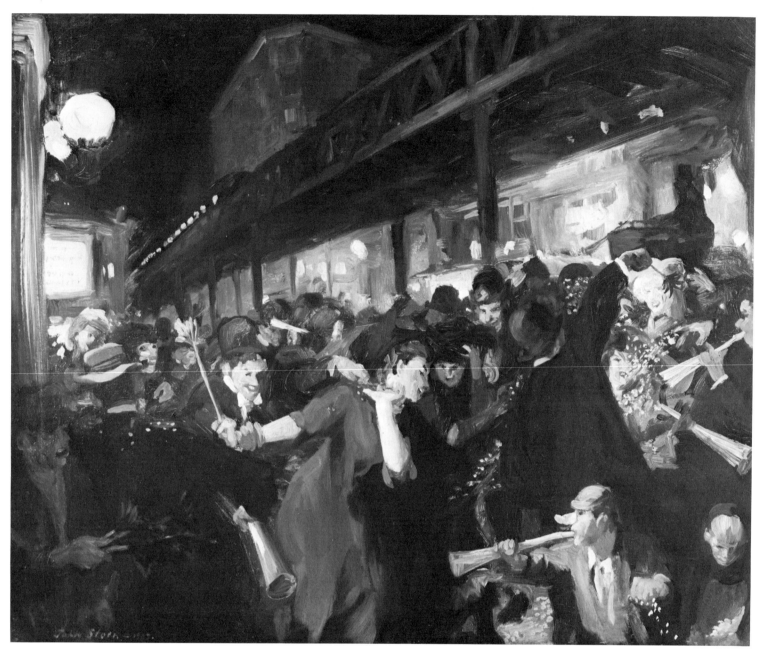

Election Night in Herald Square. 1907. Oil on canvas, 26″ x 32″. The Memorial
Art Gallery of the University of Rochester, New York. R. T. Miller Fund.

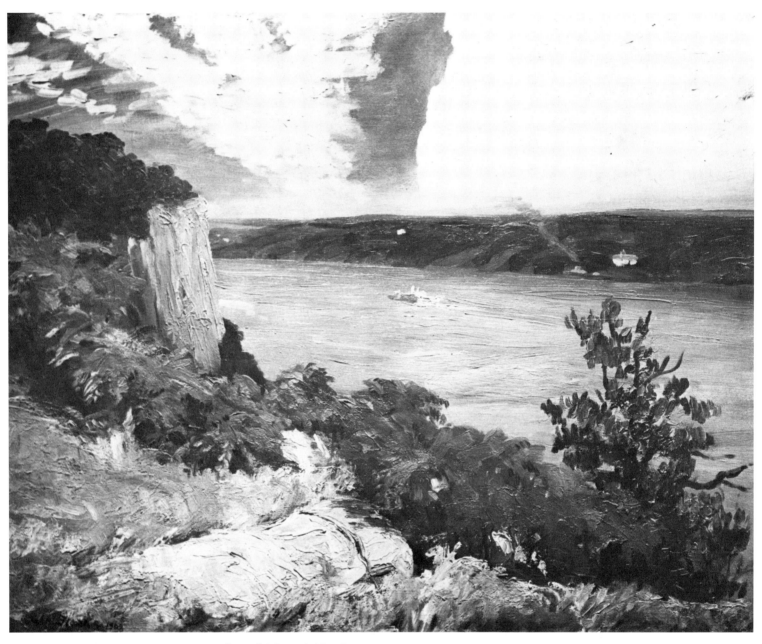

Hudson Sky. 1908. Oil on canvas, 26″ x 32″. The Wichita Art Museum, Wichita, Kansas. Roland P. Murdock Collection.

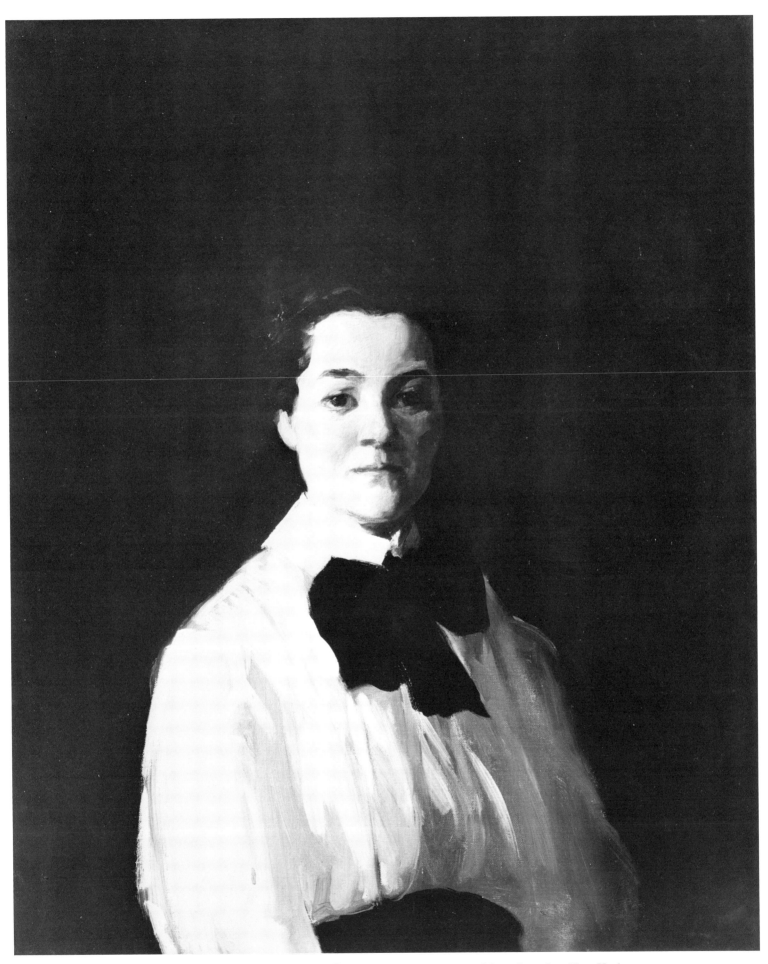

Dolly with a Black Bow. 1909. Oil on canvas, 32″ x 26″. The Whitney Museum of American Art, New York.

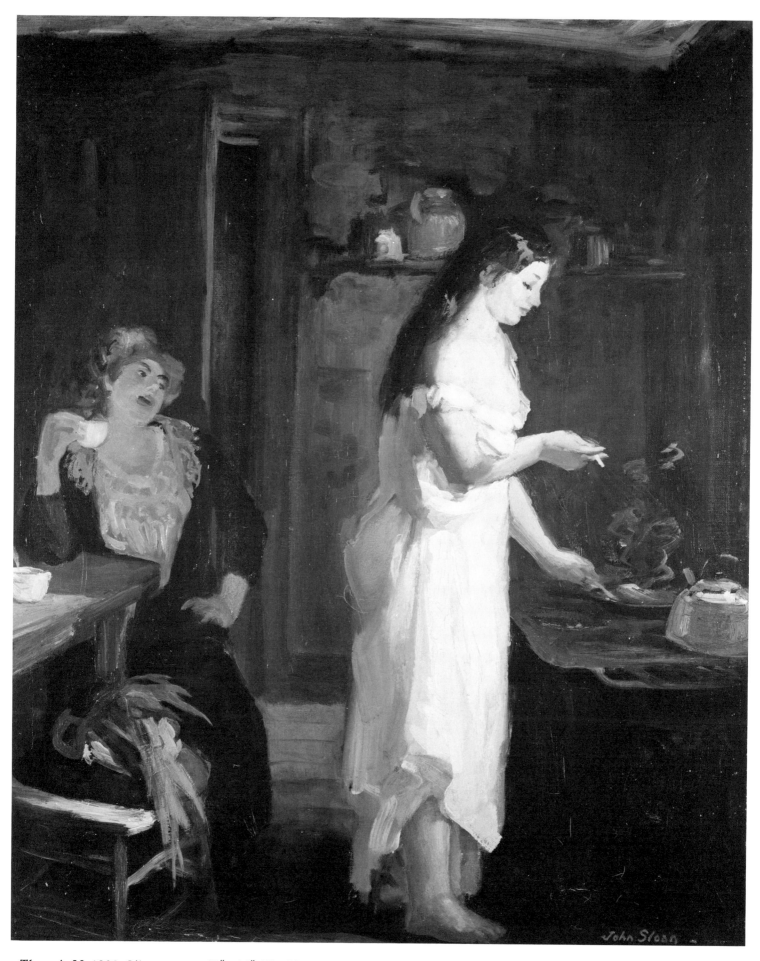

Three A. M. 1909. Oil on canvas, 32″ x 26″. The Philadelphia Museum of Art, Pennsylvania. Gift of Mrs. Cyrus McCormick.

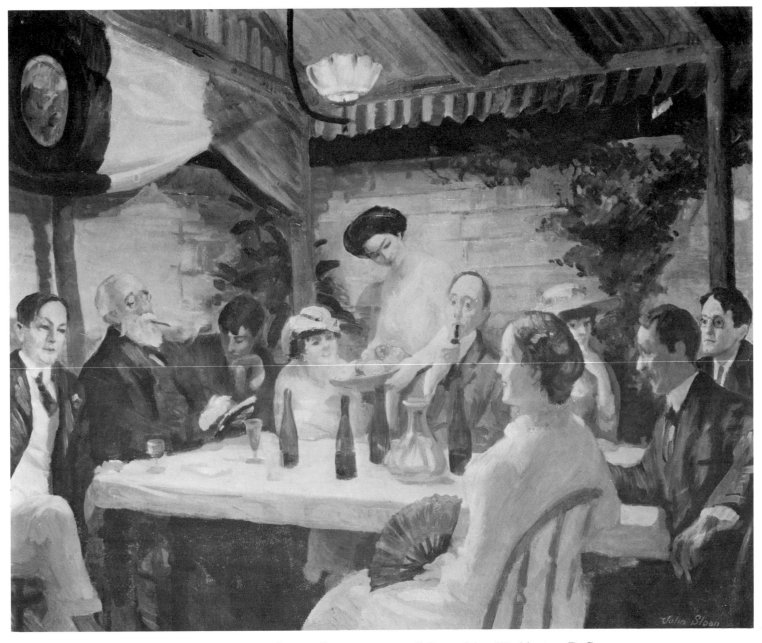

Yeats at Petitpas. 1910. Oil on canvas, 26⅜″ x 32¼″. The Corcoran Gallery of Art, Washington, D. C.

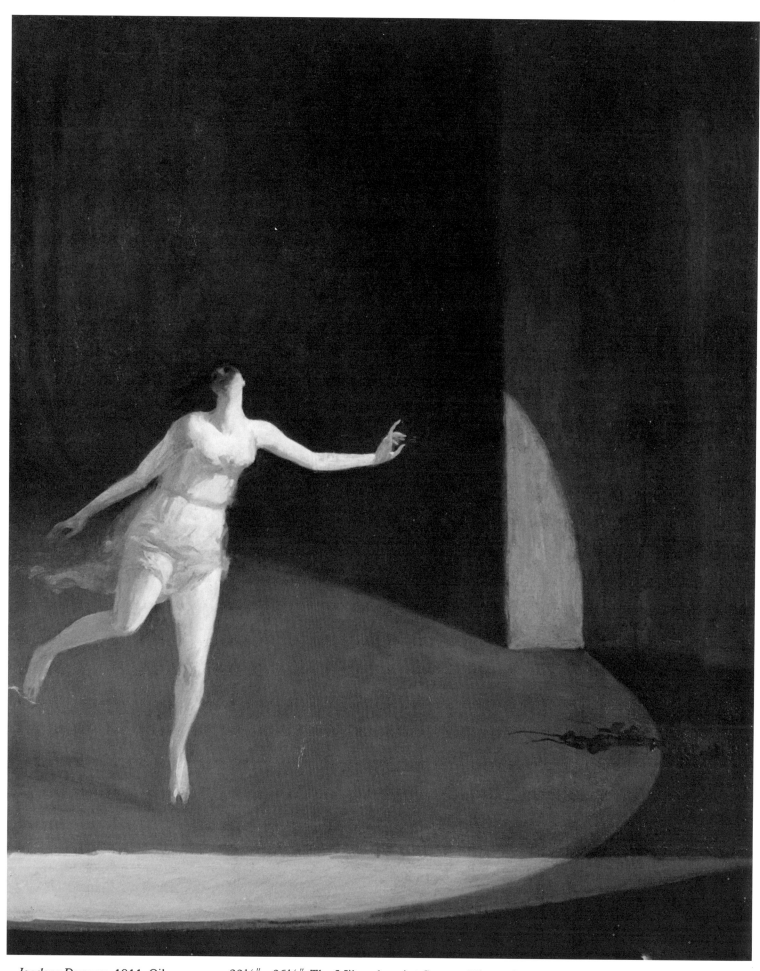

Isadora Duncan. 1911. Oil on canvas, 32¼″ x 26¼″. The Milwaukee Art Center, Wisconsin. Gift of Mr. and Mrs. Donald B. Abert.

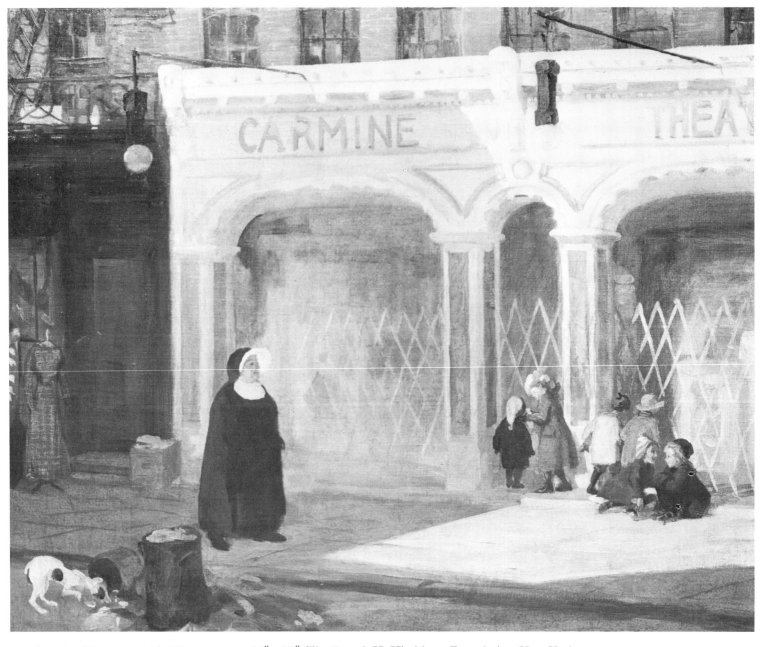

Carmine Theater. 1912. Oil on canvas, 26″ x 32″. The Joseph H. Hirshhorn Foundation, New York.

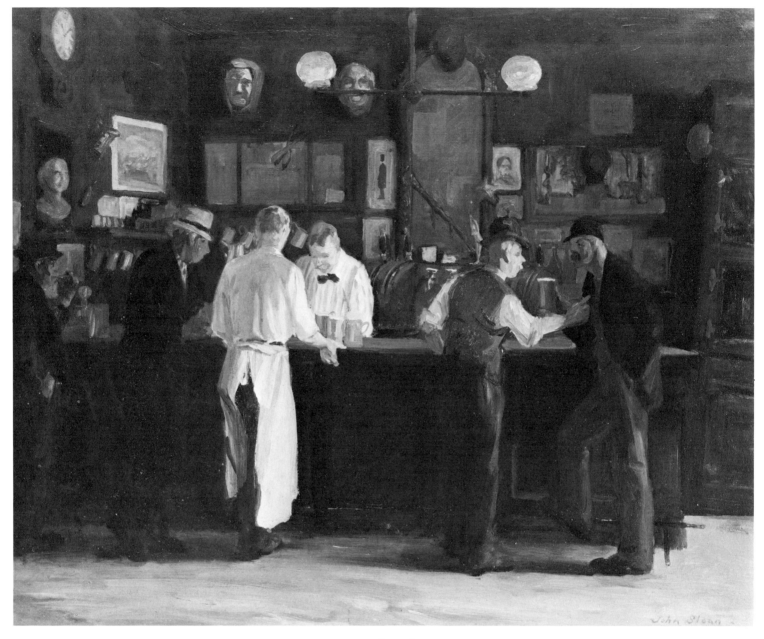

McSorley's Bar (McSorley's Ale House). 1912. Oil on canvas, 26″ x 32″. The Detroit Institute of Arts, Michigan.

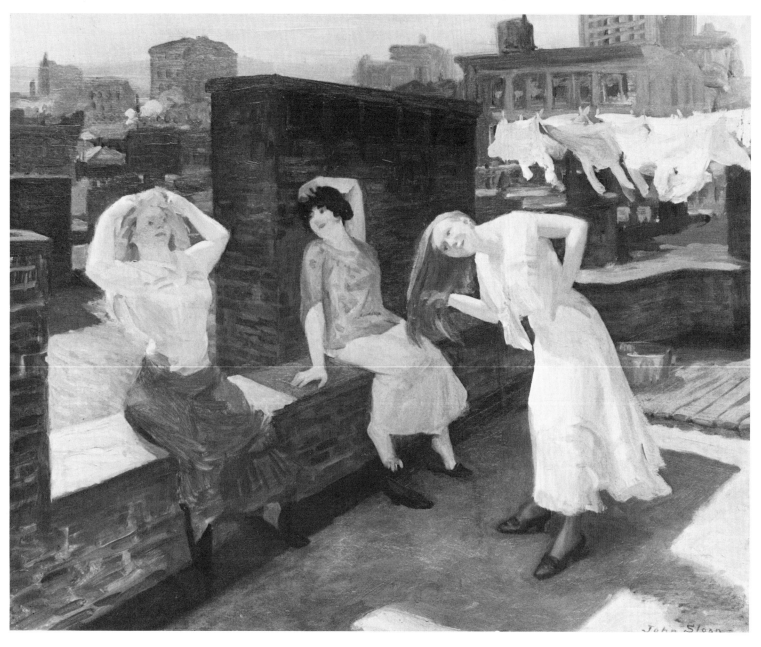

Sunday, Women Drying Their Hair. 1912. Oil on canvas, 25½″ x 31½″. The Addison Gallery of American Art, Philips Academy, Andover, Massachusetts.

YEARS OF CHANGE
1908·1918

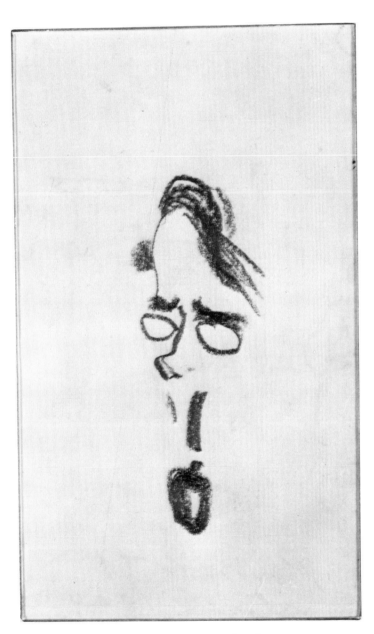

Robert Henri. *John Sloan*. Charcoal, 7″ x 4″. The
Chapellier Galleries, New York.

THE CALL AND THE MASSES

The year 1908 was one of new achievements and new departures for John Sloan. He not only found himself a national figure after the February exhibition at the Macbeth Gallery but, by the end of the year, was also enjoying fairly steady commissions as an illustrator. Characteristically, as soon as Sloan was recognized as a painter of city genre, he made his first serious attempt at landscape. In addition, by the year's end he was well on the way to converting to socialism.

The motivation for this political decision was deeply rooted in his nature, coming from his stubborn individualism and independence, his strong sense of justice, and his impatience with corruption. As a boy he had been indelibly impressed by the principles of Christian humanism exemplified by such men as his great-uncle Horatio Hastings Weld (an Episcopal minister who had been editor of the Boston *Transcript* and then of the Philadelphia *Ledger*) and the family minister, Henry Batterson, whom he knew well through his participation in the church choir. As a Christian, however, he became a complete independent, for he could not tolerate the "hypocrisy" of the church services his sisters so devotedly attended but he found "full of ideas and formulas of life which I think positively against the intentions of that great Socialist Jesus Christ."[49]

A humanist in the grain, Sloan endeavored to look at life whole and to keep his recurrent sense of outrage within bounds, but at times he was swept away by anger at injustice. Helen Sloan recounts that once as a child he was carried home bleeding, having jumped into an areaway to protect a kitten that some boys were pelting with stones and thereby having been stoned himself.

Sloan was by nature distrustful of political systems. He stood off the arguments of his friend Charles Rudy, who embraced guild socialism in the 1890s, and also of Henri, who advocated philosophical anarchism. At the same time, his heart went out to the victims of society, and he had the habit of dropping in at night courts where he boiled inwardly when observing the "snap justice" inflicted on "the poor things" hauled before the magistrate.[50] Later he argued that "it was not essentially wrong to break a law, that one might commit a greater wrong by obeying a law—a bad law,"[51] and years later he wrote, "I am suspicious of all government because government is violence."[52]

The emergence of Sloan's socialism followed the elections of November 1908. He had voted for Bryan because he had felt that "some stop must be put to the rottenness of the Republican administration." It was not that he was a Democrat, he wrote. "I'm of no party. I'm for change—for the operating knife when a party rots in power."[53] Disgusted with the prospect of Taft succeeding Roosevelt, he began to have long conversations with his socialist friends—Lichtenstein, who had organized the itinerary for The Eight's traveling exhibition; Charles Wisner Barrell, who was preparing an article on Sloan for the *Craftsman;* and even his old teacher, Thomas Anshutz.

Sloan's diary reflects his deepening involvement in socialism

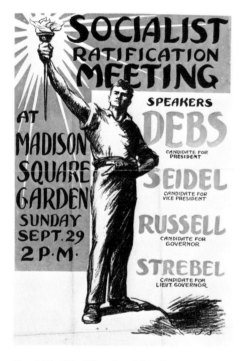

Socialist Ratification Meeting.
1912. Relief linecut, photomechanical, 32½" x 22". The Smithsonian Institution, Washington, D. C.

during 1909. After talking with Barrell in April, he wrote that he was still "rather more interested in the human beings themselves than in the schemes for betterment."[54] In May he told Piet Vlag and Herman Bloch, art writer for the socialist daily *The Call*, "I had no intention of working for any Socialist object in my etchings and paintings though I do think it is the proper party to cast votes for at this time in America."[55] Yet a few days later, coming upon a recruiting station in Union Square, he thought it might be possible to paint a protest. The resulting picture turned out to be another attractive city-park scene. He exhibited the painting widely for a time before deciding that his attempt to convey his antiwar feelings in this way only served to demonstrate that his instinctive distrust of mixing propaganda and oil paint had been right in the first place.

From month to month Sloan's commitment deepened, and by mid-August he was determined to make contributions of both money and cartoons to *The Call*. This was the beginning of some five years of drawing for the socialist cause—a period during which his graphic expression came to a peak and he established himself as one of the most powerful draftsmen of his time.

During the fall of 1909, he became fairly obsessed with socialism and with the problem of assimilating his theories with his work as an artist. In December, he wrote somewhat wistfully and prematurely, "I think . . . that I have passed the feverish stage in my make up. I feel much more quiet and in a sense happier minded."[56] Before the end of the month, he and Dolly had filled out the forms applying for membership in the Socialist party.

The year 1910 brought even greater involvement with the party. There were numerous drawings to do for *The Call* and *The Coming Nation,* and the Sloans attended almost daily discussions, lectures, and party meetings. Dolly became the organizer of "Branch One," and in November Sloan ran for the state assembly on the Socialist ticket, garnering 103 votes.

During the years of Sloan's socialist fever the principal calming influence came from a new, but soon very close friend—John Butler Yeats, the father of William Butler Yeats. This "fine old unspoiled artist gentleman" with a "slightly spotted" vest became a second father to John and Dolly,[57] praising their achievements and chiding them for their socialist extremism. The Sloans often went to the Petitpas' boarding house where the old man held forth nightly before an audience of "young poets, painters, writers and actors who eagerly enjoyed his talk which was always greatly entertaining."[58]

Van Wyck Brooks was at Yeats' table as Sloan portrayed it in his famous painting of 1910 (page 103). Years later Brooks quoted Sloan as referring to his "crisis of conscience" of 1909–1912, when he "was so concerned about socialism that he very seldom 'saw pictures,'" almost ceasing to paint for a time.[59] The strain showed in his temper as well, and the diary records repeated flare-ups, including one on the last day of 1910 in which he broke off a long-standing friendship with Rollin Kirby, who had complained that Sloan had "lost his sense of humor" over socialism. More than a year later, following a disagreement over some

There Was a Cubic Man (The Cubic Man). Illustration in the April, 1913 *Masses.* Black crayon, 7¾″ x 6⅛″. The Kraushaar Galleries, New York.

The Curse. Illustration in the February, 1913, *Masses.* Crayon, 13½″ x 4½″. Collection of Mr. and Mrs. Hermann Warner Williams, Jr., Washington, D.C.

cartoons at *The Call* office, he confessed, "I felt rather frightened at my mental attitude. I have no right toward myself to damage myself by such rages."[60]

Work for the Party and the periodicals was carried on at fever pitch throughout 1911. In October, Dolly strenuously promoted a lecture by Eugene Debs, who impressed Sloan deeply. Following the successful Debs appearance, the Henris took the Sloans to hear the anarchist Emma Goldman. Sloan admired Emma Goldman's courage, though he thought she demanded "too much social consciousness from the artist," since art "is simple truth as felt by a painter."[61] The Sloans attended a number of Emma Goldman's lectures, and later when she was jailed for being an anarchist, Dolly worked to raise her bail. During February and March of 1912, Dolly made heroic efforts toward another cause—providing for some two hundred children from Lawrence, Massachusetts, who needed food and shelter during a strike.

Sloan, at this point, was determined to turn back to painting, and he signed a lease for a loft studio at Fourth Street and Sixth Avenue. At last his "fever" was subsiding, and both his drawing and painting benefited immensely.

That same March, Sloan attended a lecture by Max Eastman, the young Columbia professor with whom he was to become so closely associated on *The Masses.* The monthly magazine, then just over a year old, faced a very uncertain future, and in the fall some of the publisher's friends, including Sloan, formulated plans to redesign it completely. Eastman assumed the position of editor and Sloan acted as art editor, although his name did not appear on the masthead with that title until December 1914. Dolly became business manager and treasurer of the magazine, dropping the first post after six months but continuing for a time in the second and helping to raise funds for the cooperative venture. *The Masses* announced itself as "a magazine with a sense of humor and no respect for the respectable, frank, arrogant, impertinent; a magazine whose policy is to do as it pleases and to conciliate nobody—not even its readers."[62] It was the outgrowth of an idea that had been germinating for some time, in Sloan's mind and others'; as far back as 1906 Sloan had contemplated founding a periodical to be called *The Eye,* and in October of 1909 he had discussed with Koplin "starting a political Socialist humorous paper somewhat on the lines of *Simplicissimus.*"[63]

The impact of *The Masses* was out of all proportion to its circulation, which rose to a peak of twelve thousand. Robert Herrick caught its flavor in the Chicago *Tribune:* "*The Masses* is the only American periodical that I examine with much pleasure month by month. It is the only one capable of giving any surprise. I like the illustrations in it—those rude, raw drawings by Mr. Sloan and his friends, so different from the insipidities of all other magazines. . . . *The Masses* seems to find our American world ridiculously lopsided, both the 'reactionary' and the 'progressive' end of it, and it says so with all the fresh brutality, the delirious delight of youth, when it is saying something unpleasant for the sake of saying it."[64]

Sloan's "rude, raw drawings" mark the high point of his work as

At the Top of the Swing. Illustration in the May, 1913, *Masses*. Black chalk, pen and ink, 15½″ x 12¾″. The Yale University Art Gallery, New Haven, Connecticut. Gift of Dr. Charles E. Farr.

Adam and Eve Strolling (The Foray).
Illustration in the February, 1913,
Masses. Crayon, 9″ x 5½″. The John
Sloan Trust, Wilmington, Delaware.

Love on the Roof. 1914. Etching, 6″ x
4⅜″ (plate). The John Sloan Estate.
Photo courtesy of the Smithsonian In-
stitution, Washington, D. C.

an illustrator. They range from straightforward, sympathetic characterizations of daily life in the city (*Top of the Swing*) through social concern (*The Curse*) and satire (*Eve and Adam Strolling*) to bitter political cartooning when events roused him (*Ludlow, Colorado*). His work was never broader or more forceful, and these same large, direct, uncluttered qualities marked the magazine's layout, which was revolutionary in America at the time, and initiated an important trend in periodical design. Max Eastman later paid tribute to Sloan in his assessment of the influence of the *Masses:*

> The long-time result of our pictorial revolt, it seems to me, was to introduce into commercial journalism some of the subtler values of creative art. This change, at least, has taken place and *The Masses* led the way. . . . The pictorial revolution for which *The Masses* artists worked without pay turned out to be one of the most profitable innovations in the history of journalism. At least that is my view, and I take no credit for this innovation except as a willing pupil. The central force in putting it through was John Sloan, and I consider my aesthetic development under his guidance one of the lucky turns in my very accidental education.[65]

For all the triumphs of *The Masses,* the conflict between the demands of art and socialism continued to beset Sloan. Max Eastman and Art Young led a group who believed in advocating the magazine's ideological message; Sloan, with other artists such as Stuart Davis and Glenn Coleman, wished to keep the contents as broad in scope as their responses to life. By September 1914, Sloan had ceased to do new drawings, but it was not until April of 1916 that the final confrontation occurred: an attempt to place all editorial responsibility in the hands of the literary and art editors, a move that would have weakened the control of the doctrinaire socialists, was defeated. Sloan and his friends resigned, and Art Young—whom he greatly admired for his draftsmanship in spite of their ideological differences—summed the matter up by telling the press that the rebels were "artists opposed to a 'policy' " who "want to run pictures of ash cans and girls hitching their skirts up on Horatio Street—regardless of ideas—and without title."[66]

After leaving *The Masses,* Sloan drifted out of the Socialist party, though he always retained sympathy for socialism and liberal causes. Looking back at the end of his life, he summed up his socialist adventure and his underlying philosophy:

> We all felt that we were a part of a crusade that would help to bring about more social justice at home and prevent the outbreak of world war. We were seriously alarmed by the new scientific discoveries which could make warfare a thing of terrible violence. . . . We did not have any doctrinaire ideas about running the world. Every time we went to a meeting, the speakers would talk about some new ideas for bringing about more justice without getting the world into the tyranny of some huge bureaucracy. Debs used to warn us that the socialist party should never have power of its own, that the ideas of the movement should be carried out through many different agencies of private and governmental types. It is hard for the man living in 1950 to realize that many of the things he takes for granted were considered radical proposals back in 1910; Women's suffrage, income taxes, workmen's compensation and social security, supervision of the stock exchange and regulation of interstate commerce, the United Nations. . . . I

had great hope for the socialist parties up until the time when the First World War broke out in 1914. Then I saw how they fell apart. Some of the leaders were killed; the emotional patterns of national pride set one country against another. I became disillusioned. I used to think that greed for money was the worst evil in the world, but after we saw what happened under Mussolini, Hitler, and Stalin, I realize that the desire for power over other people is a far more terrible evil. If most of us took our religion seriously, as a real thing, of course we would have no war.[67]

THE LOFT STUDIO AND GLOUCESTER

The period from 1912 to 1918—which embraced the Armory Show and its immediate aftermath—was one of critical development for Sloan's painting, although some of his best canvases of these years are too little recognized (probably because he is so largely identified with the early city scenes and the late figure studies).

Sloan's return to intensive painting after his socialist "crisis of conscience" began in the late spring of 1912, when he decided to lease a loft studio on the eleventh floor of the recently completed "triangle building" at Fourth Street and Sixth Avenue, thereby uprooting himself "for a new way of life—working away from home."[68] The loft studio meant more regular and consistent painting, and also gave Sloan his first opportunity to paint in a space large enough to accommodate a model stand properly. He fell hard at work at once. By the end of the year, he had produced far more canvases than in any previous year, including the bumper one of 1907.

Sloan was by now self-conscious about the social implications that might be read into his work. The 1912 city paintings include three pleasant park scenes and only one composition that touches on the vulgar.

The half-dozen nudes, figure studies, and portraits of 1912 show that even *before* the Armory Show he "began consciously to work from plastic motives rather than from what might erroneously be called 'story telling' motives."[69] In fact, the year marked a watershed in Sloan's method of work and approach to subject matter. Prior to 1912, the majority of his paintings were done from memory, based on observations of a scene or incident that struck him as a fit motif. But after his move to the studio he began to place a new emphasis on working directly from the subject, though remaining concerned with the penetration to essentials that memory painting encouraged.

Sloan's esthetic concerns had begun to change even before 1912, for he was of course aware of the interests of Davies, Pach, Kuhn, and the other shapers of the Armory Show. He tended to be sympathetic toward the work of Dove, Hartley, and Weber of the Stieglitz circle, and he had studied reproductions of Cézanne. Moreover, his involvement with the Maratta palette and color system that Henri introduced him to in 1909 led not only to heightened "abstraction" in color concepts, but also, through Maratta's later theories, to "the geometrical problem of rhythm in

Ludlow, Colorado. Illustration for "Class War in Colorado," in the July, 1914, *Masses.* Crayon, 18″ x 12″. Dartmouth College, Hanover, New Hampshire. Gift of John and Helen Farr Sloan.

Isadora Duncan. 1915. Etching, 9″ x 7½″ (plate). The John Sloan Estate. Photo courtesy of the Smithsonian Institution, Washington, D. C.

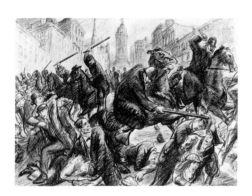

The Constabulary, Policing the Rural
Districts in Philadelphia, 1910.
Illustration in the April, 1915, Masses.
Crayon and ink, 18⅛" x 25¼". The
John Sloan Trust, Wilmington, Dela-
ware.

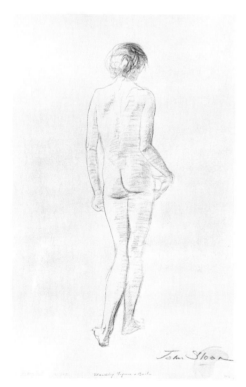

Standing Figure, Back. 1916. San-
guine, 16" x 10½". The Kraushaar
Galleries, New York.

construction and design of pictures and form."[70] As early as 1911,
his inspired tribute to the dancer Isadora Duncan showed a
powerful effect created through the starkest and most abstract of
geometrical settings.

As the opening of the Armory Show approached, he told a
reporter that he thought "Matisse and the 'neo-Impressionists' and
Cubists, etc." were "a splendid symptom, a bomb under
conventions,"[71] and the exhibition itself had a deep effect upon
him. Years later he recalled that the show was "the beginning of a
journey into the living past." "The blinders fell from my eyes and
I could look at religious pictures without seeing their subjects. I
was freed to enjoy the sculptures of Africa and prehistoric Mexico
because visual verisimilitude was no longer important. I realized
that these things were made in response to life, distorted to
emphasize ideas about life, emotional qualities about life."[72]

If 1912 had been a year of record production, 1913 far sur-
passed it—but now the great majority of canvases were figure or
nude studies. One lesson of the Armory Show, Sloan said, was that
a painter must work regularly at painting—not sporadically, wait-
ing for a subject to occur.

Doubtless it was to facilitate working regularly from a motif
directly at hand (in contrast to combing the city for a subject) that
he spent the summer of 1914 in Gloucester, Massachusetts, and
returned there each year through 1918. He painted morning and
afternoon, often working on two pictures a day during the first
three summers, going directly to nature and laying paint on the
canvas with vibrant color and rich texture. The expressive power
of Van Gogh had deeply impressed him when he saw the
Dutchman's pictures at the Armory Show, and Sloan emulated his
color intensity, impetuous rhythm, and graphic bite. Behind the
apparently spontaneous paintings lay careful preliminary planning
and individually selected set palettes. On this foundation he
constructed pictures that, at their best, were powerful and im-
mediate transcriptions of the Gloucester scene, a new achievement
for him in pictorial expressiveness.

In January of 1916, Sloan had his first one-man exhibition at
Mrs. Gertrude Vanderbilt Whitney's gallery. The show included
his city scenes, nude studies, Gloucester landscapes, etchings, and
drawings. The critic of the Sun persisted in interpreting all his city
subjects as being fundamentally attempts at satire, but the general
reaction was far more perceptive. One reviewer found in him "the
joyous realism of a forthright mind, rich in sturdy sympathy," and
recognized that it was "the power, the authority with which the
man speaks, the life behind the symbols he uses, that convince
us."[73]

The year 1916 was to prove, once again, a turning point. It
marked not only Sloan's first one-man show (and a gratifying
critical appreciation of his work), but also the beginning of a long
association with a sympathetic dealer, John F. Kraushaar. It was
the year of the final break with The Masses, and the start of what
was to become a full-fledged teaching career at the Art Students
League. It is also possible to trace the beginning of a new
emphasis on structure in the paintings done that summer in

Gloucester. The crisply geometric shapes of *Gloucester Harbor,* for example, stand in contrast to the fluent forms of such pictures as *Wonson's Rocks and Ten Pound Island* of 1915 (Plate 21).

Many of the earlier Gloucester sketches were exercises in lyrical transcription and reduction to essentials; now Sloan increasingly stressed stability in the large forms of the composition. Some seascapes of 1916 and 1917, like *Red Rock and Quiet Sea,* achieved the strength of the "splendid big thoughts . . . like big prayers to God" that he had felt in Rockwell Kent's paintings of rocks and the sea ten years before. [74]

In an etching of January 1917, *Arch Conspirators,* Sloan recorded a now-historic party held atop the Washington Square Arch, at which the celebrants—including Marcel Duchamp—formally declared the secession of Greenwich Village from the United States. About the same time, he was working on a print he titled *Mosaic,* ostensibly a satire on abstract art but with overtones of a serious experiment in Cubist compositional devices. His subsequent paintings reflect an increased concern with formal arrangement, and in some instances during the next few years he introduced devices taken directly from the abstract painters, for he confessedly "absorbed a great deal from the work of the ultra moderns" though painting no actual abstractions himself.[75] (Sloan's modernism, of course, stopped short of Dada, though he helped perpetrate the "Injy-Injy Movement" as a hoax to gain publicity for the Society of Independent Artists.)

As he became consciously concerned with the structural arrangement of the pictorial elements, he began to resist perspective, holding down the immediate foreground and tilting the landscape up against the plane of the canvas, as in *The Red Lane* of 1918. Sustained picture-building took on a new interest—he posed Dolly on the sofa in the tiny parlor of their red cottage at Gloucester, and Eugenie Stein next to the window of the large studio in the apartment the Sloans had taken on the top floor of 88

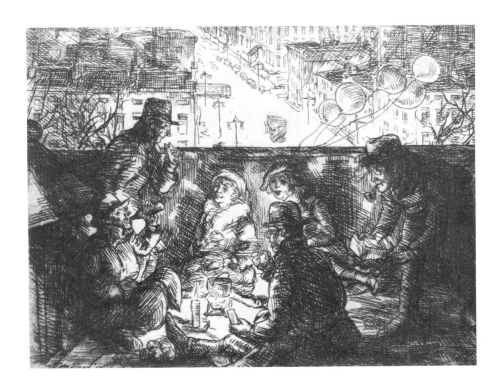

Arch Conspirators. 1917. Etching, 4½″ x 6″ (plate). The John Sloan Estate. Photo courtesy of the Smithsonian Institution, Washington, D. C.

Washington Place. Now the qualities of pictorial form he sought were less those conveyed by the graphic brushwork of Van Gogh than the fuller plastic volumes of the late Renoir and Cézanne. At times he even echoed the latter's angular and flattened planes of color when building form, as in *My Wife in Blue* (Plate 24). Again, he projected the main compositional lines through the picture in a firm, geometric grid, as in *Bleecker Street Saturday Night* and *The City from Greenwich Village* (Plate 28). Altogether, his work of this period represents a substantial stride toward realization.

Though Sloan dropped social overtones from his paintings, he continued to delight in portraying the raw aspects of life in his prints. His *Love on the Roof* of 1914 was later to be cited as an example of "immorality" in art, while *Mars and Bacchante* (1915), *Sidewalk* (1917), and *Hell Hole* (1917) carry on his tradition of Hogarthian social satire and are closer to *The Masses* drawings than to his paintings. In general he chose to ignore the war, which he deplored, but he found aspects of prohibition amusing, and from time to time poked fun at it as well as at the contradictory, flamboyant mores of the postwar period. Until the end of the twenties, in fact, his prints continued a viewpoint much like that of his New York city-life series, whereas his paintings shifted in emphasis from the city scene to figure and landscape subjects.

Mosaic. 1917. Etching and aquatint, 8″ x 10″ (plate). The John Sloan Estate. Photo courtesy of the Smithsonian Institution, Washington, D. C.

THE TEACHER

When Sloan leased the loft studio in 1912, he began to take on private pupils, in fact students began to seek him out, particularly for instruction in etching. He took on a summer class in Gloucester, and apparently he became reconciled to the idea of committing himself seriously to teaching at about the time he was wearying of the constant effort required to find commissions and please art editors as an illustrator.

By the time Sloan joined the faculty of the Art Students League of New York in 1916, his opinion of the school had undergone a change for the better, for in 1910, when asked to do a sketch for the "Fakir Show" catalog, he had retorted that he "would not consent to any connection with the A.S.L." since he objected to "such an academic institution."[76]

The Sloan class became one of the famous traditions of the League. Although the students were to eventually fade away as his style became unpopular in the late thirties, the class enjoyed a great heyday in the twenties and was at times so crowded that two models and two sections were necessary. The experience was stimulating for his painting, too: "Teaching lashes me into a state of consciousness; I try to prove in my own work some of the things I dig out of my subconsciousness to pass on to others."[77] A dedicated and sometimes boisterous band of disciples gathered about the master—terming themselves "the Sloanian nuts," listening with eager respect to the philosophy, aphorisms, trenchant criticisms, and occasional biting sarcasm that came so freely from Sloan during class sessions. He combined some of the qualities of a prophet with those of an actor. Deeply serious in his intention, he

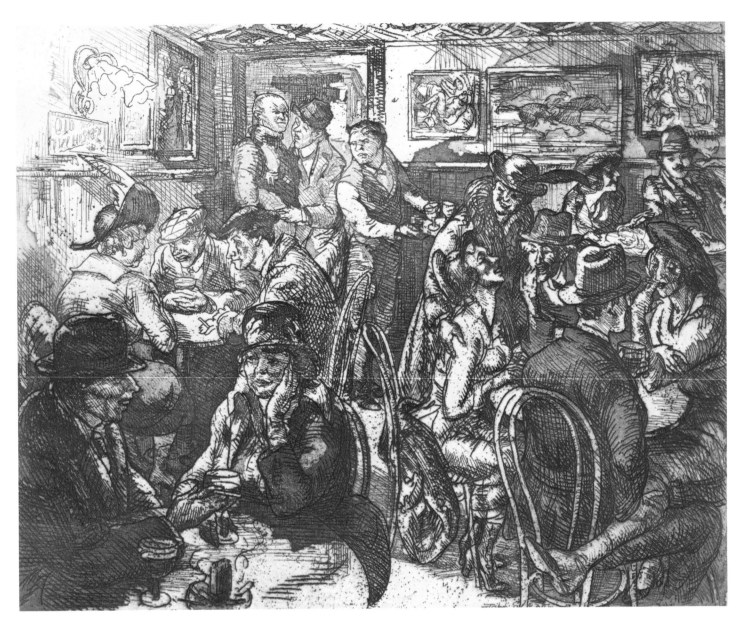

The Hell Hole. 1917. Etching and aquatint (zinc plate), 8″ x 10″ (plate). The John Sloan Estate. Photo courtesy of the Smithsonian Institution, Washington, D. C.

was witty and dramatic in his manner, and at informal gatherings he revealed unsuspected talent with (as he confessed) a "thick slice of ham" in his songs and pantomimes.

His teaching career was in many ways reminiscent of Henri's, and he saw himself as continuing the work of his "father in art." At the same time, he consciously wanted to make something more solid of his teaching, as he did of his painting. "I have tried to go on from the inspirational teaching of Henri to give my students more technical information about how to think and do."[78]

Like Henri in the first decade of the century, Sloan in the third helped to shape a number of future leaders of the art world. Some were to be primarily cartoonists or graphic artists, like Otto Soglow, Peggy Bacon, Don Freeman, and Edmund Duffy; others, such as Alexander Calder and David Smith, made their marks in sculpture; Angna Enters made hers as a dance mime. The painters, who of course predominated, included Reginald Marsh, Doris Rosenthal, Aaron Bohrod, John Graham, Lee Gatch, George L. K. Morris, Adolph Gottlieb, and Barnett Newman.

In 1931 Sloan was elected president of the Art Students League. The following year he took a stand, quite out of idealism

but also marked by stubbornness, that cost him his position and made him "some pretty fine enemies."[79] On the surface the quarrel resulted from the board's rejection of Sloan's request that George Grosz, who was then leaving Germany, be asked to teach at the League. Sloan was attracted by Grosz's incisive drawings, which employed a modern idiom but were grounded in academic training. Sloan felt the rejection was the "culmination of a series of sentimental and financial timidies," and indicated "that the board was not acting fearlessly for the best interests of the students."[80] The appointment of George Grosz was not in fact the basic issue, for the League reconsidered and hired him that summer. The outburst had come from tensions that resulted from Sloan's eagerness for reforms in the League's policy, urged in what seemed to the board a "dictatorial manner," and from his short-fused temper. "I had been sitting on my safety valve for months," Sloan said. And when he finally blew up, he attacked the board to their faces, calling them art politicians, and the League a sinking ship.[81] Subsequently, Sloan resigned; the students stormed in protest, asked Sloan to run again for the presidency, and threatened secession. When elections were held a few days later, Henry Schnackenberg won by an easy margin, though Sloan pointed out that the victory came from proxy votes, whereas the students in actual attendance largely supported him.

Sloan was reported to have said to the board of the League that he "cared no longer to lend the prestige of his name to such an institution,"[82] and he left for about three years. During this interval he taught at Archipenko's École d'Arte and later, when George Luks died in November of 1933, at the Luks School of Painting. When he accepted the invitation of the loyal Luks students to take the place of the late great "rowdy oldster," he made his position explicitly clear in a press interview: he believed in "encouraging younger painters to combine the best academic principles with the 'stimulating discoveries' of modern art and 'then to forge ahead for creative self-expression.' "[83]

Stuart Davis. 1913.
Oil on canvas, 32" x 26".
Private collection.

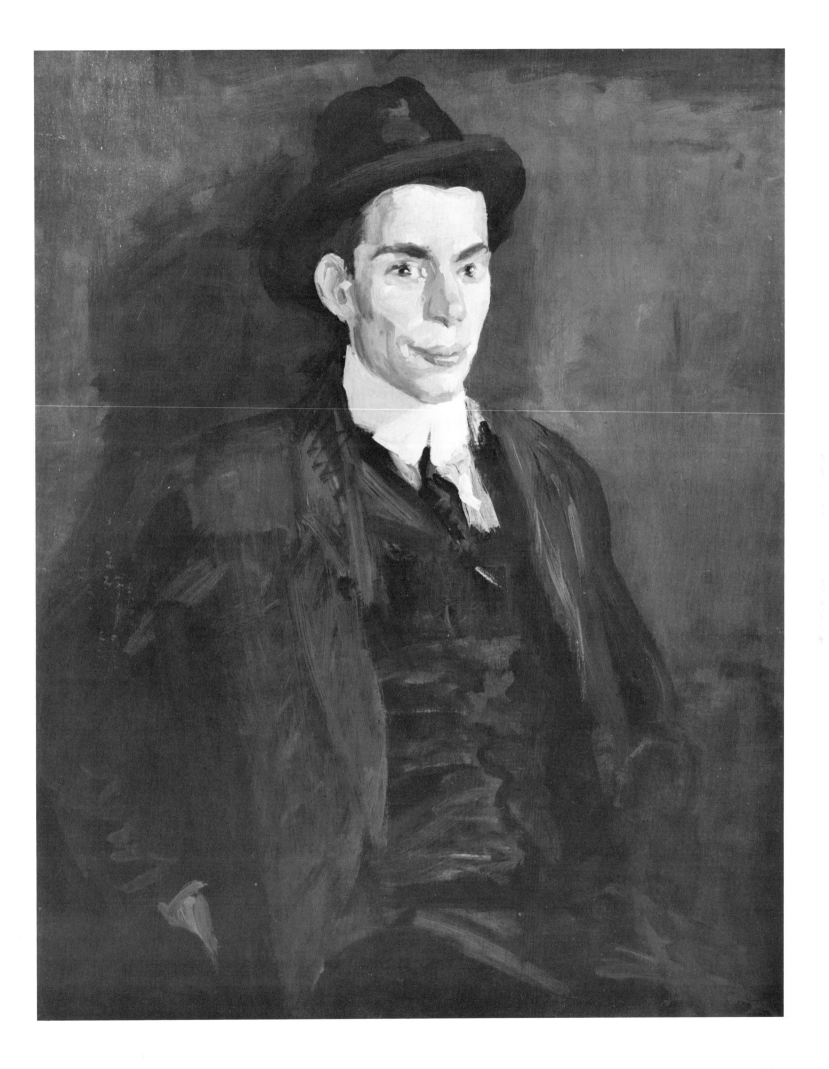

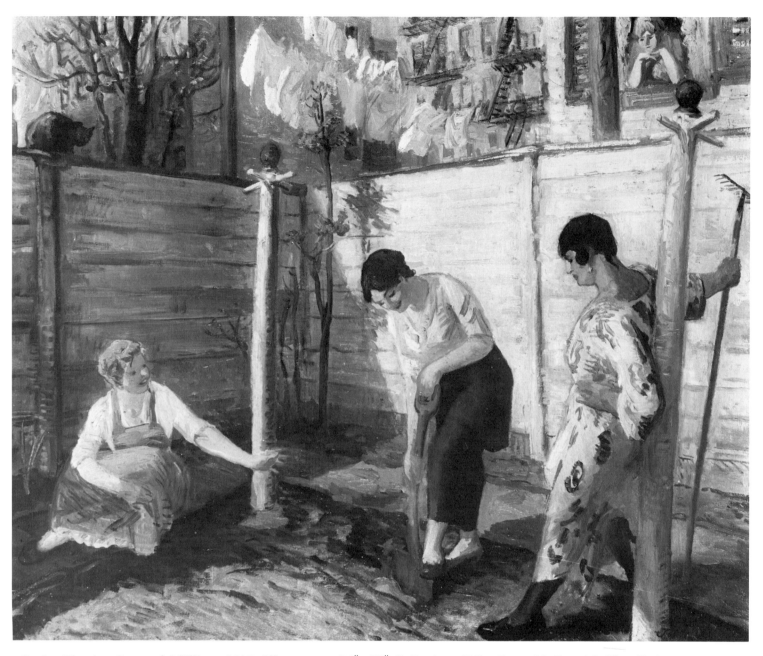

Spring Planting, Greenwich Village. 1913. Oil on canvas, 26″ x 32″. Collection of Mrs. Cyrus McCormick, New York.

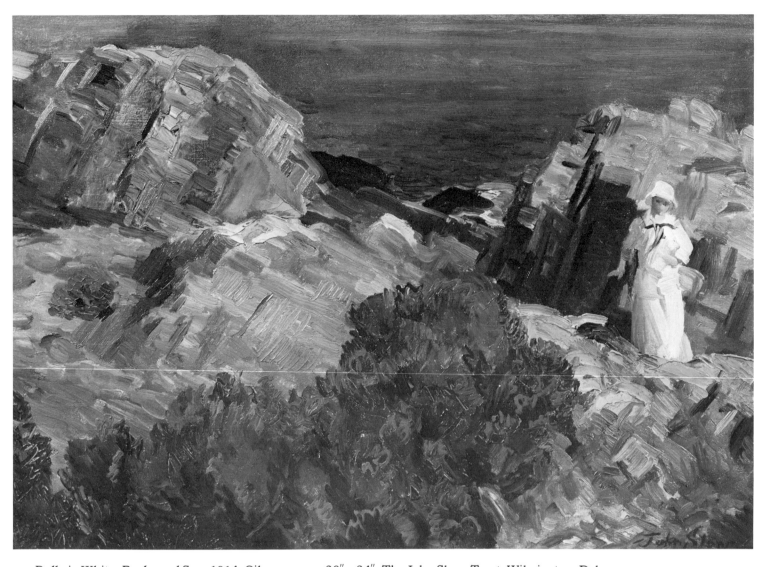

Dolly in White, Rocks and Sea. 1914. Oil on canvas, 20″ x 24″. The John Sloan Trust, Wilmington, Delaware.

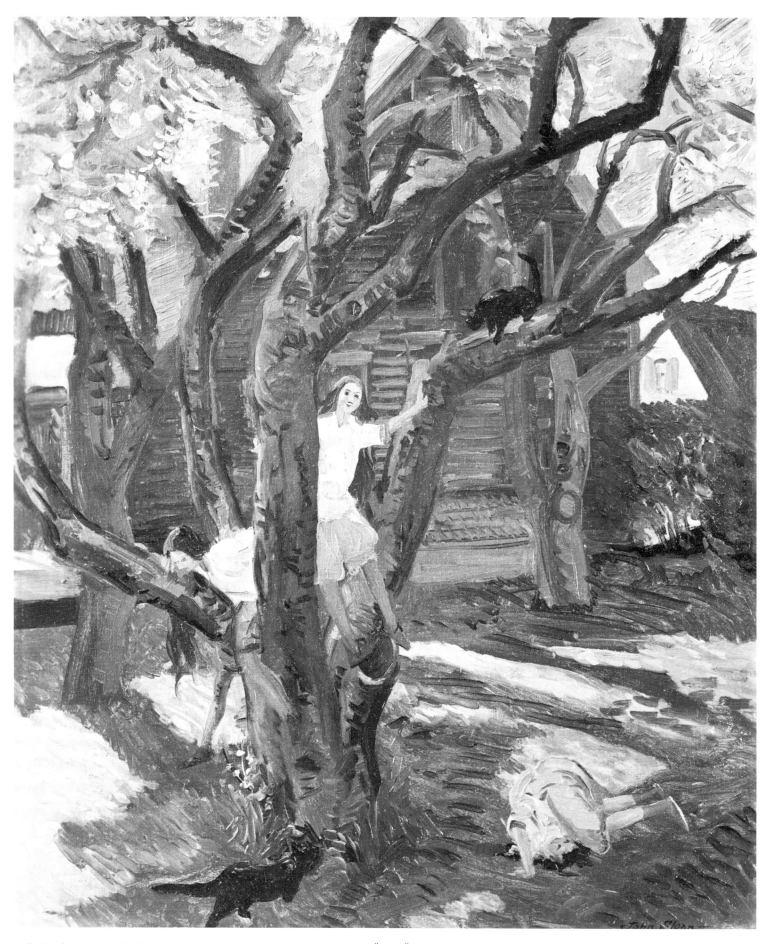

Sally, Sarah and Sadie, Peter and Paul. 1915. Oil on canvas, 32″ x 26″. The Kraushaar Galleries, New York.

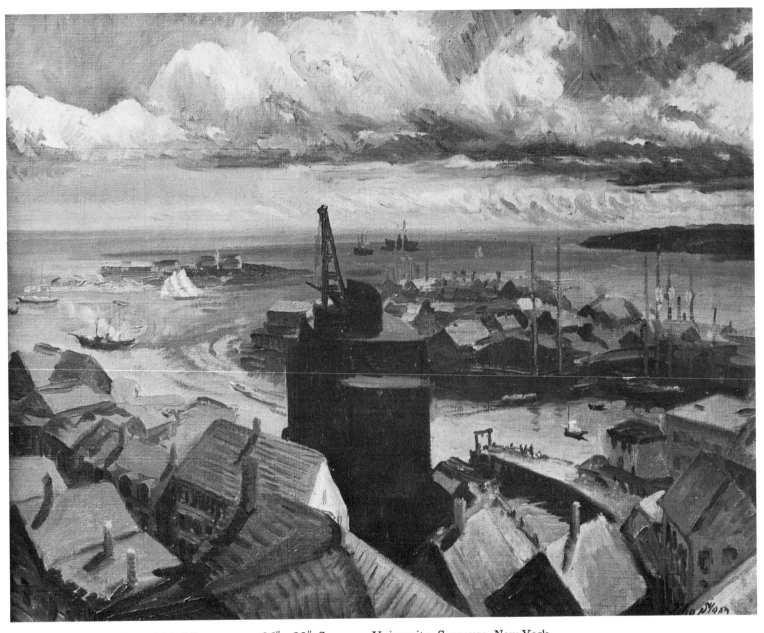

Gloucester Harbor. 1916. Oil on canvas, 26″ x 32″. Syracuse University, Syracuse, New York.

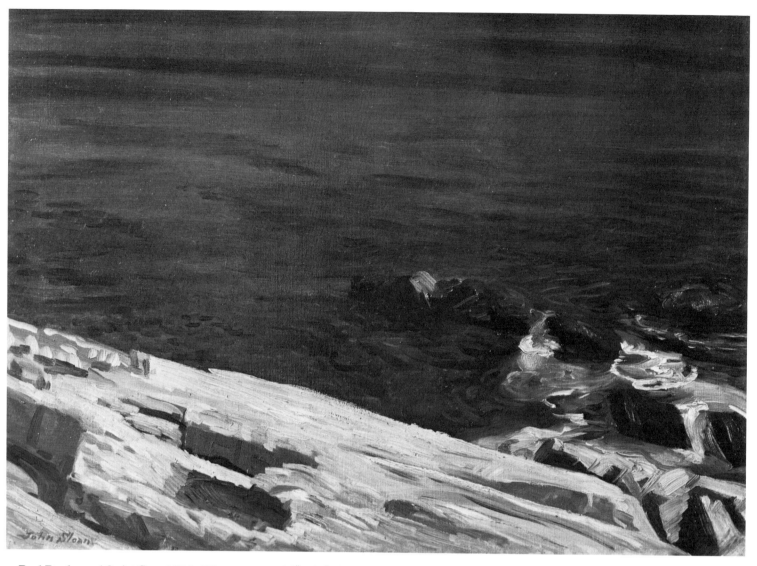

Red Rocks and Quiet Sea. 1916. Oil on canvas, 26″ x 32″. Collection of Miss Ruth Martin, New York.

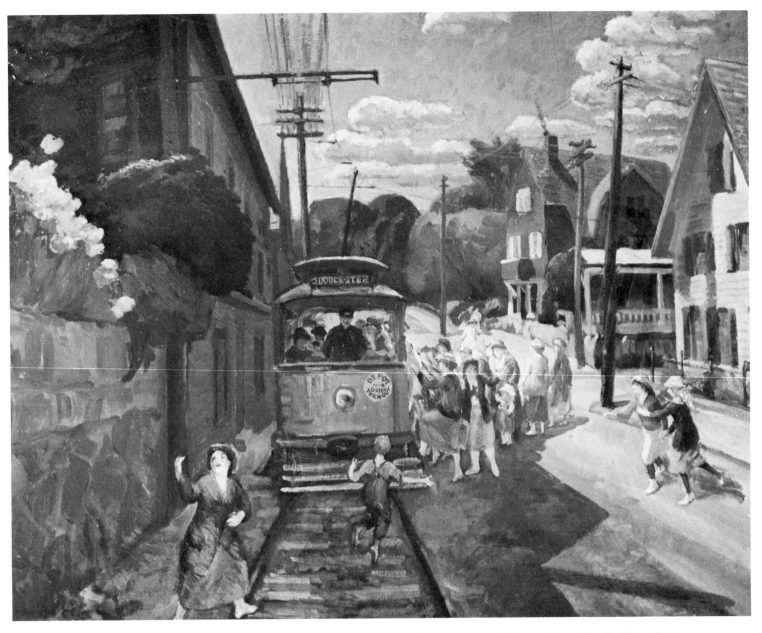

Gloucester Trolley. 1917. Oil on canvas, 26″ x 32″. The Canajoharie Library and Art Gallery, Canajoharie, New York.

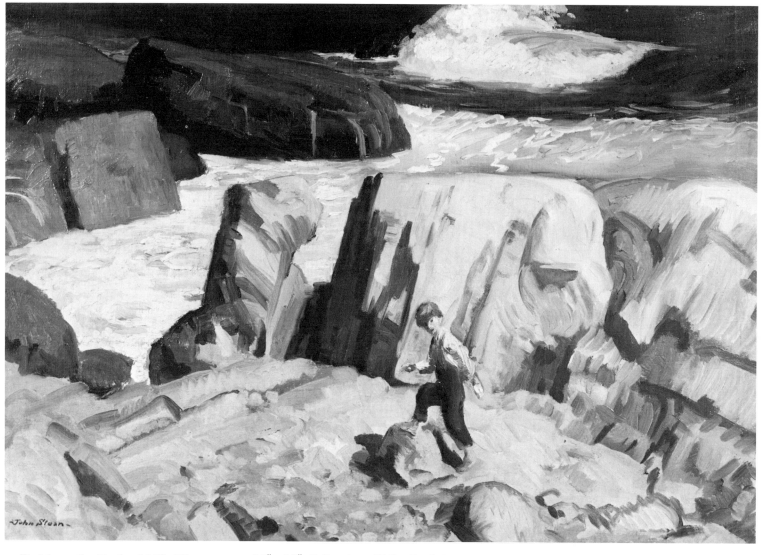

Reddy on the Rocks. 1917. Oil on canvas, 26″ x 32″. Collection of Miss Ruth Martin, New York.

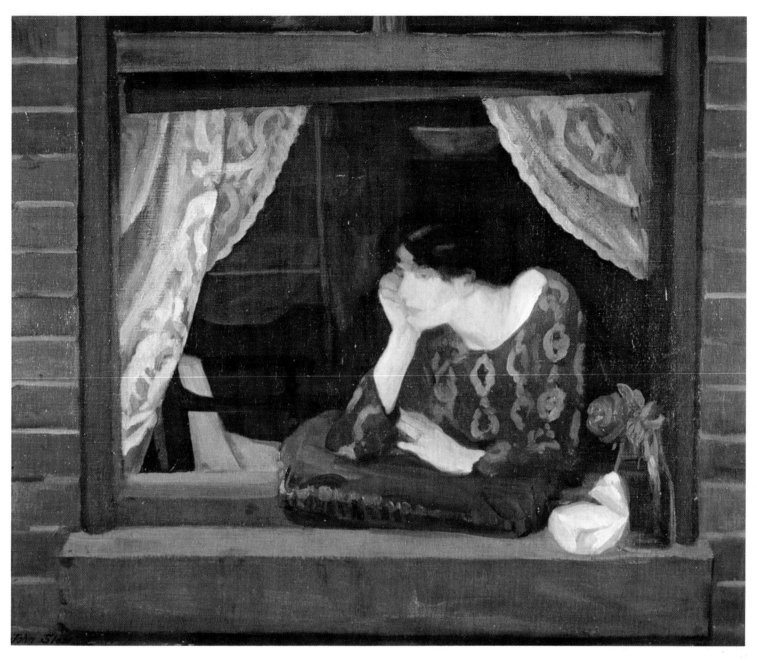

Plate 17. *A Window on the Street*. 1912. Oil on canvas, 26″ x 32″. The Bowdoin
College Museum of Art, Brunswick, Maine. Hamlin Collection.

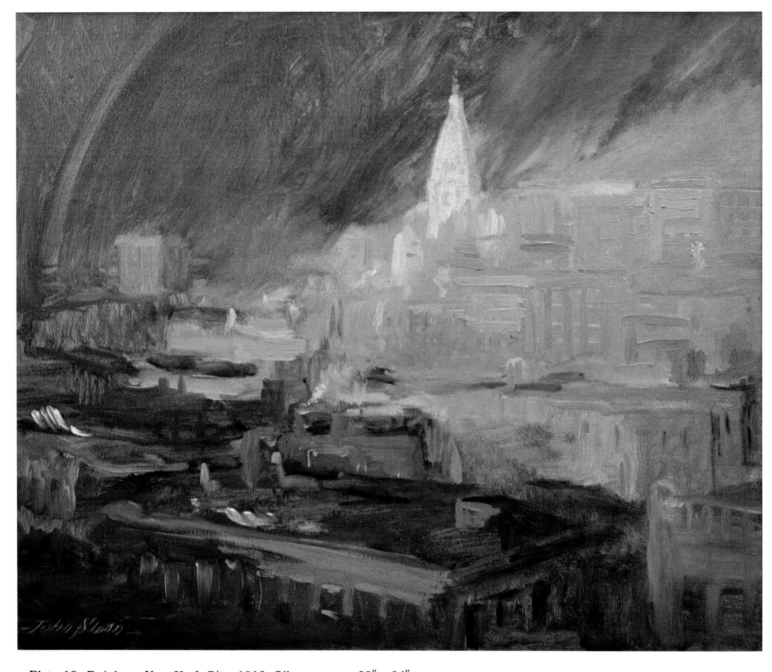

Plate 18. *Rainbow, New York City*. 1912. Oil on canvas, 20″ x 24″.
Collection of Dr. and Mrs. James Hustead Semans, Durham, North Carolina.

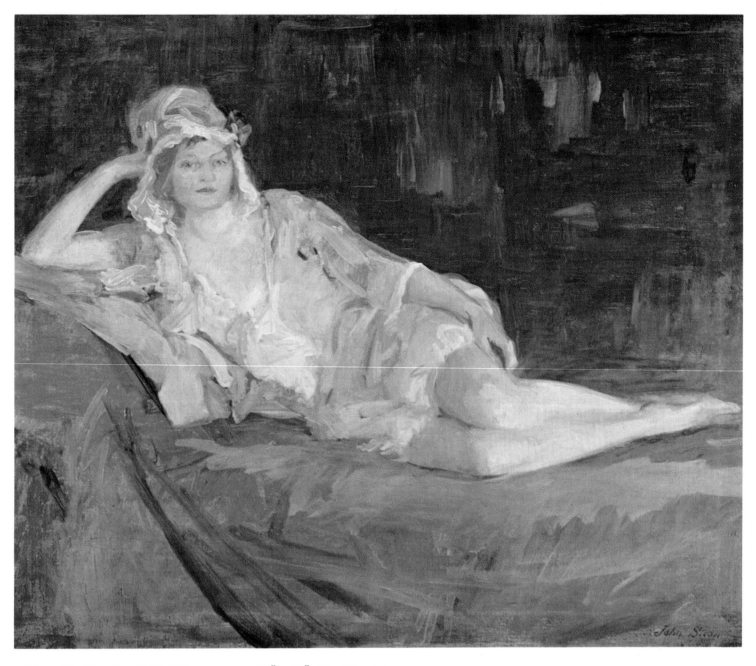

Plate 19. *Rosette*. 1913. Oil on canvas, 26″ x 32″. The Bowdoin
College Museum of Art, Brunswick, Maine. Hamlin Collection.

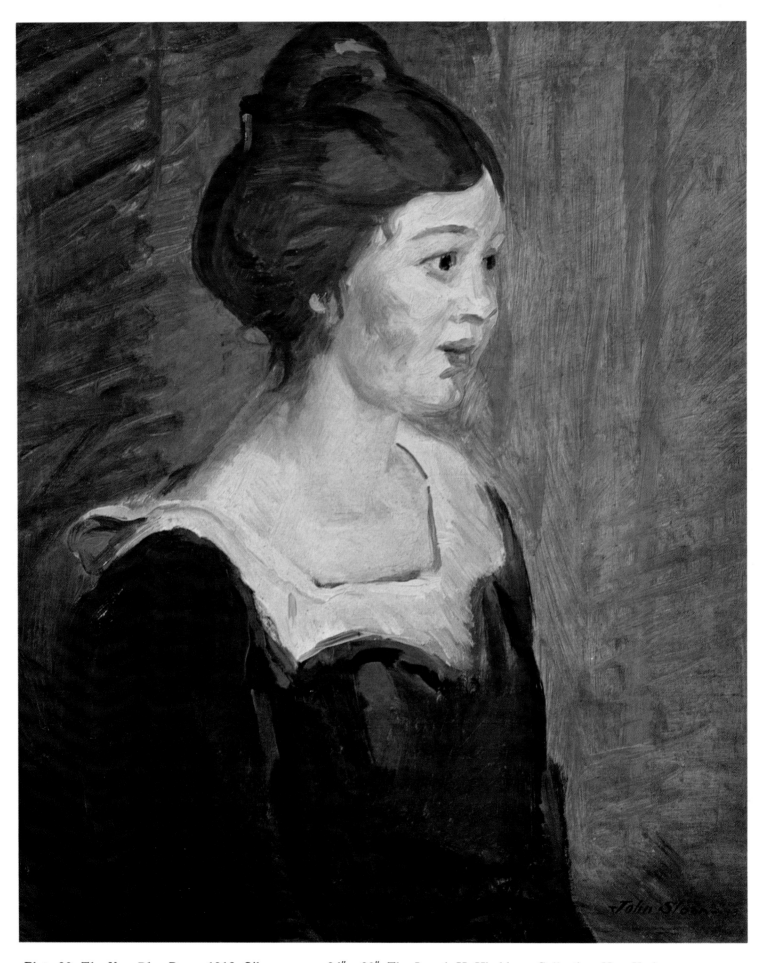

Plate 20. *The New Blue Dress*. 1913. Oil on canvas, 24″ x 20″. The Joseph H. Hirshhorn Collection, New York.

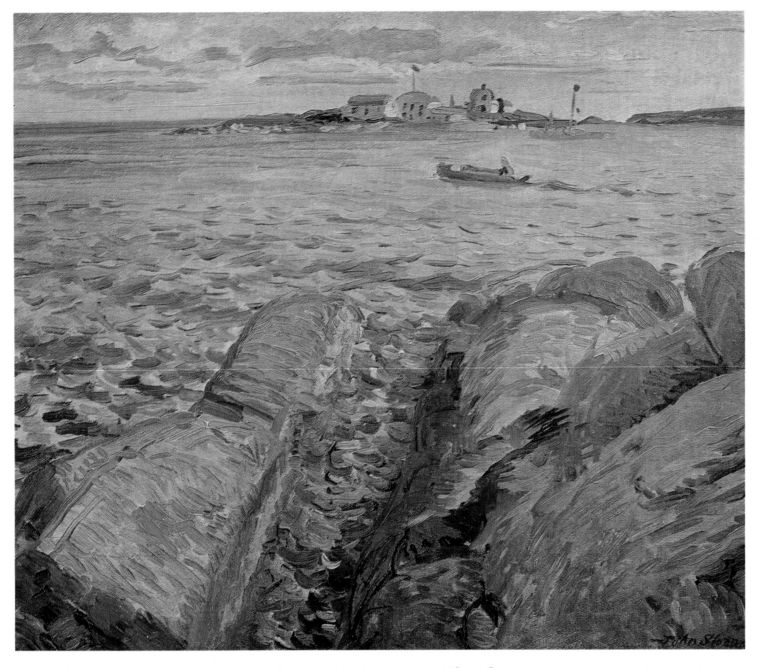

Plate 21. *Wonson's Rocks and Ten Pound Island*. 1915. Oil on canvas. 20″ x 24″. The Kraushaar Galleries, New York.

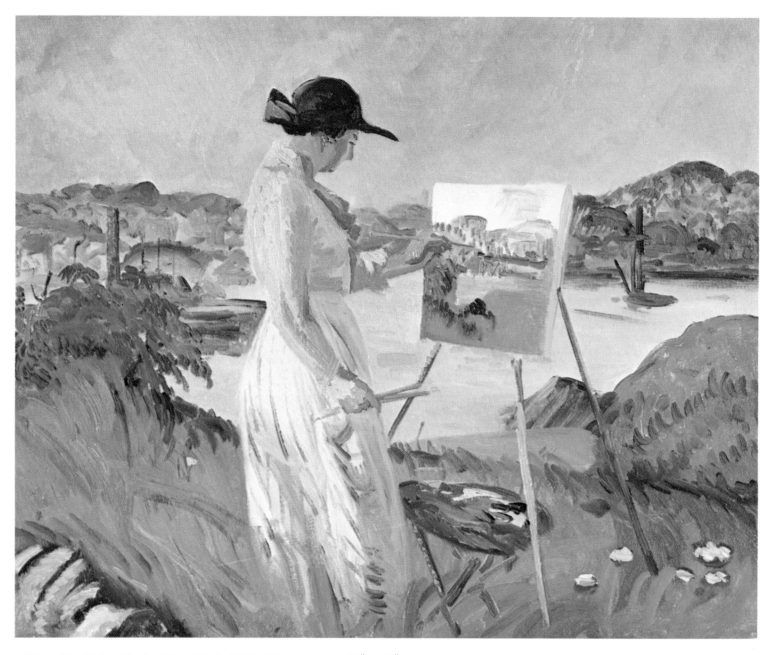

Plate 22. *Helen Taylor Sketching.* 1916. Oil on canvas, 26″ x 32″.
The Everson Museum of Art, Syracuse, New York.

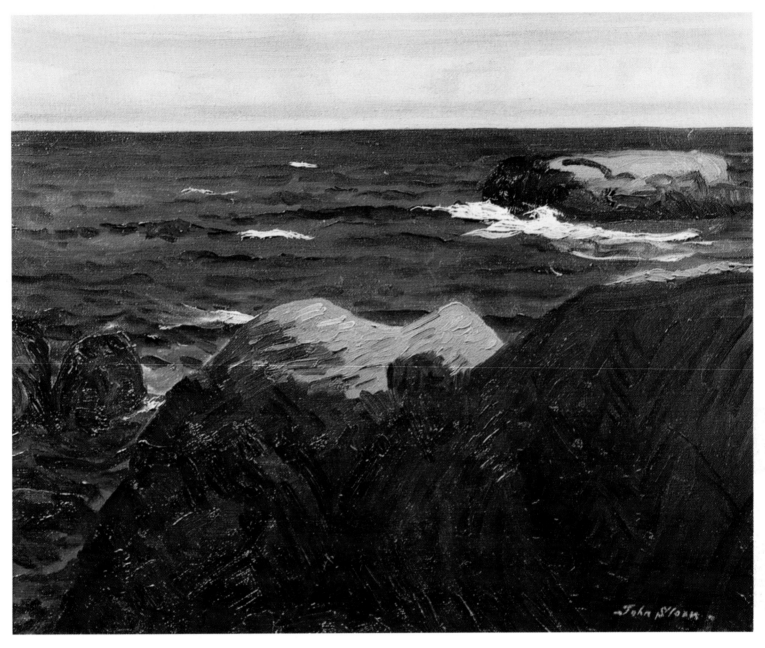

Plate 23. *Deep Blue Sea*. 1916. Oil on canvas, 20″ x 24″. The Bowdoin
College Museum of Art, Brunswick, Maine. Hamlin Collection.

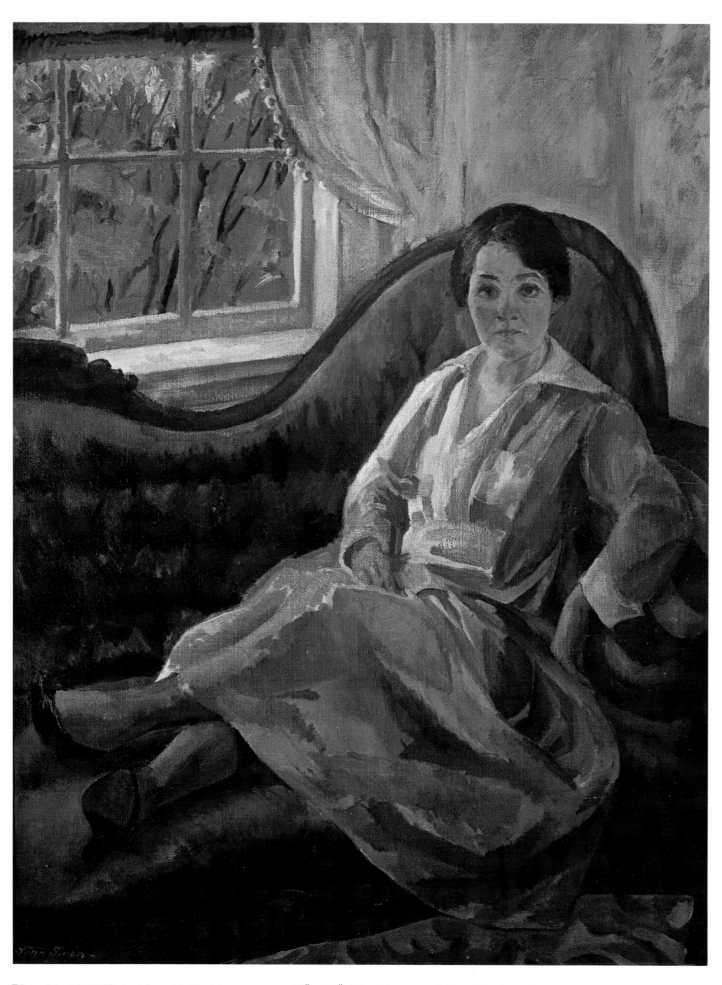

Plate 24. *My Wife in Blue*. 1917. Oil on canvas, 45″ x 36″. The Museum of New Mexico, Santa Fe.

Plate 25. *Street, Lilacs, Noon Sun.* 1918. Oil on canvas, 20″ x 24″. The Kraushaar Galleries, New York.

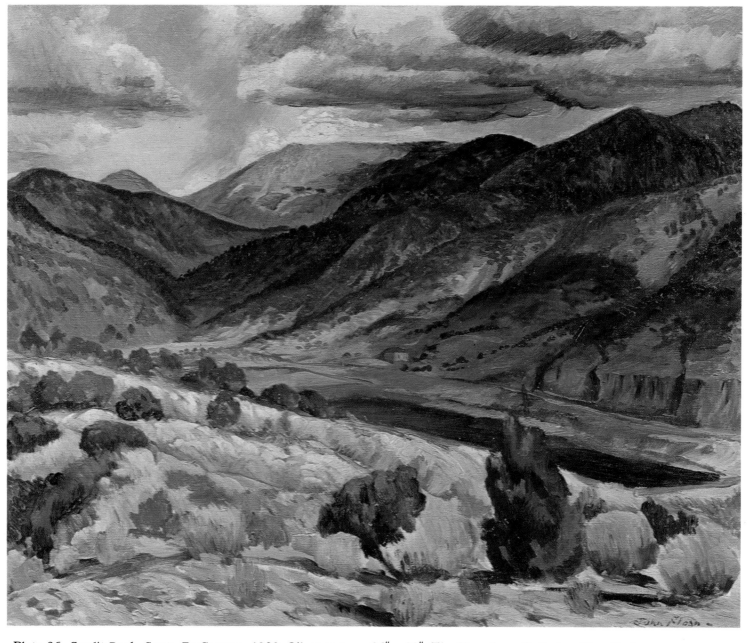

Plate 26. *Sunlit Peak, Santa Fe Canyon.* 1920. Oil on canvas, 26″ x 32″. The Kraushaar Galleries, New York.

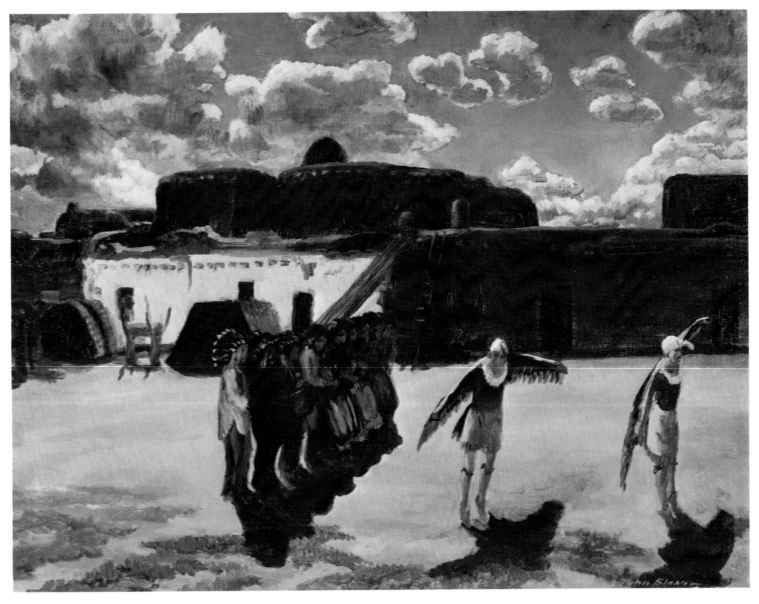

Plate 27. *Eagles of Tesuque*. 1921. Oil on canvas, 26″ x 34″. The Colorado Springs
Fine Arts Center. Carlton and Debutante Ball Funds.

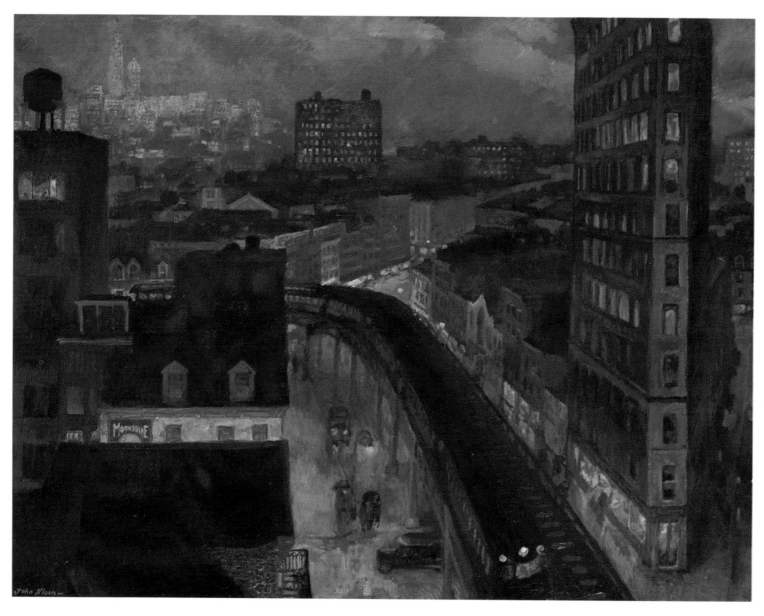

Plate 28. *The City from Greenwich Village.* 1922. Oil on canvas, 26″ x 34″.
The National Gallery of Art, Washington, D. C. Gift of Helen Farr Sloan.

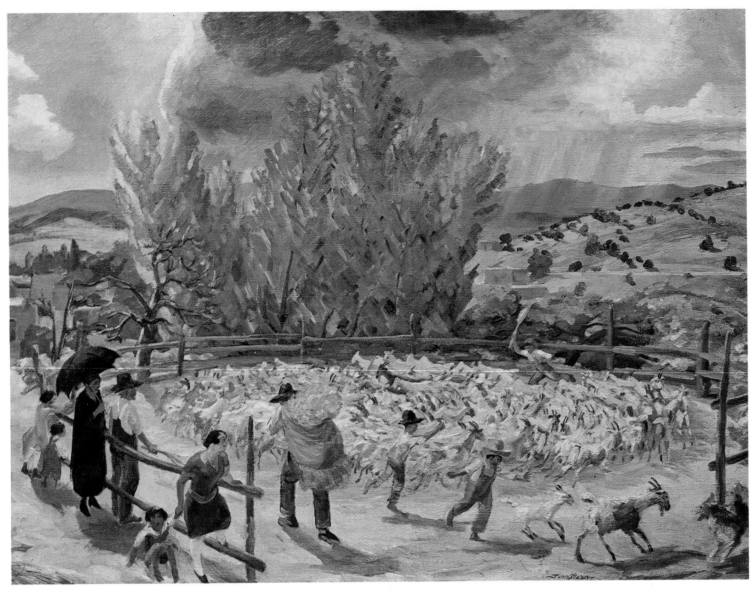

Plate 29. *Threshing Floor, Goats.* 1924. Oil on canvas, 30″ x 40″.
The John Sloan Trust, Wilmington, Delaware.

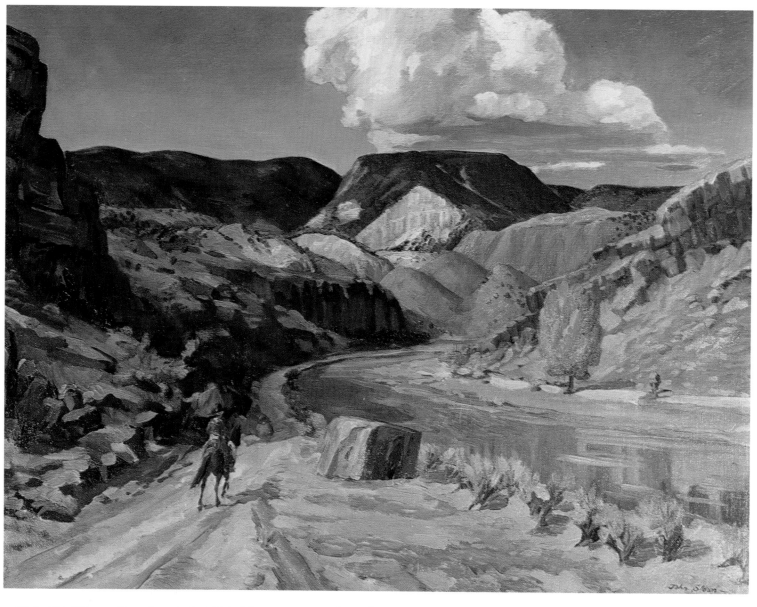

Plate 30. *Chama Running Red*. 1925. Oil on canvas, 30″ x 40″. Collection of Miss Ruth Martin, New York

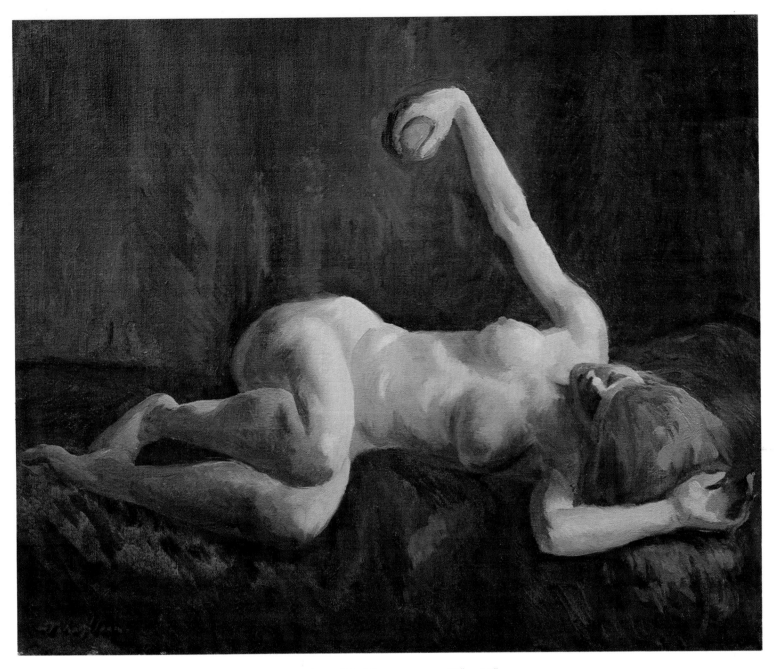

Plate 31. *Blond Nude with Orange, Blue Couch.* 1925. Oil on canvas, 20″ x 24″.
The John Sloan Trust, Wilmington, Delaware.

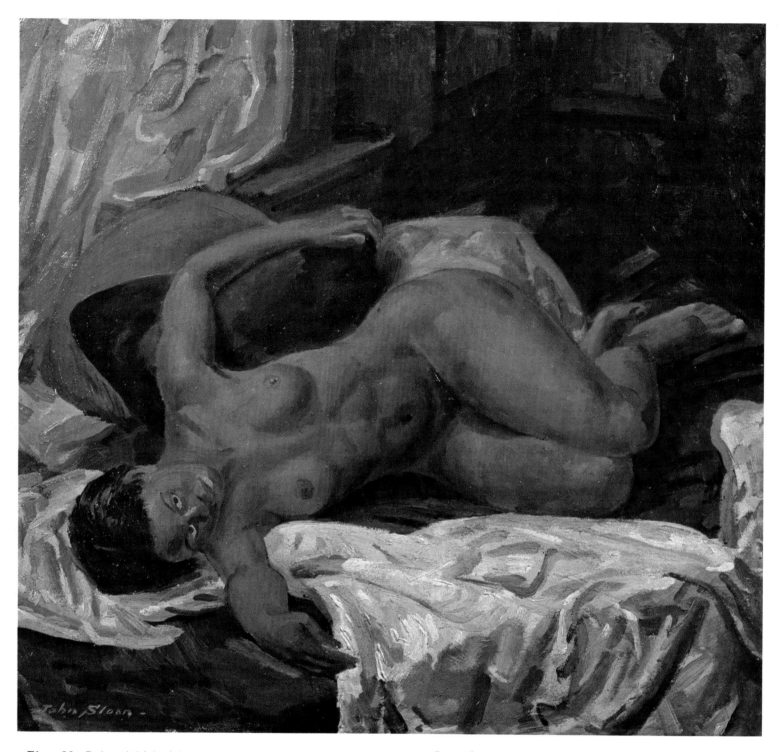

Plate 32. *Colored Girl with Gold and Silver.* Ca. 1927. Oil on panel, 23″ x 25″.
The John Sloan Trust, Wilmington, Delaware.

144

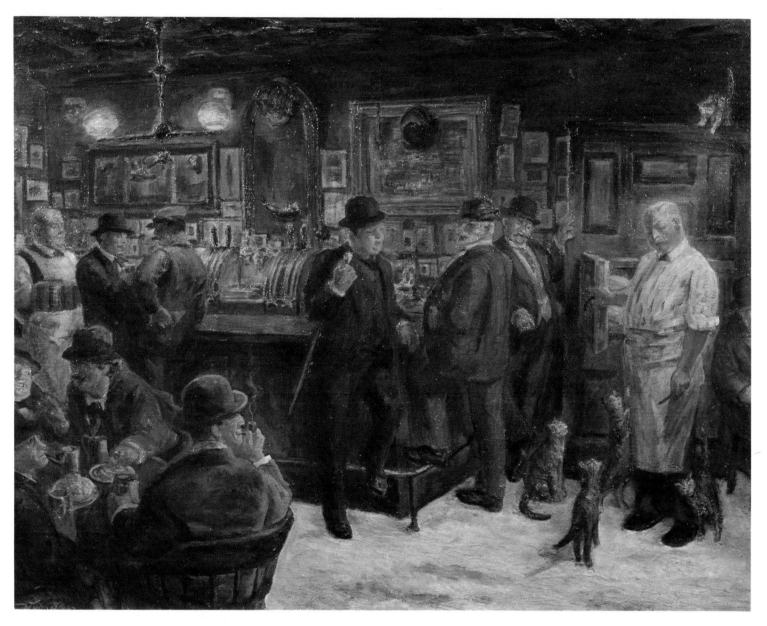

Plate 33. *McSorley's Cats.* 1928 – 29. Tempera with overglaze
on canvas, 35″ x 45″. The John Sloan Trust, Wilmington, Delaware.

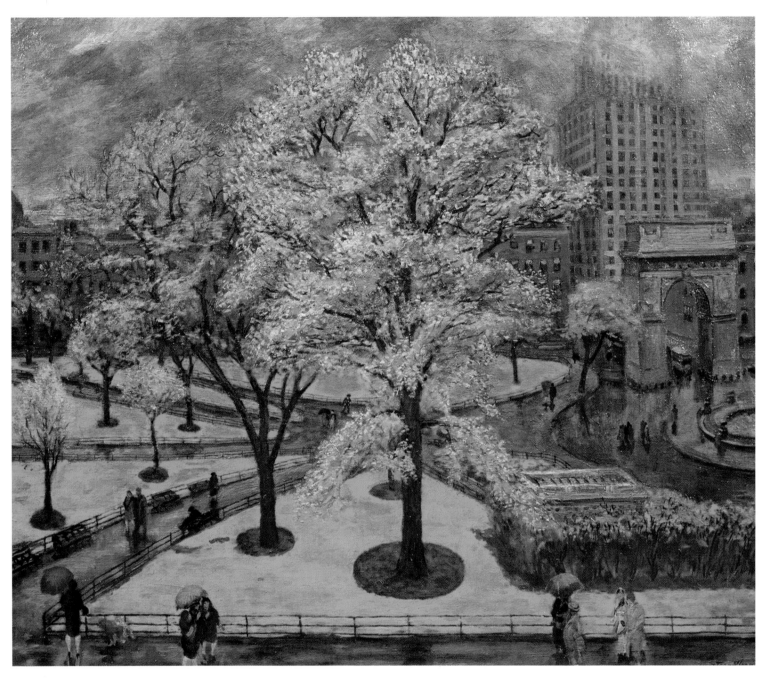

Plate 34. *Spring, Washington Square*. 1928 and 1950. Oil with overglaze on canvas, 26″ x 32″. Private Collection.

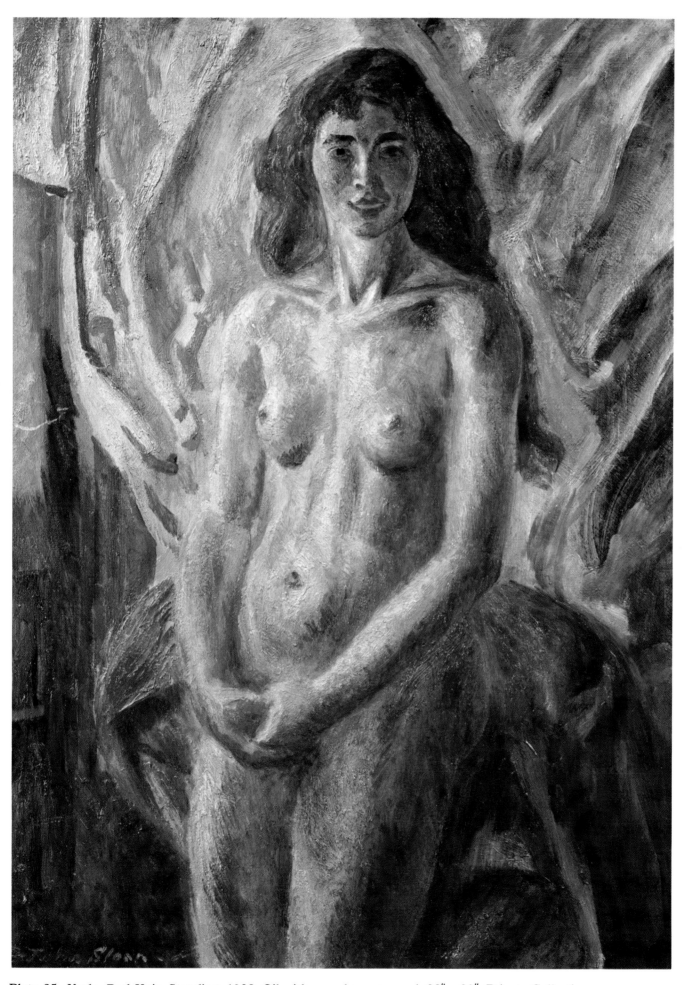

Plate 35. *Nude, Red Hair, Standing*. 1928. Oil with overglaze on panel, 28″ x 20″. Private Collection.

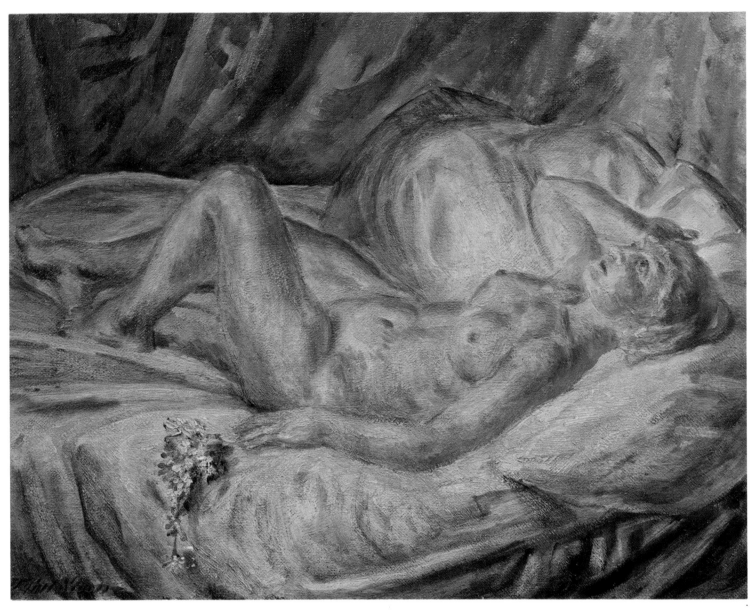

Plate 36. *Blond Nude and Flowers*. 1929. Oil with overglaze
on panel, 18″ x 24″. The Kraushaar Galleries, New York.

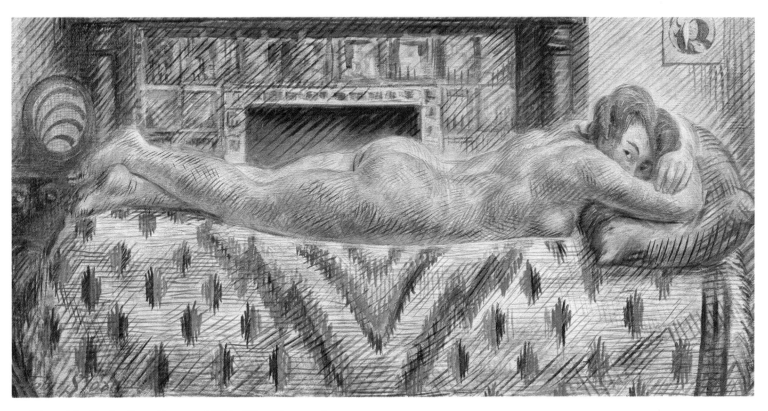

Plate 37. *Nude, Four Senses*. 1929. Oil with overglaze
on canvas, 24″ x 48″. The John Sloan Trust, Wilmington, Delaware.

Plate 38. *Juanita*. 1930. Tempera with overglaze on panel, 32″ x 26″. The Kraushaar Galleries, New York.

Plate 39. *Dolly Reading Newspaper.* 1931. Colored Crayon, 11″ x 8 1/2″. The John Sloan Trust, Wilmington, Delaware.

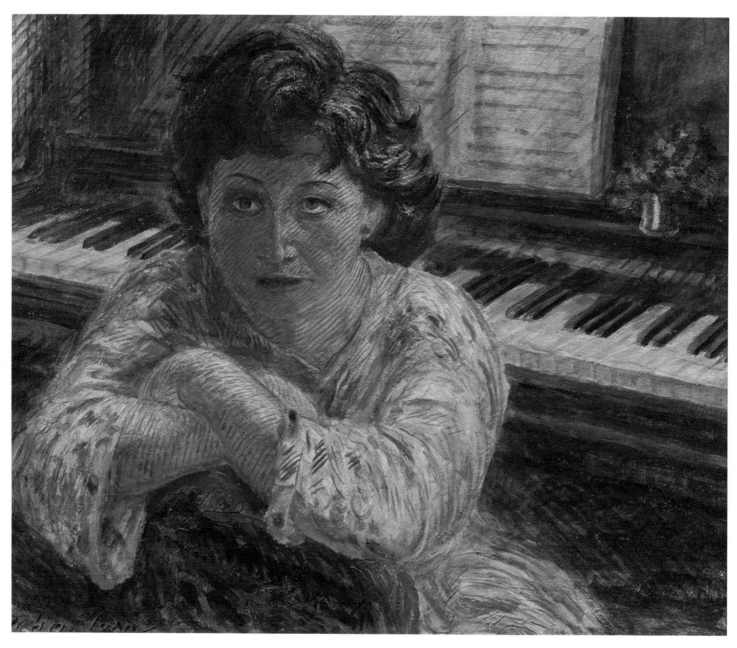

Plate 40. *Girl, Back to the Piano*. 1932. Tempera with overglaze
on panel, 20″ x 24″. The John Sloan Trust, Wilmington, Delaware.

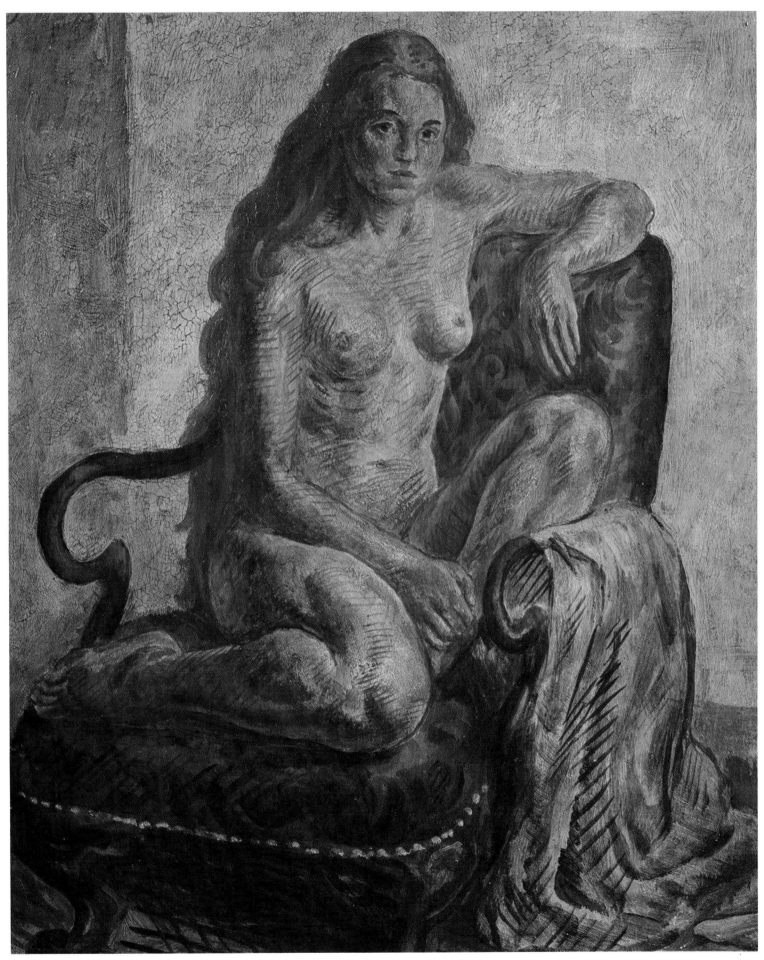

Plate 41. *Nude, Terra Cotta*. 1933. Tempera with overglaze on panel, 24″ x 20″.
Collection of John M. Stratton, Greenwich, Connecticut.

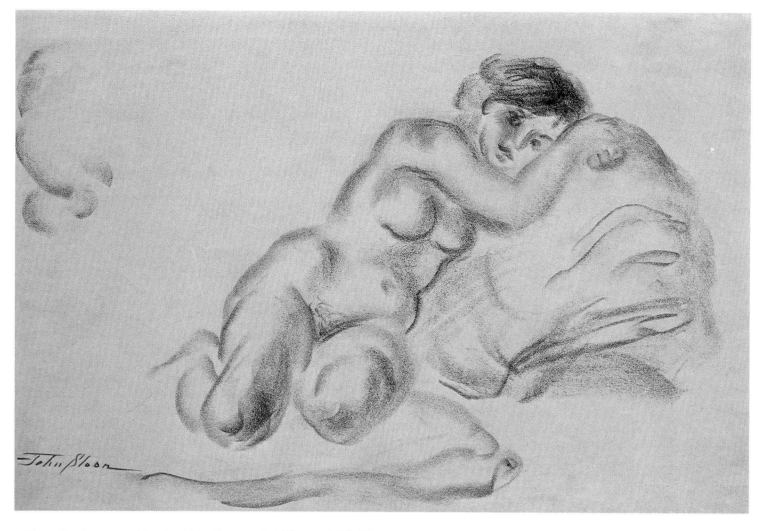

Plate 42. *Green and Red.* 1938. Crayon, 9 1/2″ x 13 7/8″. The John Sloan Trust, Wilmington, Delaware.

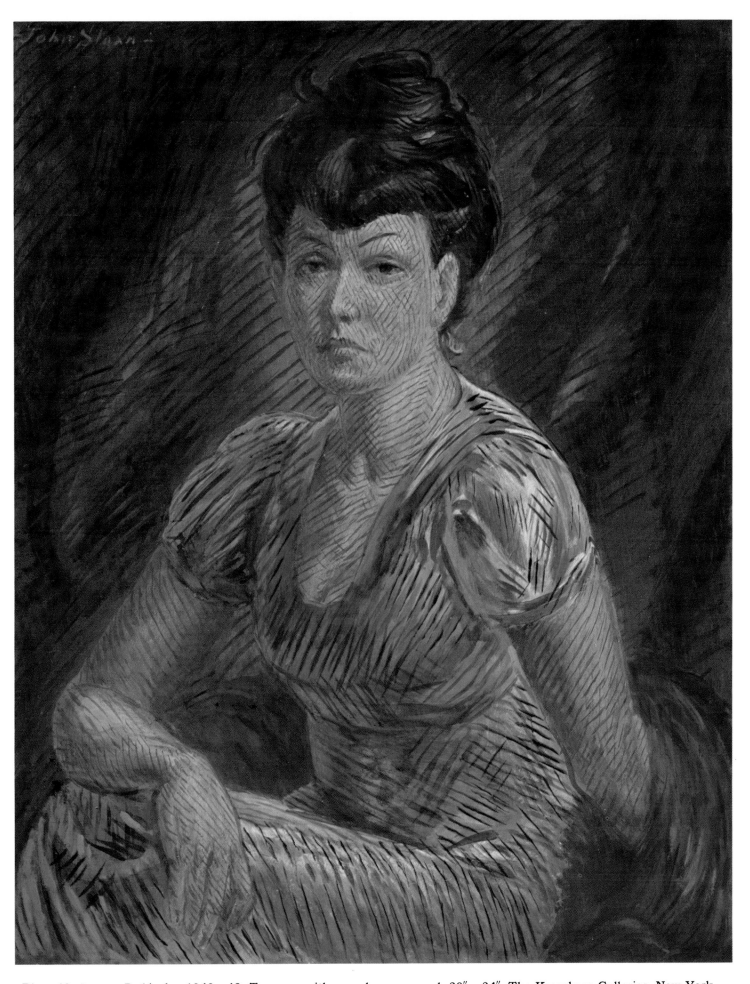

Plate 43. *Jeanne Dubinsky*. 1940 – 42. Tempera with overglaze on panel, 30″ x 24″. The Kraushaar Galleries, New York.

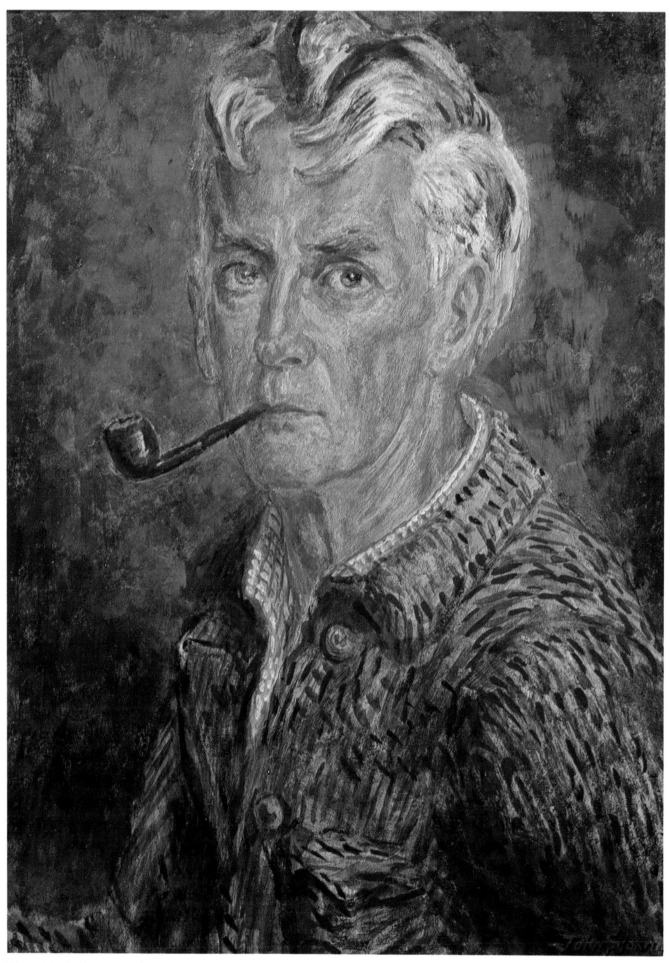

Plate 44. *Self-Portrait (Pipe and Brown Jacket)*, 1946–47. Tempera
with overglaze on panel, 16″ x 12″. Private Collection.

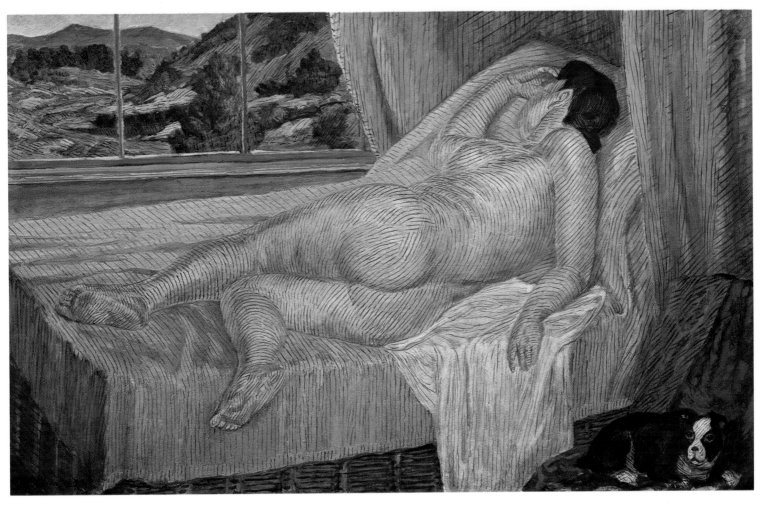

Plate 45. *Santa Fe Siesta*. 1948 – 49. Tempera with overglaze
on panel, 22″ x 35″. The John Sloan Trust, Wilmington, Delaware.

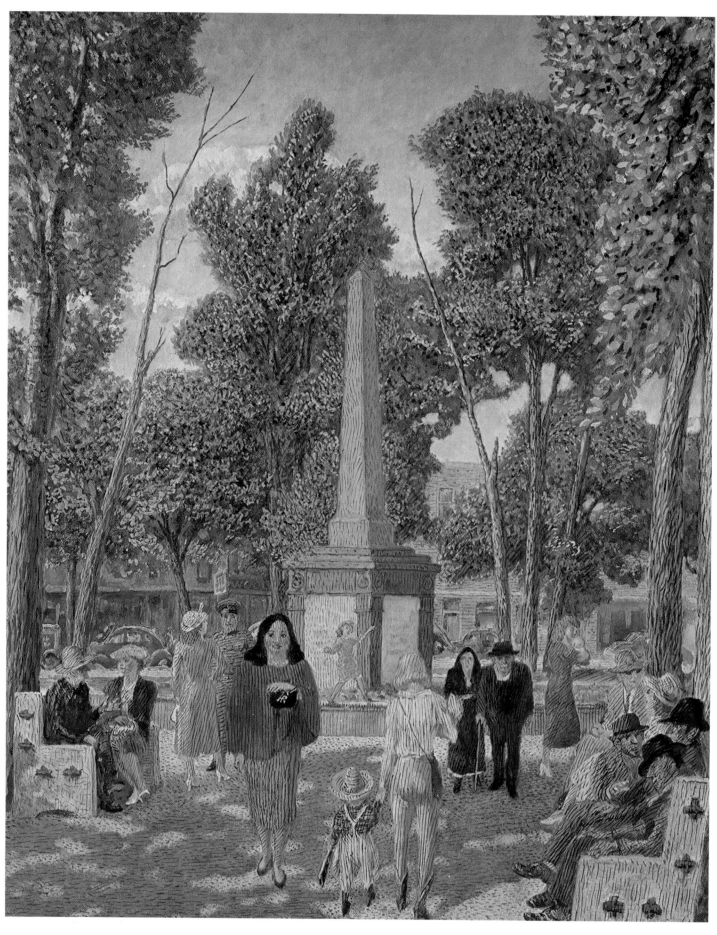

Plate 46. *Monument in the Plaza*. 1948–49. Tempera with overglaze
on panel, 32″ x 26″. The John Sloan Trust, Wilmington, Delaware.

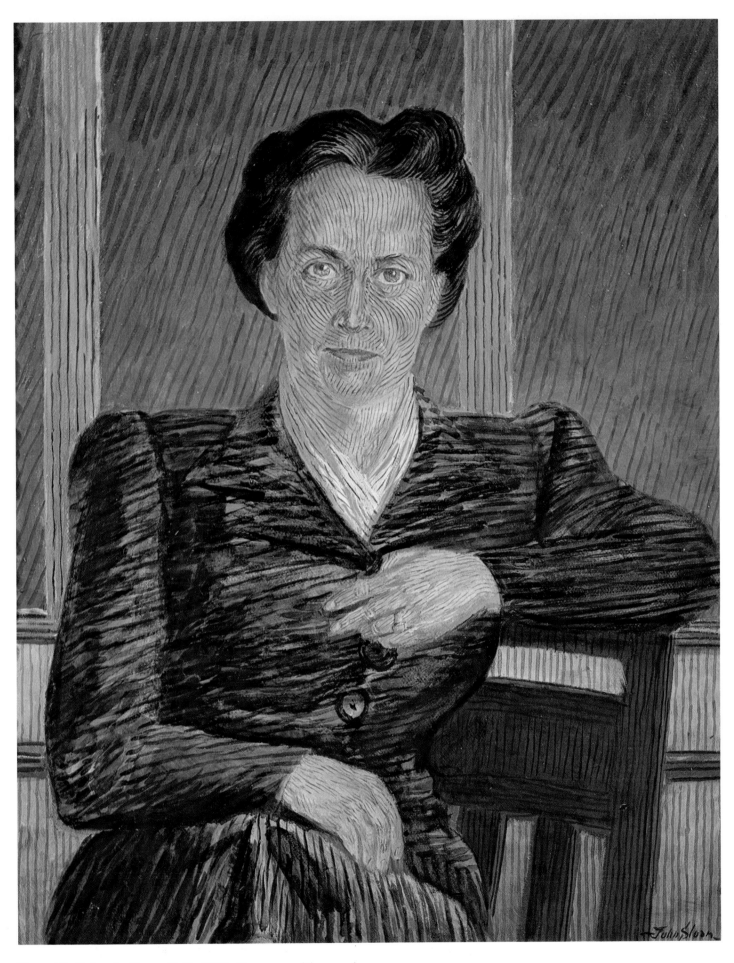

Plate 47. *Helen in Green Suit*. 1950. Tempera with overglaze
on panel, 30″ x 24″. The Kraushaar Galleries, New York.

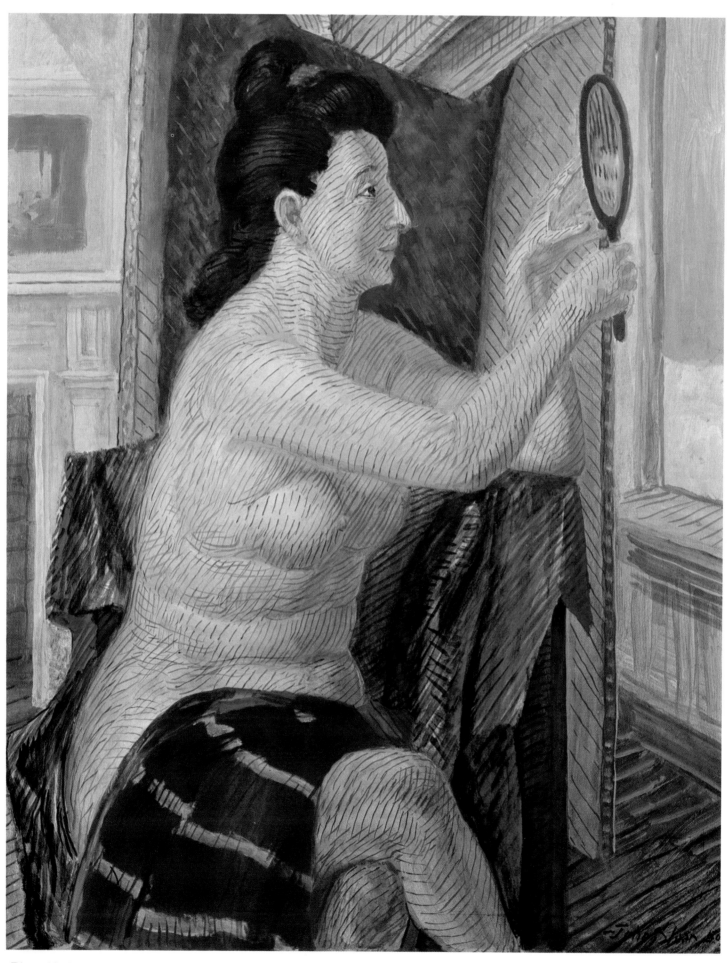

Plate 48. *Nude with Red Hand Mirror*. 1950. Tempera with overglaze
on panel, 30″ x 24″. The John Sloan Trust, Wilmington, Delaware.

NEW VISTAS
1918·1939

Trip to Santa Fe. Sketch in a letter to John F. Kraushaar, July 5, 1919. Pen and ink, 2″ x 3″.
The Kraushaar Galleries, New York.

NEW MEXICO

Robert Henri, fresh from visiting New Mexico in search of colorful types to paint, returned to New York in the fall of 1918 glowing with enthusiasm for the Southwest and found John Sloan complaining that Gloucester was so full of artists that there was one painting in every shadow of a cow. The next summer the Sloans and the Randall Daveys decided to head for Santa Fe in the Daveys's Simplex touring car. When they finally arrived, they fell in love with the town. Sloan soon wrote to Henri that he had thirteen canvases under way, working entirely from memories of the landscape and life of the area. He was especially pleased that his return to a memory approach seemed to be producing results: "Some of the things seem more like 'works' and less like 'studies'."[84]

The following summer the Sloans returned again—as they were to do every summer but one while Dolly lived, and as Sloan would do until 1951—arriving in June or July and remaining until September or October. They bought an adobe house with a large garden on Calle García and began to enter into local cultural affairs. Sloan helped prepare costumes and floats for the fiesta, one year creating a giant kiddie car for the parade as a spoof on the Harvey tour buses. Dolly, with her usual dedication to causes, raised money for dozens of prizes to encourage the fiesta revelry. Before long, Sloan was involved with the local art museum, supporting an open-door policy of Henri's that would allow all artists to exhibit. In short, Santa Fe became their second home.

Sloan was fascinated by the landscape and the people. He had never traveled abroad, as had Henri and his other artist friends, and he was especially intrigued to discover a new world and new cultures within the United States. He found the land itself a helpful subject in his advance toward "plastic realization": "I like to paint the landscape of the Southwest because of the fine geometric formations and handsome color. Study of the desert forms, so severe and clear in that atmosphere, helped me to work out principles of plastic design, the low relief concept. I like the colors out there. The ground is not covered with green mold as it is elsewhere. The piñon trees dot the surface of hills and mesas with exciting textures. . . . Because the air is so clear you feel the reality of things in the distance."[85]

The life of the Southwest affected him in the same way as New York City had when he moved there fifteen years earlier. The traditional ways of the Spanish-speaking population and of the Indians intrigued him, and he attempted to capture them in painting—to get at the basic expressions of cultural traditions so different from his own. He painted black-clad women with rebozos and religious processions by candlelight. He bought a Ford and visited old missions and cliff dwellings. He observed the dances of the Indians of San Ildefonso, Cochiti, Santo Domingo, and Tesuque, and he found "the Indian's deep harmony with nature" unforgettable.[86] He studied the ceremonials, bought Indian blankets, admired the pottery designs, and dressed in Navajo costume for the Independents' Ball in New York in 1922. He brought

Sketch for The City From Greenwich Village. c. 1920–22. Sanguine, 8″ x 10″. The National Gallery of Art, Washington, D. C.

Standing by Draped Stool. c. 1924. Charcoal, 20½″ x 15¼″. The John Sloan Trust, Wilmington, Delaware.

respect to all the native customs as well as an increasing appreciation of the value of tradition. When he painted, his satire was confined to depictions of the tourists and visiting artists who completely lacked the dignity of the Indians.

Sloan was impressed by the fact that the Indians conserved indigenous esthetic forms of great significance, and he made efforts to have their work exhibited, both to encourage the artists and to share the excitement of his discovery. In 1922 he sponsored a show of the work of young Indian painters at the Independents, and in 1931 he served as president of the Exposition of Indian Tribal Arts at the Grand Central Galleries in New York City. The exposition was later converted into smaller exhibits that were shown across the United States and in Europe. Through such efforts the creations of the Indians of New Mexico were finally presented as living art, not merely as anthropological specimens.

The Exposition of Indian Tribal Arts was made possible by substantial support from Amelia Elizabeth White and by efforts of such men as Oliver La Farge, Witter Bynner, and Dr. Herbert J. Spinden. Miss White, who was a loyal patron of Sloan's, subsequently underwrote the Gallery of American Indian Art in New York, and Dolly's salary for managing the enterprise went far toward helping the Sloans weather the Depression years.

Snowstorm in the Village. 1925. Etching, 7″ x 5″ (plate). The John Sloan Estate. Photo courtesy of the Smithsonian Institution, Washington, D. C.

TECHNIQUE AND REALIZATION

We have seen that in 1917 Sloan experimented with "abstract" etching and that his paintings began to show an intensified formal preoccupation, with echoes of Cézanne. For several years his paintings reflected this conscious negation of perspective and a tying of forms to the picture plane by such devices as flattening the formal elements and their constituent planes, building up the background and raising the horizon line, and relating contours to one another to create continuous horizontal and vertical lines across the canvas. To a greater or lesser degree this approach was used in such paintings as *My Wife in Blue* (1917), *The Red Lane* (1918), *Range and the Burro* (1919), painted during his first summer in Santa Fe, and *The City from Greenwich Village* (1922). This last painting, which evolved from several sketches that still exist, reveals Sloan's increasing concern for the realization of mental concepts more significant than mere visual reality.

While Sloan experimented with techniques for achieving formal order, he worked with Henri, George Bellows, and Randall Davey on color systems.[87] In 1915, Hardesty Maratta and Charles Winter helped the artists devise a rectangular chart, and Winter introduced them to the Dudeen color triangle, which served Sloan as a basis for color ordering. Imposing an order independent of the accidents of nature or random mixing served to free Sloan, not restrict him: "The palette is an instrument, like a piano or violin. To stumble around in full colors and raw white is as stupid as it would be if a musician were to play the piano wearing boxing gloves."[88]

For several years Sloan used "an arsenal of forty-eight tones,

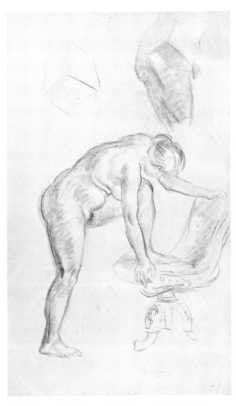

Posing with Harp Chair. c. 1925. Charcoal, 16½″ x 9½″. The John Sloan Trust, Wilmington, Delaware.

Reading in the Subway. 1926. Etching, 5" x 4" (plate). The John Sloan Estate. Photo courtesy of the Smithsonian Institution, Washington, D. C.

Twenty-Fifth Anniversary. 1926. Etching, 4" x 5" (plate). The John Sloan Estate. Photo courtesy of the Smithsonian Institution, Washington, D. C.

each in three shades, and all in separate stock jars," selecting a preplanned, limited palette for each painting.[89] With his change in technique at the end of the twenties, he felt he no longer needed to set a limited palette, though he continued to think in terms of preconceived color harmonies.

With this approach to color, Sloan firmly believed he was strengthening his art by realigning himself with the great tradition of Western painting, a tradition he felt had been lost by academicians and "eye" realists, but which the "ultra-moderns" had helped uncover by exploring the basic techniques of art. Titian, Rubens, Rembrandt, and—chief among the moderns—Delacroix and Renoir, employed "systems" to achieve the plastic power of color. "Delacroix was a great innovator. . . . He used color systems but was never dominated by any one formula. Each picture was painted with a specially designed palette set with key notes, colors of specific composition as to intensity and height. He could then draw with paint, vividly and subtly."[90]

In choosing the nude as a subject for special study, Sloan again felt he was following in the tradition of the masters. During the mid-twenties, his continuing preoccupation with formal problems can best be traced through his drawings and paintings of the human figure—a subject which did not yet predominate in his work, but which he treated with a tough intensity sometimes missing in his more genial and discursive genre scenes and landscapes. Thus, the brusque, sculptural quality of *Nude Resting, Striped Blanket* (1923) was continued and refined in *Nude Glancing Back* (1926) and *Large White Nude* (1927–28). He consciously resisted the distortions of perspective and began to approach painting from the model as though he were "painting from memory, using the model as the inspiration for an exciting plastic design."[91] Surface modeling was as richly developed as it was consistent with the formal organization of the figure and the total painting.

He retained—and would always retain—a strong characterization of the particular human being who served as his model, and this resulted in a tension between the individuality of the subject and the universality of the formal concept. He would have pointed out that this was one of the elements that gave power to the paintings of his most revered master, Rembrandt. This unexpected combination of direct realism and pure painting was also characteristic of Courbet, whom Sloan sometimes cited in class discussions, and of Manet, who served as a point of departure for *Nude with Booklet* (1928), in which Sloan paid him unconscious tribute while, at the same time, reacting against the influence the French master exerted on his early work.

It was largely through his figure studies that Sloan worked his way toward his painting style of the thirties. It was a significant insight when he realized that his vigorous charcoal drawings—characteristic of the years from about 1924 on—obtained a realization of form through a grainy texture and graphic incisiveness that was missing in his paintings. In 1927 he decided to experiment with the separation of the underlying form statement from the color-texture "skin." He became aware that both Delacroix

and Renoir had turned to underpainting and glazes in their later work, and he began to search for a similar technique to convey his desired effect.

By the end of 1927 and early in 1928, he was using white lead to create a heavy initial impasto in some of his figure paintings, superimposing lively red and green glazes and creating richly colored, broadly treated, ample forms quite reminiscent of Renoir. The white lead was slow to dry, and by summer he was trying flaxseed emulsion as suggested by Paul Dougherty, but again he had difficulty with the medium, since the emulsion thickened if it grew cool. In 1930 he tried an egg tempera from a Ralph Mayer recipe, but he had trouble with cracking, a problem that persisted through various experiments for several years. Finally, in 1935, he adopted a formula using casein and titanium white that he found entirely satisfactory.

Nothing has caused more difficulty in the acceptance of Sloan's later work than his linear overlay, although it is but one aspect of his decision to pursue formal realization rather than beguiling subject matter. It was a choice that inevitably led to his losing much of his following. The critics joined the public in objecting to his cross-hatching, feeling that whatever might be said for the strength of formal realization in Sloan's art, his figures basically represented a transcription of the visual world as we know it, whereas the surface markings belonged to another plane of abstraction. To Sloan, whose years of drawing and etching made the graphic linework second nature, it not only heightened the forms as visual and tactile symbols, but it also transformed the entire work into an experience on another level. He was doubtless gratified that the hatch marks crossed out, as it were, the possibility of taking his paintings as an imitation of appearances.

Since the linear surface marking Sloan used has been such a stumbling block to the appreciation of his later work, he should be allowed to say a few words in its defense:

> I like to use linework to give added significance to the surfaces in the light and to increase the sensation of light and shade. It is possible with sets of lines to force the color power of the painting without cutting down lightness as much as has to be done if the color changes are all indicated with tones. For instance, neutral red lines can be drawn in the shadow of a green form to say something about the surface and the shape without using a dark solid tone, without losing the green color skin. . . .
>
> Rembrandt's rough underpaintings, in which the graphic brushwork describes the textural existence of the form in the light, serves to make significant texture in a similar way.[92]

Elsewhere he explains that the "undersubstance is given realization by superimposed color-textures, force colors," and comments, "texture is what vitalizes form."[93]

Beginning in 1929, Sloan plunged wholeheartedly into the exploration and restatement of the timeless problem of depicting the human figure, enjoying one of the most vigorously creative periods of his career. His approach was based on a few underlying principles whose implications he wished to develop fully:

> The importance of the mental technique of seeing things; an emphasis on plastic consciousness; the fact that all things in nature are composed of

Fourteenth Street, The Wigwam (Tammany Hall). 1928. Etching, 9¾" x 7" (plate).

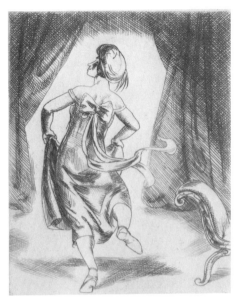

"Antique à la Française." 1929. Etching and engraving, 5″ x 4″ (plate). The John Sloan Estate. Photo courtesy of the Smithsonian Institution, Washington, D. C.

variations of the five simple solids; . . . the significance of devices in drawing, by which we represent three-dimensional forms on a two-dimensional surface; the low relief concept of composition; the importance of foreshortening rather than visual perspective in signifying spatial projection and recession; the use of color as a graphic tool; emphasis on realization rather than realism as the essential quality of reality in art.[94]

One challenge, in particular, Sloan took on repeatedly: posing the figure in a starkly frontal or prone pose, with a loglike coherence of mass that threw on the artist the full burden of creating interest through sculptural quality. *Nude on Navajo Blanket, Nude, Four Senses* (Plate 37), *Miscationary,* and *Nude at Foot of Stairs,* all painted between 1929 and 1933, show the most uncompromising poses, but several related canvases—*Arachne, Nude, Terra Cotta* (Plate 41), and *Blond on Crimson Chaise*—reflect a similarly intense concentration on sculptural effects, reminding us of his definition of a good painting as "a colored relief without air pockets."[95]

During the first part of 1931 Sloan produced an extraordinary series of fifteen etchings of nudes, and he did a like number in 1933. These, taken together with the great portrait of Robert Henri of the same period, represent some of his most monumental

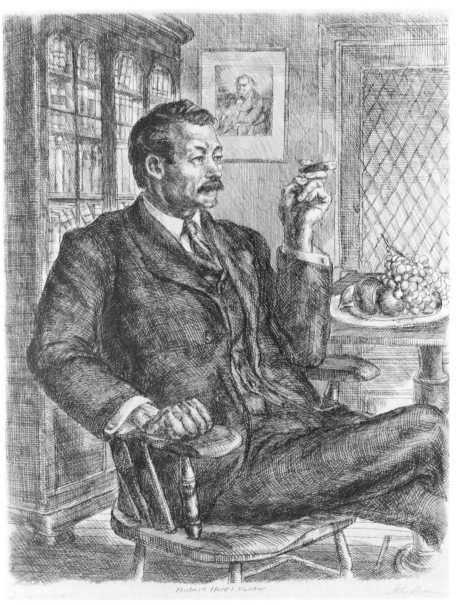

Robert Henri, Painter. 1931. Etching, 14″ x 11″ (plate). The Smithsonian Institution, Washington, D. C.

work in etching. As in the paintings, several of the poses are utterly stark, with a sculptural quality tempered to a hardness like metal—a comparison Sloan relished. In these relief-like works, whether paintings or etchings, there was quite naturally a tendency to depersonalize the model and eliminate the enveloping atmosphere.

At the other extreme, during the early and mid-thirties, Sloan created some of the warmest, most atmospheric paintings and prints of his career. (It was characteristic of him to explore a wide range of approaches at one time: he left it to the Academicians "to spend their little lives making the same picture over and over again."[96]) This was, in fact, a period of incisive portraits, delightful views of McSorley's Ale House (Plate 33) and Washington Square, and intimate figure studies whose glowing tonalities and textural weave prompted him to confess that "a strong relationship" to "the painting of Renoir [was to him] quite noticeable."[97]

In 1937, Sloan's health was not good and he appeared frail, as I observed when I entered his class at the League in the fall. In 1938 he left the League and underwent a gall-bladder operation, but it was not successful, and he suffered a prolonged period of ill health.

In 1939, his health partially and temporarily recovered, he painted a sixteen-foot-long mural (commissioned by the United States Treasury Department) for the post office in Bronxville, New York. That same year saw the publication of *Gist of Art,* the invaluable record of his mature thought and technique that was largely derived from the class notes of a student, Helen Farr. This summary appeared, fortuitously, at the end of an epoch in his work, for during the ensuing five years he painted relatively little. When he became once again fully active, his art had undergone a subtle but significant change.

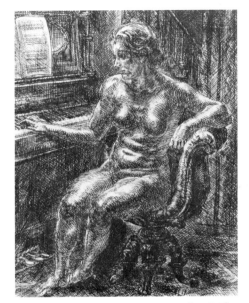

Nude at Piano. 1933. Etching, 7″ x 5½″ (plate). The John Sloan Estate. Photo courtesy of the Smithsonian Institution, Washington, D. C.

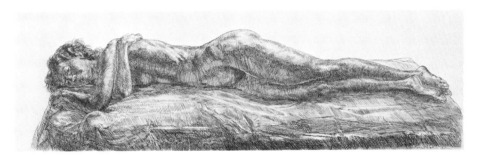

Long Prone Nude. 1931. Etching and engraving, 4¼″ x 13¾″ (plate). The John Sloan Estate. Photo courtesy of the Smithsonian Institution, Washington D. C.

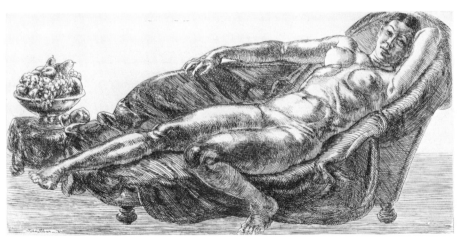

Nude with Bowl of Fruit. 1931. Etching and engraving, 5¼″ x 10¾″ (plate). The John Sloan Estate. Photo courtesy of the Smithsonian Institution, Washington, D. C.

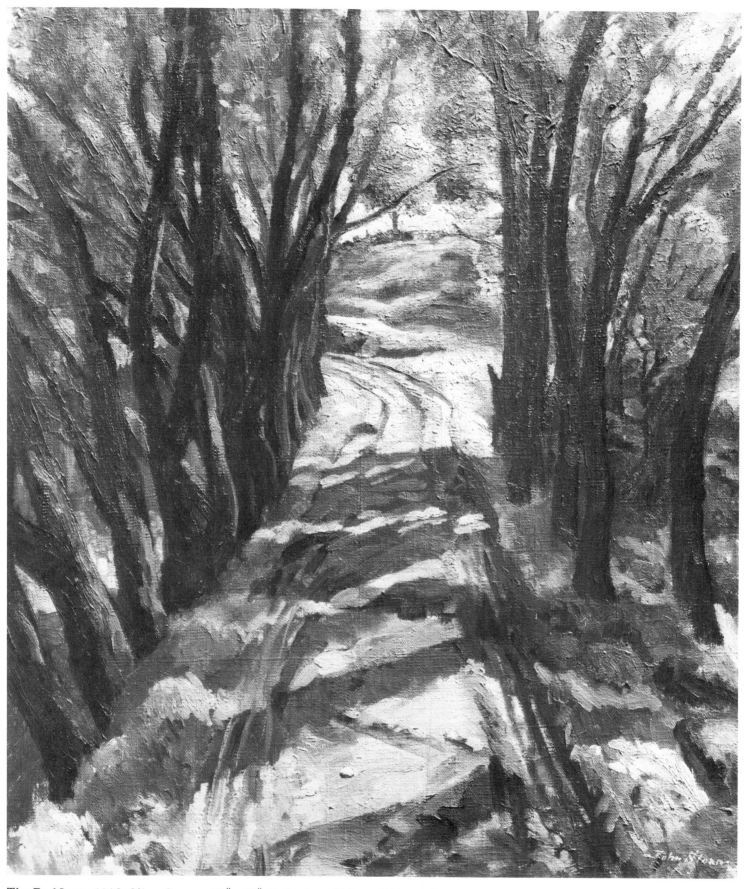

The Red Lane. 1918. Oil on Canvas, 32″ x 26″. Collection of Mr. and Mrs. Julian P. Brodie, New York.

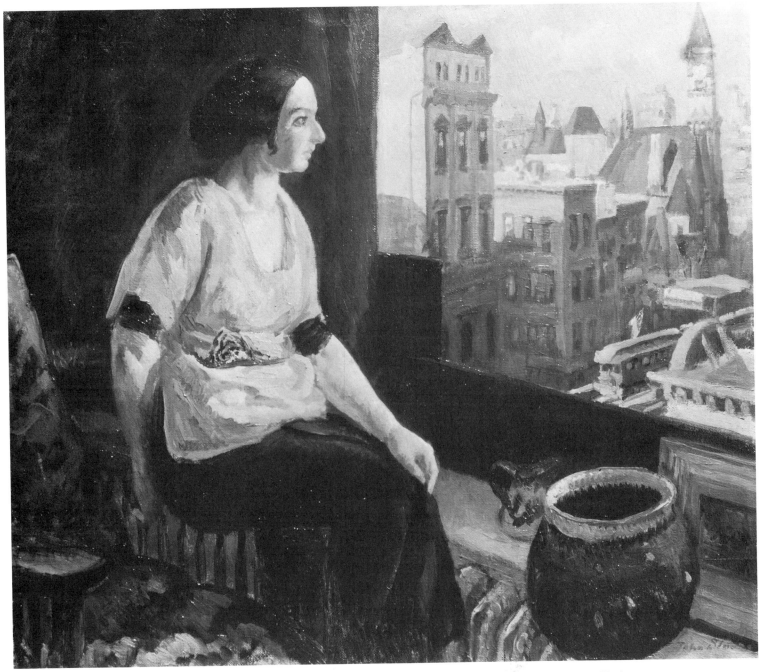

Stein at Studio Window, Sixth Avenue. 1918. Oil on canvas, 23″ x 27″. The Kraushaar Galleries, New York.

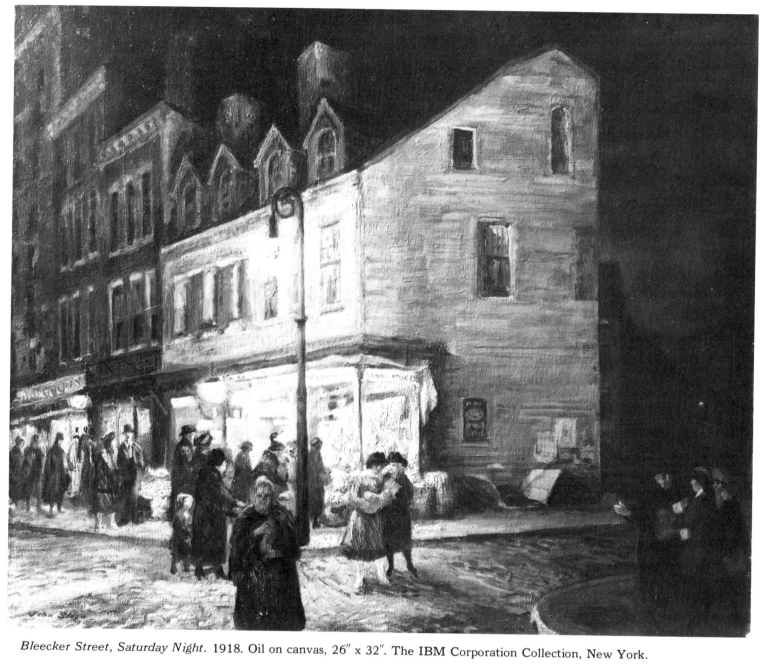

Bleecker Street, Saturday Night. 1918. Oil on canvas, 26″ x 32″. The IBM Corporation Collection, New York.

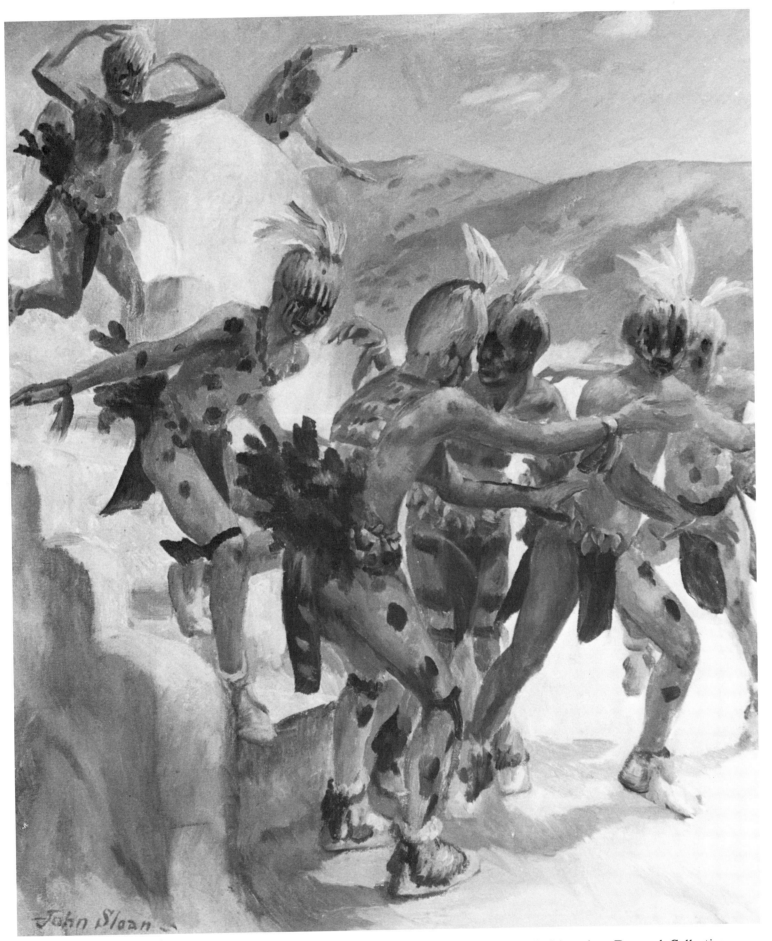

Koshare. 1919. Oil on canvas, 24″ x 20″. The Museum of New Mexico, Santa Fe. School of American Research Collection.

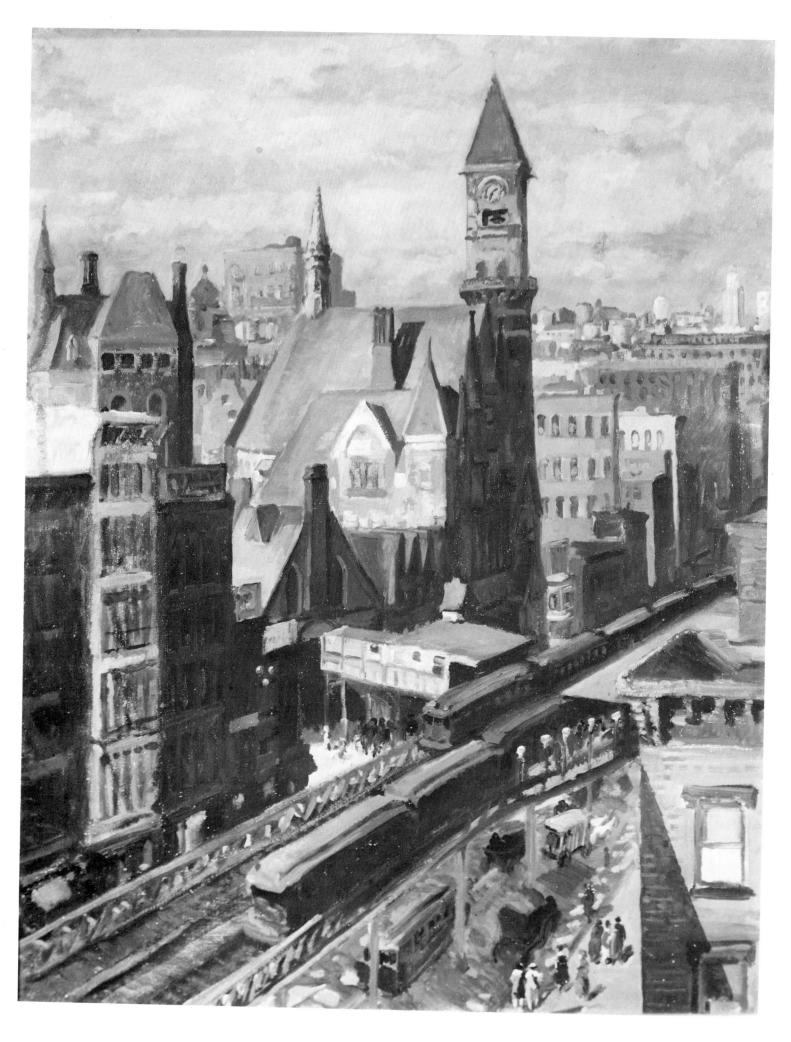

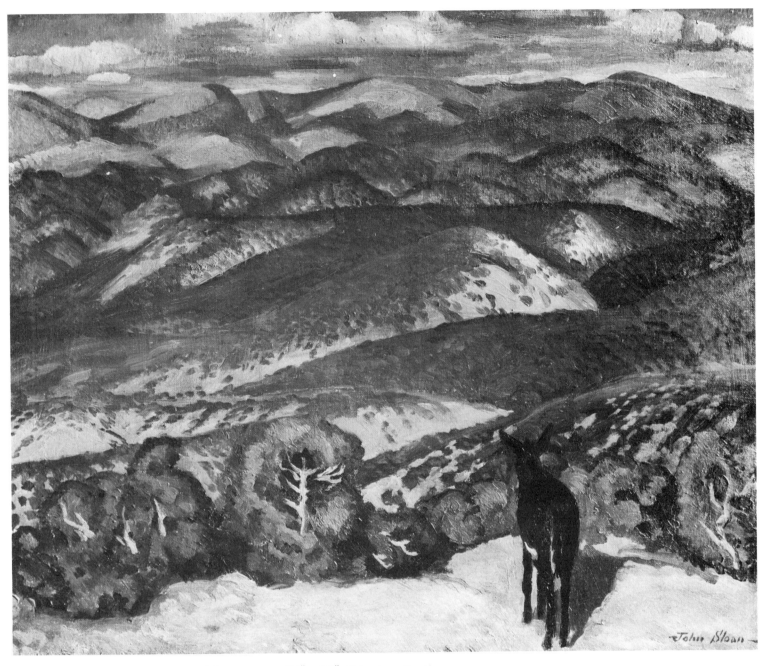

Range and the Burro. 1919. Oil on canvas, 20″ x 24″. Private collection.

Jefferson Market, Sixth Avenue. 1917 and 1922.
Oil on canvas, 32″ x 26″. The Pennsylvania Academy
of the Fine Arts, Philadelphia.

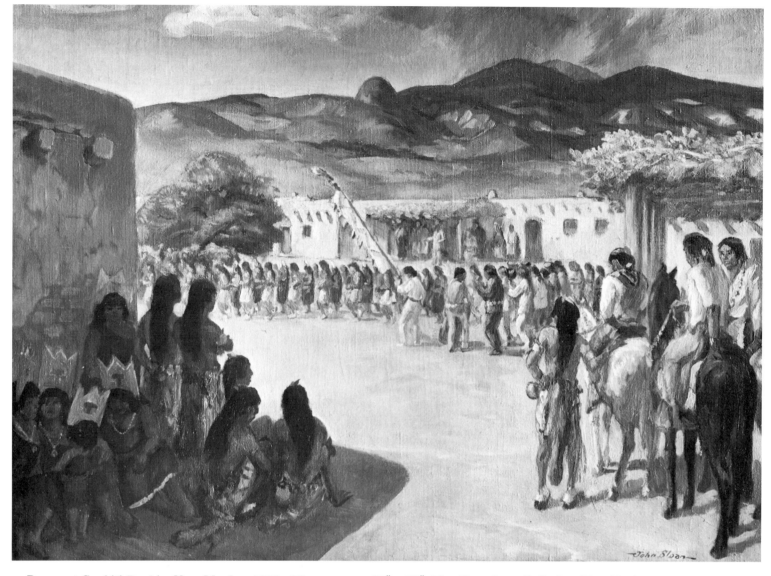

Dance at Cochiti Pueblo, New Mexico. 1922. Oil on canvas, 22″ x 30″. The Kraushaar Galleries, New York.

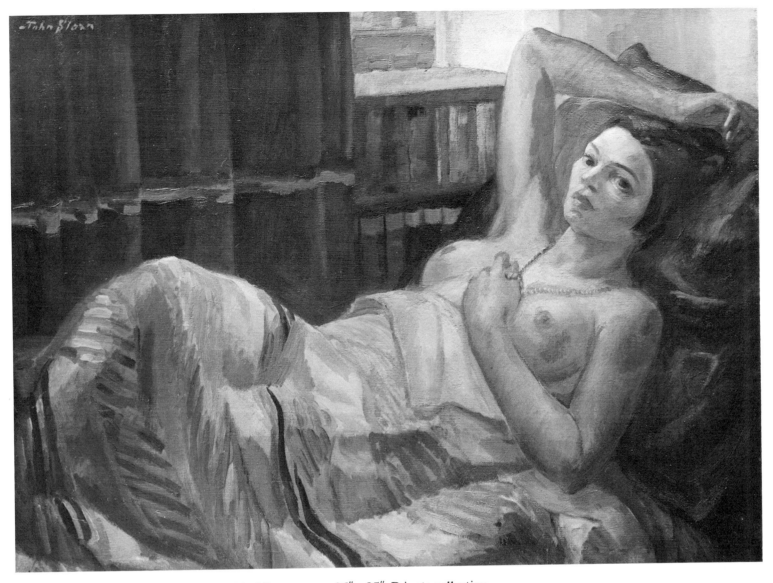

Nude Resting, Striped Blanket. 1923. Oil on canvas, 26″ x 35″. Private collection.

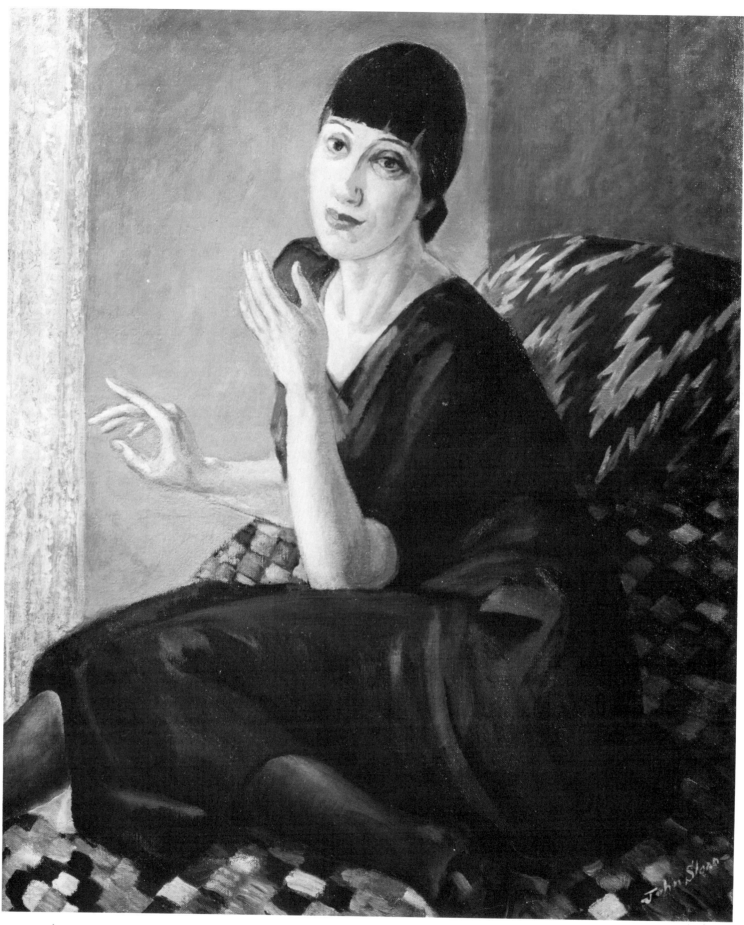

Angna Enters. c. 1926 and 1945. Oil on canvas, 32″ x 26″. The John Sloan Trust, Wilmington, Delaware.

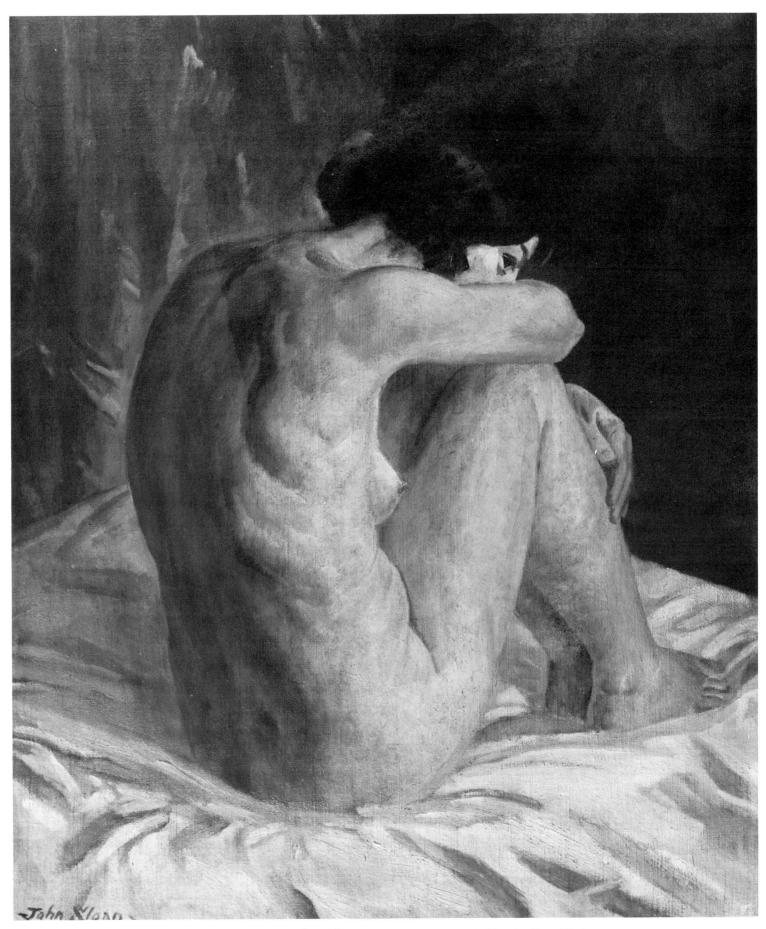

Nude Glancing Back. 1926. Oil on canvas, 32″ x 26″. Collection of Miss Ruth Martin, New York.

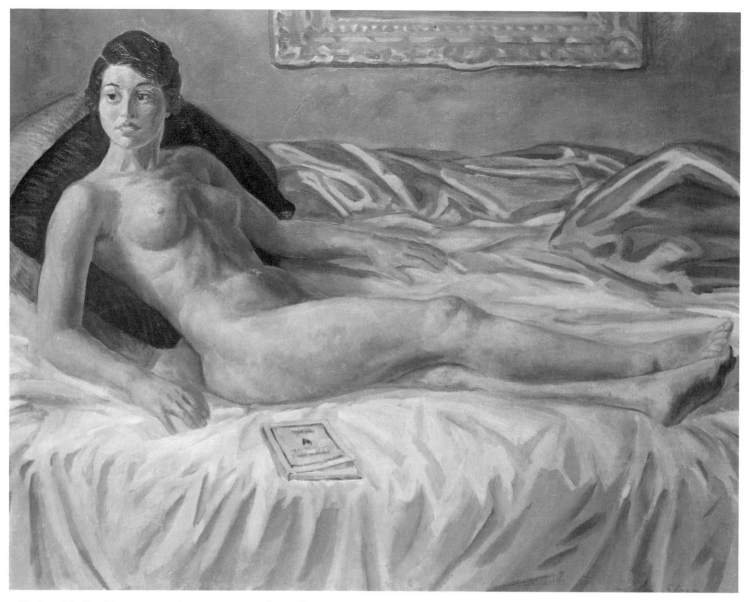

Nude with Booklet. 1928. Oil on canvas, 30″ x 40″. The John Sloan Trust, Wilmington, Delaware.

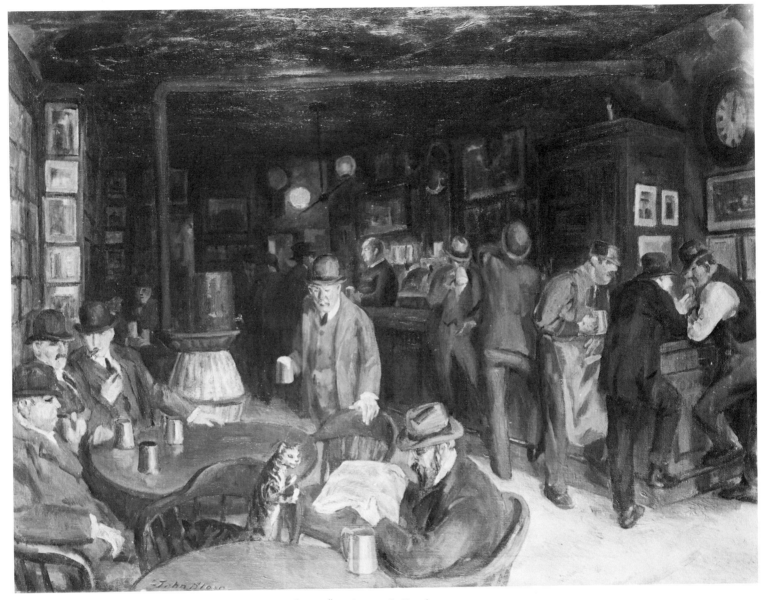

McSorley's at Home. 1928. Oil on canvas, 30″ x 40″. Private Collection.

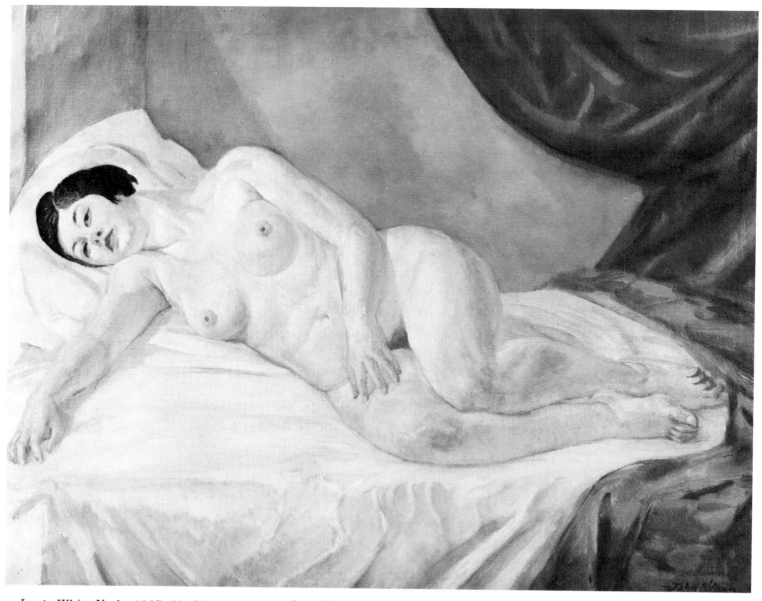

Large White Nude. 1927–28. Oil on canvas, 30″ x 40″. The John Sloan Trust, Wilmington, Delaware.

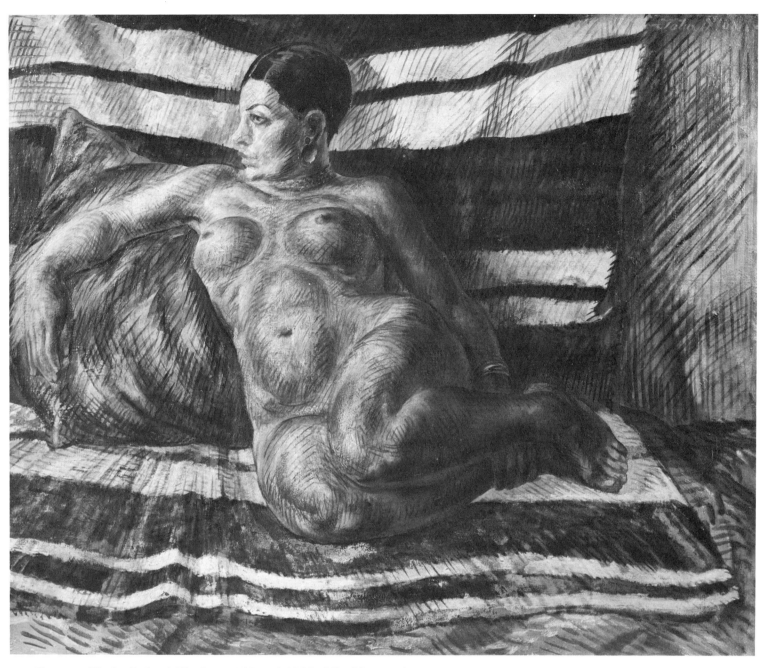

Brunette Nude, Striped Blanket. 1928 and 1930. Oil with overglaze
on canvas, 26″ x 32″. Collection of Miss Ruth Martin, New York.

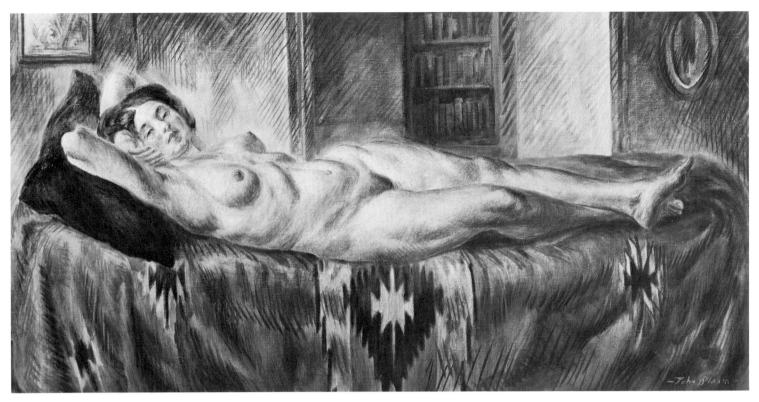

Nude on Navajo Blanket. 1929. Oil with overglaze on canvas, 24″ x 48″.
Oil with overglaze on canvas, 24″ x 48″. The Kraushaar Galleries, New York.

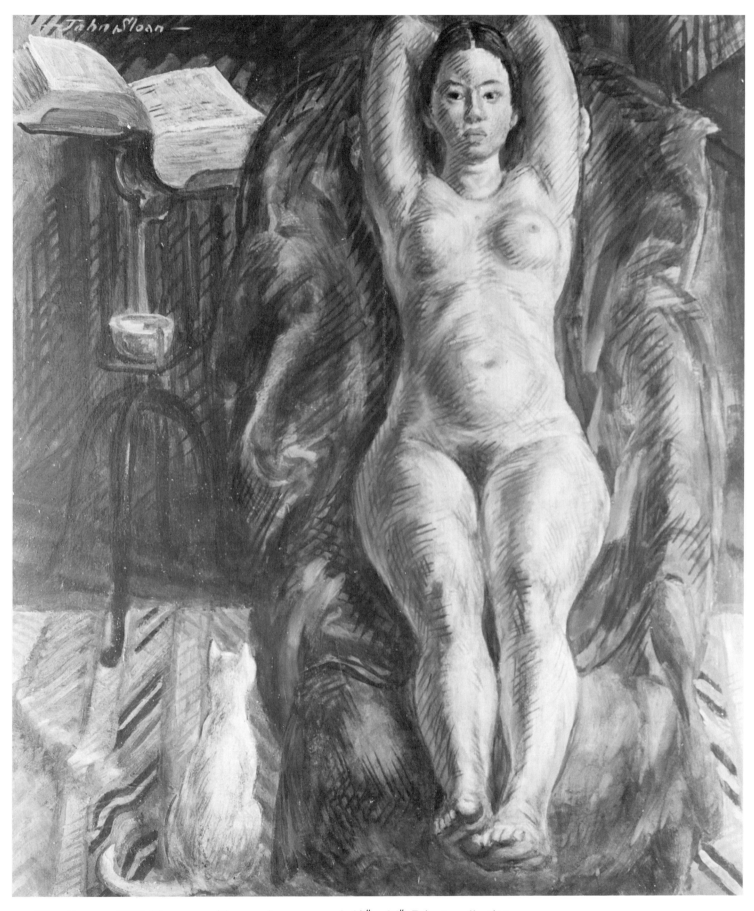

Miscationary. 1930. Tempera with overglaze on panel, 27″ x 24″. Private collection.

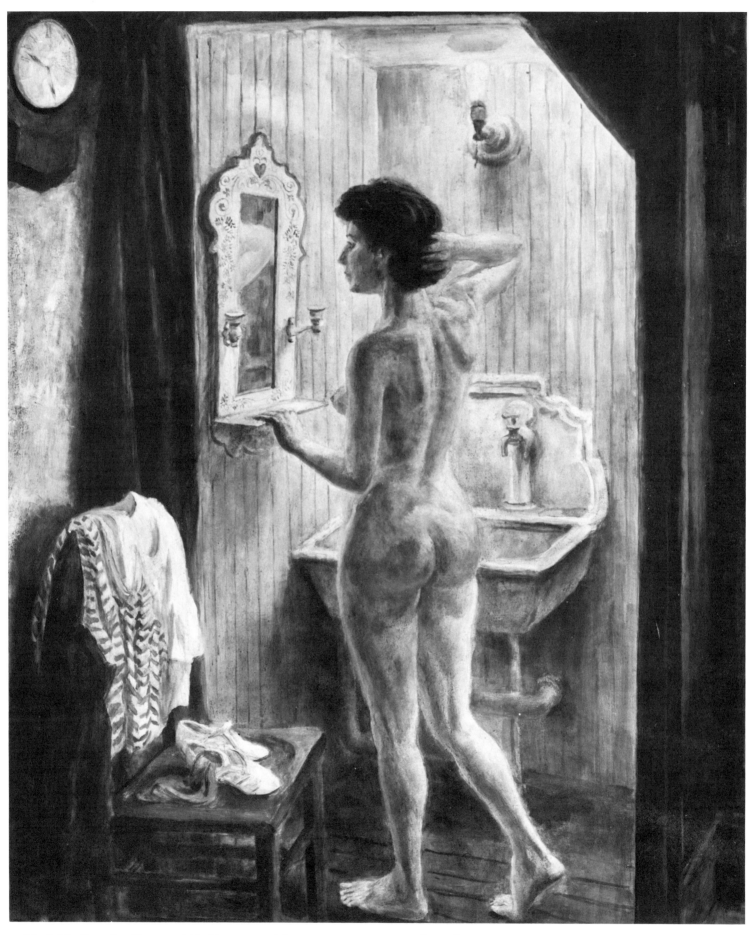

Model in Dressing Room. 1933. Tempera with overglaze on panel, 36″ x 30″. The Whitney Museum of American Art, New York. Gift of Mrs. John Sloan.

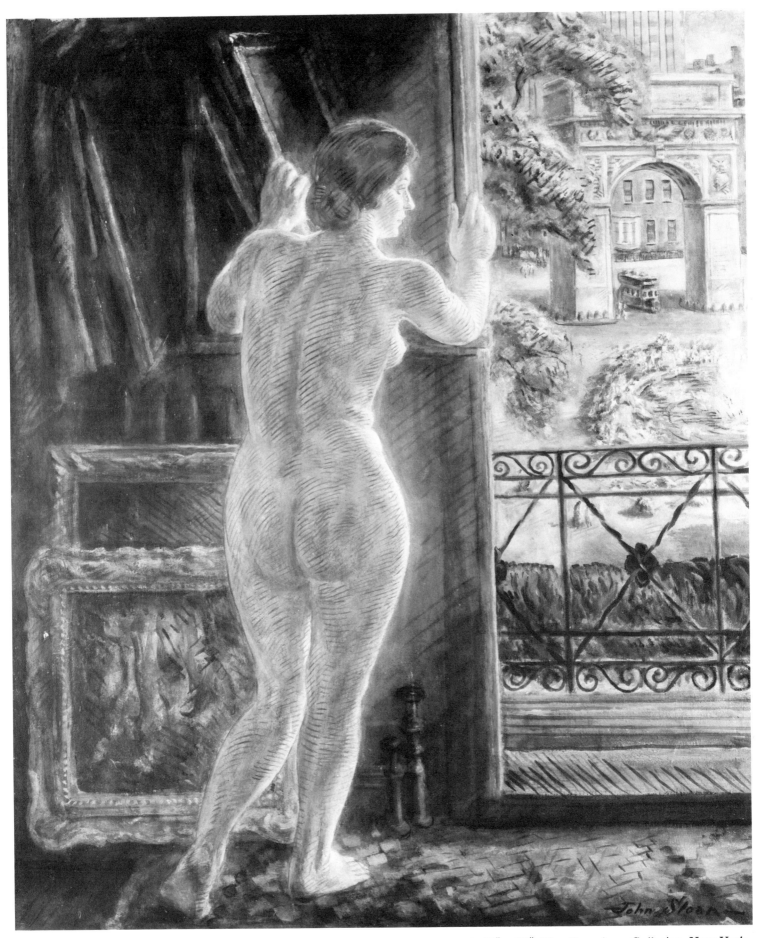

Looking Out on Washington Square. 1933. Tempera with overglaze on panel, 36″ x 30″. The Kraushaar Galleries, New York.

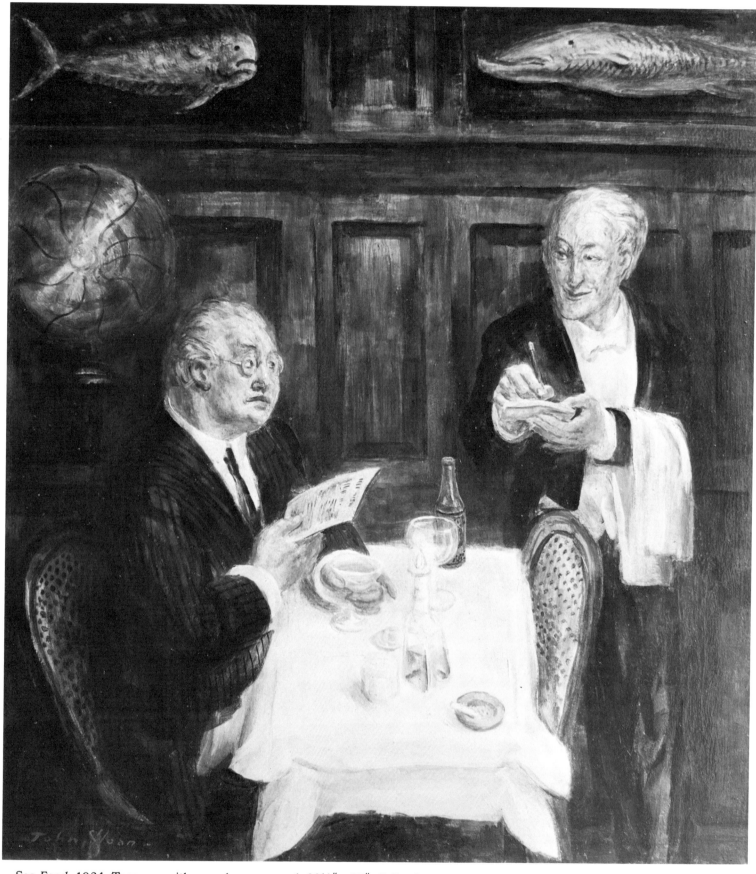

Sea Food. 1934. Tempera with overglaze on panel, 23½″ x 20″. Collection of Mr. and Mrs. George Perutz, Dallas, Texas.

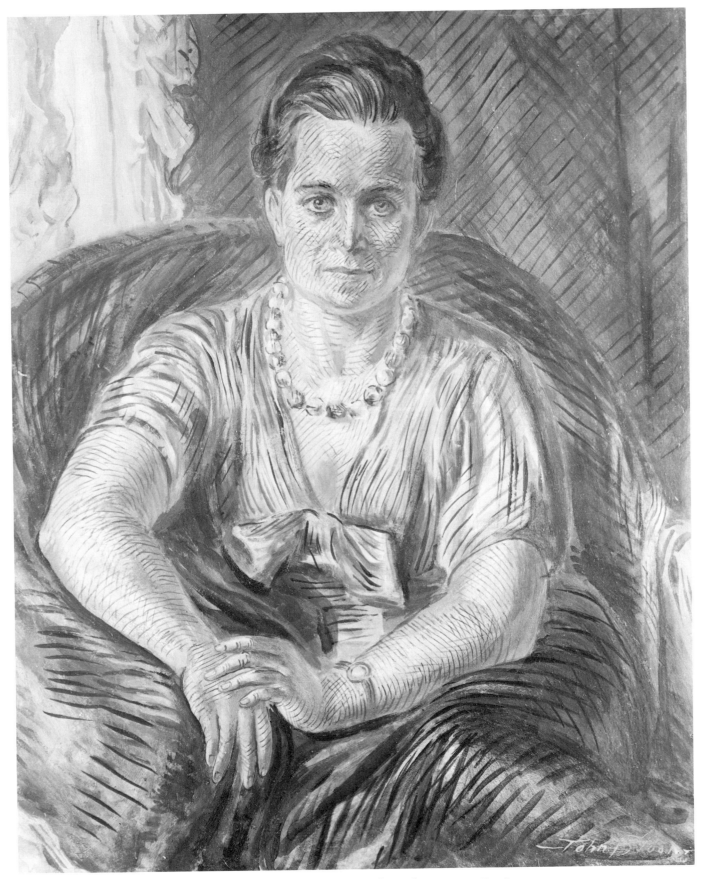

Portrait of "Pete." 1935. Tempera with overglaze on panel, 24″ x 20″. Private collection.

CULMINATION
1941·1950

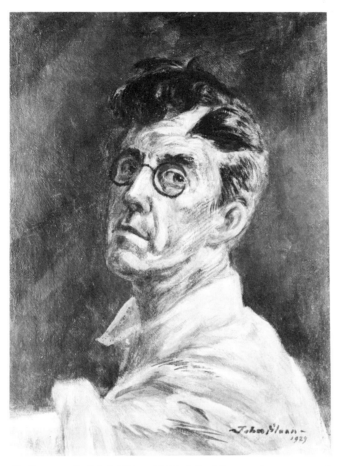

Self-Portrait, Pink Shirt. 1929. Oil with overglaze on panel,
20″ x 16″. Private collection.

"A POINT OF VIEW ABOUT ART"

John Sloan had a deep respect for "style" and a reverence for "beauty," but he did not use such terms freely or loosely. To him style was "the finish with which the artist cloaks his thoughts . . . the tangible surface of the form . . . a harmony of concept, a selective force that is the artist's guiding spirit."[98]

In this sense, he worked in at least three distinct styles during his lifetime, each of which included several phases. It was his nature to keep probing and changing, as he well recognized. "I have never been interested in painting or doing things I know I can paint or do. I get an attack of enthusiasm once in awhile that lasts me for several years."[99] His creative work came in waves, and each successive wave was marked by shifts of emphasis in pictorial content and technique.

With his penchant for philosophizing and verbalizing, Sloan left markers all along the way for the student wishing to trace his development, and he also left warnings for the pedant who might take such labors too seriously. "By never saying anything I mean, I say a great deal. . . . I never mean exactly what I say. Not even this. You have to read between the words."[100]

Despite these warnings, and the fact that Sloan's philosophy remained an open rather than a closed system, there was a tough, coherent core to his thinking that formed an underlying pattern for his work. The sense of holding to such a fundamental value system sustained him, and its importance is implicit in the remark he made after seeing the sensational Sorolla exhibition of 1909 and "absolutely condemning" the paintings: "The stuff shows no philosophy being expressed in paint."[101] Since his own art underwent such marked changes from his poster period to the "Sloans" of 1908 and again to the late nudes, it is doubly helpful to consider the basic pattern of his convictions about art.

John Sloan's early philosophy, as we have seen, was drawn from readings in Ruskin, George Moore, and William Morris Hunt, and was hammered out in long discussions with Robert Henri. Sloan's respect for humble craftsmanship, for integrity, for deep involvement in the life about him can be traced to those days. These qualities were part of his temperament as much as of his reading and discussions, for, as he later said of his student period, there

Study for Realization: Reclining Figure. 1935. Charcoal, 12″ x 18″. The John Sloan Trust, Wilmington, Delaware.

190

was "a great deal of emphasis on inspiration, self-expression, and pictorial beauty."[102] His Poster Style and Art Nouveau drawings reflect his able response to this emphasis, but at the same time he was moving toward a philosophy, advocated rather than exemplified by Henri, which could have come directly from George Moore:

> To the select few the great artist is he who is most racy of his native soil. . . . In art, eclecticism means loss of character, and character is everything in art. I do not mean by character personal idiosyncracies; I mean racial and territorial characteristics. . . . A national character can only be acquired by remaining at home and saturating ourselves in the spirit of our land until it oozes from our pens and pencils in every slightest word, in every slightest touch. Our lives should be one long sacrifice to this one thing—national character. Foreign travel should be eschewed. . . . While labouring thus humbly, rather as handicraftsmen than as artists, our personality will gradually begin to appear in our work.[103]

Sloan, unlike the others of the Henri group, never went abroad. This points up his fundamental independence, as does his long and hard struggle to achieve solidity of form and his avoidance of "charm."

The evolution of this thinking took another step when he became a socialist, yet at the same time realized "that such a thing should not be put into painting."[104] He was therefore pondering problems of content when "the work of the ultra-modern artists was brought to this country by Alfred Stieglitz and the Armory Show," and he began consciously "to be aware of the technique of art: the use of graphic devices to represent plastic forms."[105] He entered into a period of experimentation, lasting well into the 1920s, during which he produced many direct paintings and studies reflecting a growing concern with form. This culminated in the decision, arrived at little by little between 1925 and 1928, to begin a new technical approach to the problem of representing form. Sloan summed up his credo precisely in *Gist of Art*:

> The eye does not see form but only visual impressions of colors and values. Form is a mental concept deduced from experience. We learn form through the sense of touch. The mind coordinates the memory of tactile sensation with the visual image (color, light, and shade) in apprehending form. The artist, in representing solid form with graphic symbols, must convey the shape with some means apart from color. Color-texture is used as a surface complexion to augment the tangibility of the form.[106]

His underlying philosophy is developed throughout *Gist of Art*. He was at pains to make it clear that he did not regard his concentration on figure and portrait painting as a lessening of his humanistic concern. "These pictures are just as much a part of my life experience as the teeming streets of New York."[107] Then, in a concluding section, "The Gist of It All":

> Art is the result of the creative consciousness of the order of existence. . . . Art is the evidence of man's understanding, the evidence of civilization. Humanness is what counts. Man doesn't change much over the centuries, but there is evidence that he is growing more human, very slowly, although this is his one great reason for being.

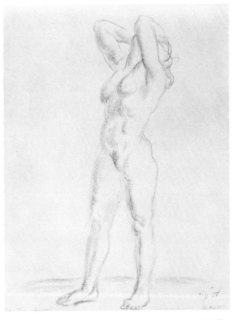

Standing Figure. 1938. Sanguine, 9⅞" x 7½". The Kraushaar Galleries, New York.

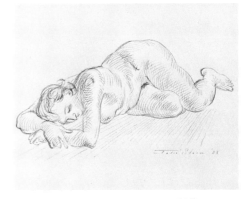

Prone Nude. 1938. Pencil, 8⅞" x 10⅜". The Kraushaar Galleries, New York.

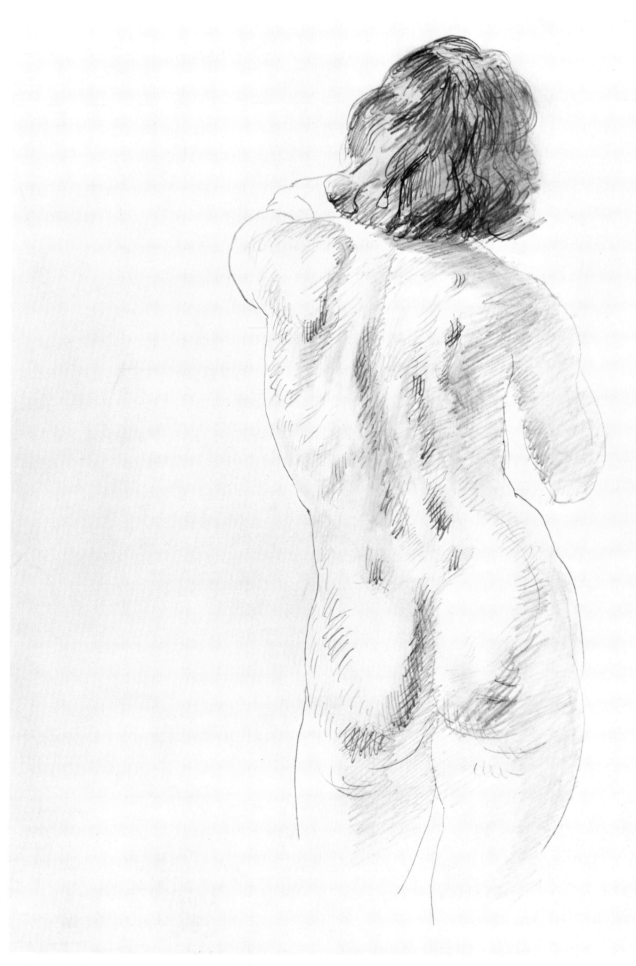

Standing Figure. 1940. Pencil, 8½″ x 4″. The John Sloan Trust, Wilmington, Delaware.

The artist has a song to sing. His creative mind is irritated by something he has to say graphically. . . . The image has greater realization than the thing itself.

An artist is a product of life, a social creature, . . . a spectator of life. . . . He understands it without having to have physical experiences. The artist is interested in life the way God is interested in the universe.[108]

As the years went by, Sloan's conviction that the artist's central concern was with a truth and beauty that could be conveyed through his creation of form grew stronger. "Art," he wrote, "is the result of a creative impulse. . . . " but just beyond that "there is good art and bad art." "Good art cannot be defined because such a definition would have to include the word *beauty*," and beauty, he continued, eludes definition.[109]

In 1949, in a talk at the Hill and Canyon School, John Sloan took a retrospective look and expressed himself in words that suggest that he, like Keats, found truth the key to this elusive quality of beauty: "For the past twenty-five years I was trying to get at that something that goes beyond the visual. . . . Truth, truth as the mind knows it, that is what the artist is looking for and trying to express."[110]

CULMINATION

As Sloan entered his seventies, he found himself becoming a national celebrity, though his current painting, as usual, received scant attention. A testimonial dinner given for him on the twenty-fifth anniversary of the Society of Independent Artists in 1941 was followed the next year by a major prize for etching, and by his election to the Academy of Arts and Letters (making him an Academician in spite of himself). These recognitions initiated a decade of honors and retrospective exhibitions. But the first years of the 1940s also marked the lowest point in his health, with chronic jaundice and almost constant suffering. Dolly had been ill as well, with heart trouble. She seemed to be better for a short period, but in May 1943, she died of a coronary.

A week after Dolly's death Sloan went to Santa Fe at the invitation of his old friend, Amelia Elizabeth White. In July he had a third, and this time successful, gall-bladder operation, and he decided to remain in Santa Fe for the winter to regain his strength. Sloan loved Santa Fe, but when he returned without Dolly to "Sinagua," the isolated house he had designed and built on a hillside some miles from town, he found himself very lonely. His letters made this clear to Helen Farr, the former student who had collaborated on *Gist of Art*. Helen was teaching in New York City, but she managed to visit Santa Fe for a few days between semesters in early February—and returned to New York as Mrs. Sloan.

Helen Farr had entered Sloan's class at the Art Students League in 1927, when she was sixteen. From the first, she had taken notes on his criticisms and class discussions, and for some years had kept in close touch with him, visiting the studio and

Ireland Finds Herself United as Never Before. 1941. Pen and ink, 6½″ x 7″. The Kraushaar Galleries, New York.

spending the summer of 1930 near the Sloans in Santa Fe. In 1935 she had served as his assistant at the League and had used the opportunity to reassemble her notes, which were gradually growing into a book. She posed for portraits, helped nurse Dolly when she was ill, worked with Sloan on matters concerning the League and the Society of Independent Artists, and ultimately supplied the main body of the text of *Gist of Art* when the American Artists Group asked Sloan for a volume to initiate its series on American artists.

His marriage to Helen in 1944 marked the beginning of a particularly happy and fruitful period for Sloan. Helen attended to his needs, shared his interests, painted with him, posed for him, encouraged him to work when he felt temporarily depressed (for she knew that only work would bring him round again), drew out the information that would provide the documentation of his amazingly productive life, and always sought to relieve him of pressures that would interfere with the free pursuit of his painting.

Pursue it he did, with mounting enthusiasm. As his health returned, his energy increased. "In his green old age," Lloyd Goodrich recalled, "Sloan with his leonine mass of gray hair, his indomitable face, his keen eyes, and his sharp tongue, was one of the legendary characters of the art world."[111] He lectured, busied himself with exhibitions and art organizations, provided colorful interviews for the press, and painted.

During his last years, Sloan turned more and more to a study of the Renaissance masters, working with increasing thoughtfulness on his own paintings. "I feel I must continue digging into this problem of drawing, the separation of form and color—the concept of the thing in its integrity, the realization of plastic existence. These problems which the artists of the Renaissance solved with

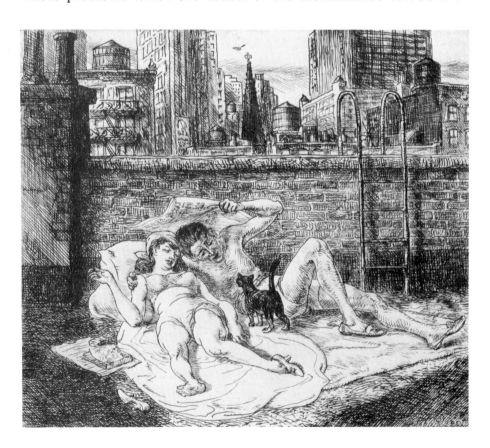

Sunbathers on the Roof. 1941. Etching, 6" x 7". (plate). The Smithsonian Institution, Washington, D. C.

such dignity. . . ."[112] Van Wyck Brooks recalled, "He spent many evenings poring over plates, usually in color, of Fouquet, Signorelli, Rubens, Giovanni Bellini, and he said he liked to have a book of Donatello's work around, for his bas-reliefs were so full of significant drawing. Mantegna's *Dead Christ* was a picture he never tired of studying, deeply involved as he was in the problem of perspective. . . . He always went back to Carpaccio and his nobility of mass, proportion and design, how full, how controlled, how simple and yet how ample."[113] Sloan's references to Renoir and Delacroix decreased, though his admiration for Rembrandt remained undiminished and his interest in the quattrocento Italians grew steadily. Piero della Francesca—whose name does not appear among the dozens of artists cited in *Gist of Art*—became a principal source of inspiration at the end of his life. It is Piero particularly, with his simple, monumental figures in light-flooded pictures, that we think of when we see the most powerful work of Sloan's last years and compare it to that of his earlier periods.

Although a few vigorous paintings date from 1944 and 1945, it was only in 1946 that Sloan found himself once more in full creative swing. Pictures of that year such as *Riders in the Hills* and *The Green Dance Dress* reveal that he had gone far toward his goal of realizing form without depending on chiaroscuro. In a transparent atmosphere, clear planes of rich color are organized to convey the large forms, and a fine graphic overlay adds a crowning tactile vitality.

The *Self-Portrait* (Plate 44) of the same year shows the astonishing alertness and vigor he enjoyed at the age of seventy-five, and reminds us that he introduced hatch lines only when he felt he needed them. Autobiographical commentary is also provided by *Exploring the Unsold* of 1947: to the end of his life, his friends observed, he "was smarting from so many years of comparative neglect."[114]

His paintings continued to become bolder, both in concept and in execution. His 1948 portrait of Helen, *Tea for One*, is a triumphant solution to the problem of creating full forms in a high-keyed, blond tonality. His studies of great massive nudes *Santa Fe Siesta* (Plate 45) and *Nude on Porch* display, with surprising technical restraint, the "amplitude of form" that he had achieved in his monumental nudes of fifteen years before only by much heavier carving. These late paintings, together with their companion piece, *Monument in the Plaza* (Plate 46), achieve their effects by a transformation of all the pictorial elements. Sloan attained his objective of carrying the observer beyond the world of superficial appearances to the world of concepts presented as tangible reality.

Beyond his seventy-fifth year, and as he approached eighty, Sloan's vigorous involvement in painting continued to increase. Time was passing "like an avalanche," and there was much he still wanted to explore. In 1950 he tried new color harmonies, new compositional arrangements, and pointillist variations of texture. Among his paintings of that year are figure studies—*Nude with Red Hand Mirror* (Plate 48), *Lady and Rembrandt*—of sparkling

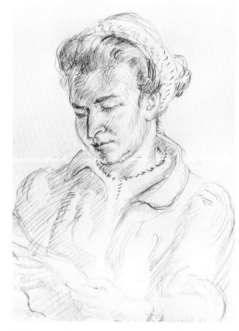

Helen at Sinagua. 1944. Pencil, 8½" x 6". The John Sloan Trust, Wilmington, Delaware.

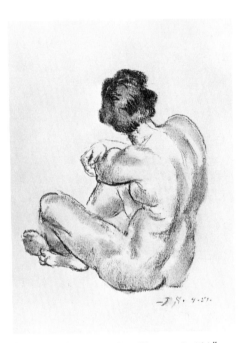

Seated Figure. 1951. Charcoal, 8½″ x
6¾″. The Kraushaar Galleries, New
York.

vitality and brilliant light and color. They possessed a haunting
magical reality suggestive of surrealism, a movement he had
found of value solely because of its "concern with realization."[115]
The large shapes of these paintings were treated as simplified
planes carrying brilliant colors. As these were flattened and ad-
justed to the total composition, the graphic overlay was tied to
them more closely, an integral expression of the texture and
movement of the abstracted forms. The linear markings, often
obtrusive in the past, now became thoroughly assimilated as the
objects and their pictorial field were more closely unified.

When Sloan was in his eightieth year, a medical examination
indicated that he should no longer subject his heart to the strain of
the altitude of Santa Fe. He loved Sinagua and had drawn
inspiration each year from the New Mexico landscape, with its
rich earthy colors, geometric forms, and clear air. When Helen
persuaded him to summer in Hanover, New Hampshire, he went
with grave reservations about the paintability of the New England
countryside. To be sure, Dartmouth College had proven itself the
most hospitable and appreciative of institutions—it had been the
first to buy one of his nudes, and had celebrated his seventy-fifth
birthday with a retrospective exhibition. Besides, he had good
friends there, and a relative, John Sloan Dickey, was president of
the college. But when he found himself surrounded by the inter-
minable verdure of trees, fields, and hills, he "felt like a desert
scorpion dropped into a green salad."[116]

Faced with a new set of painting problems and nostalgia for
Santa Fe, he was at first depressed, but soon he was wrestling with
six landscapes at the same time and was thoroughly intrigued with
the challenge. His social life proved stimulating as well: visits with
members of the college community, old-time friends such as Harry
Wickey, former acquaintances, artists, writers —including Robert
Frost—and the children of the neighborhood, who as usual be-
came his special delight. Herbert Faulkner West, who helped take
the Sloans about that summer, has left a vivid record of his
impressions of the artist: lean and alert, a little shaky on his feet
because of poor vision (Helen explained he had great difficulty in
focusing); simple and modest to a fault; "a bright old man, with
disposition a little fey, or a little pixie . . . full of the old élan vital;
no sign of depression."[117]

These last notes were made a week after the gala celebration of
Sloan's eightieth birthday and eleven days before he learned that
he had a small, operable cancer that had to be removed as soon as
possible. He entered the hospital on August 23 in good spirits,
planning a house he wanted to build for his future summers in
Hanover.

The operation, in its aftermath, proved too much for even
Sloan's exceptional stamina, and he died on the seventh of Sep-
tember, cut off in his hope that he was about to enter yet another
epoch in his art.

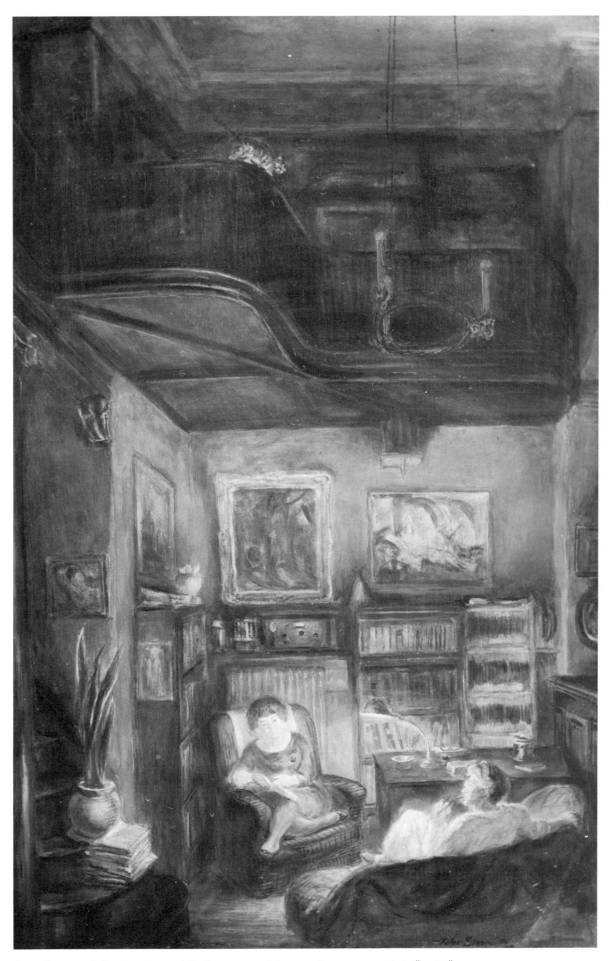

Our Corner of the Studio. 1935. Tempera with overglaze on panel, 36″ x 23″.
The John Sloan Trust, Wilmington, Delaware.

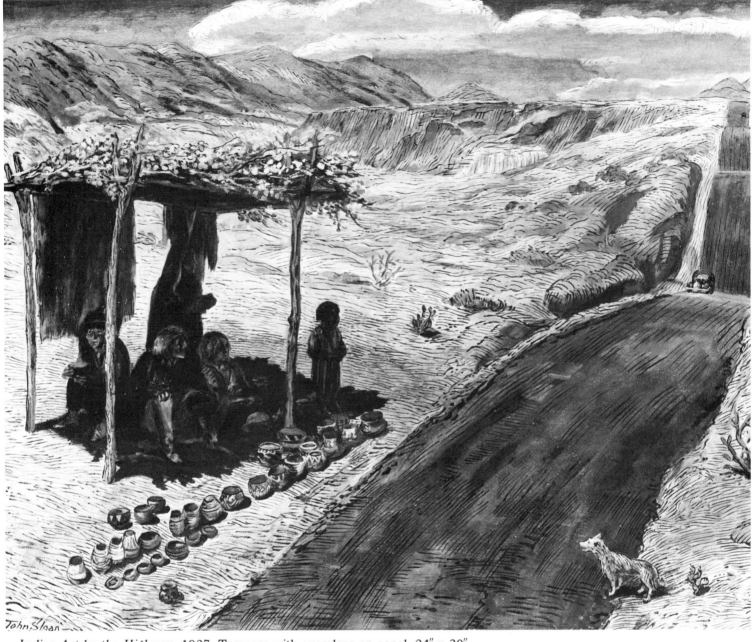

Indian Art by the Highway. 1937. Tempera with overglaze on panel, 24″ x 30″.
The Thomas Gilcrease Institute, Tulsa, Oklahoma.

The First Mail Arrives at Bronxville, 1846. 1939. Mural, 5″ x 16″. Bronxville, New York, Post Office.
Executed for the Procurement Division, U. S. Treasury Department.

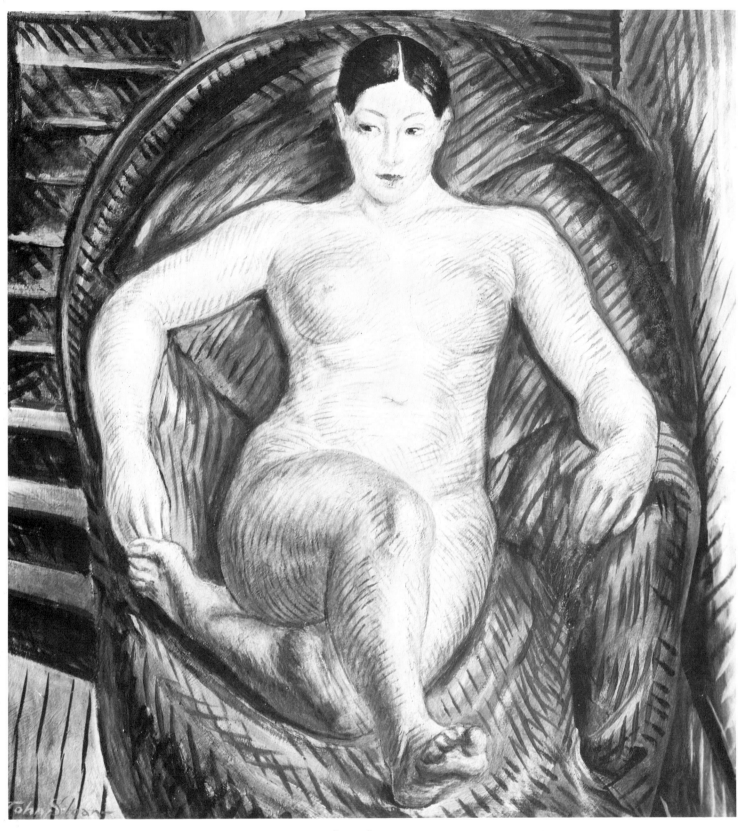

Arachne. 1940. Tempera with overglaze on panel, 28″ x 26″. The Philadelphia Museum of Art.
Gift of Mr. and Mrs. R. Sturgis Ingersoll.

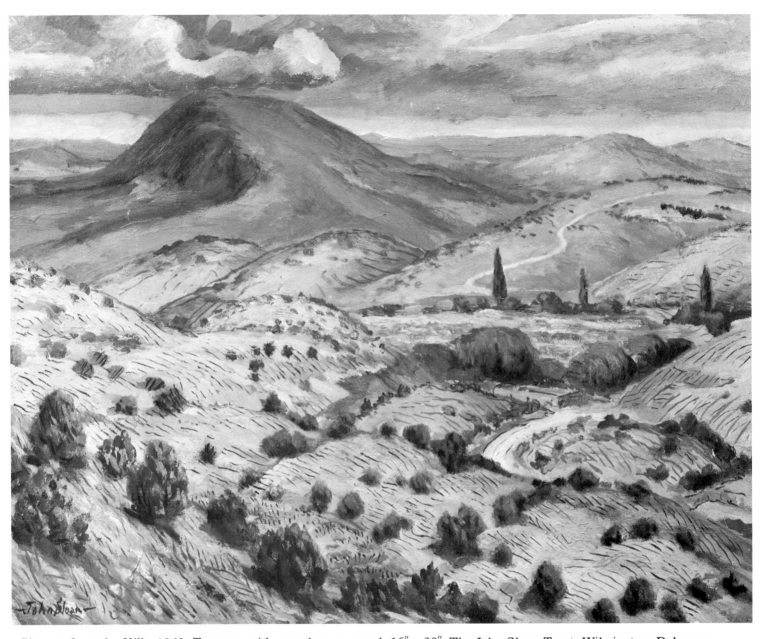

Cienega from the Hills. 1942. Tempera with overglaze on panel, 16″ x 20″. The John Sloan Trust, Wilmington, Delaware.

The Green Dance Dress (The Dance Dress). 1945–46.
Tempera with overglaze on panel, 28⅞″ x 23½″.
The Metropolitan Museum of Art, New York.
Bequest of Miss Adelaide Milton de Groot, 1967.

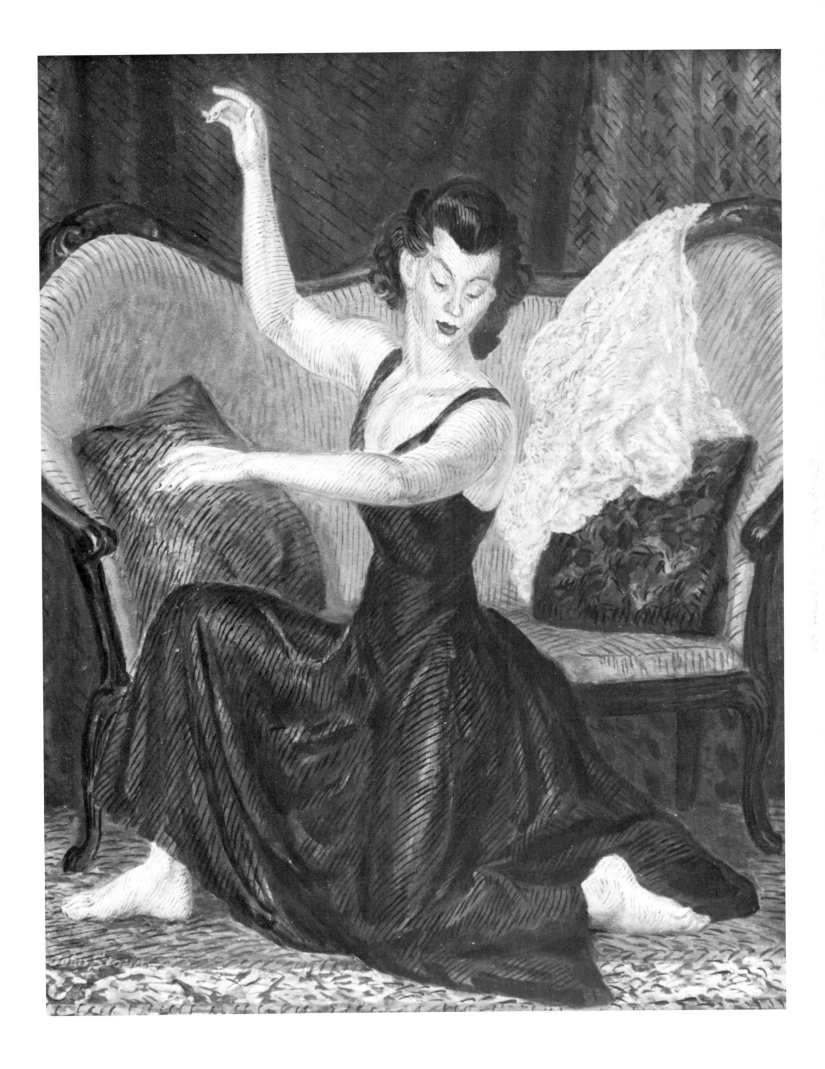

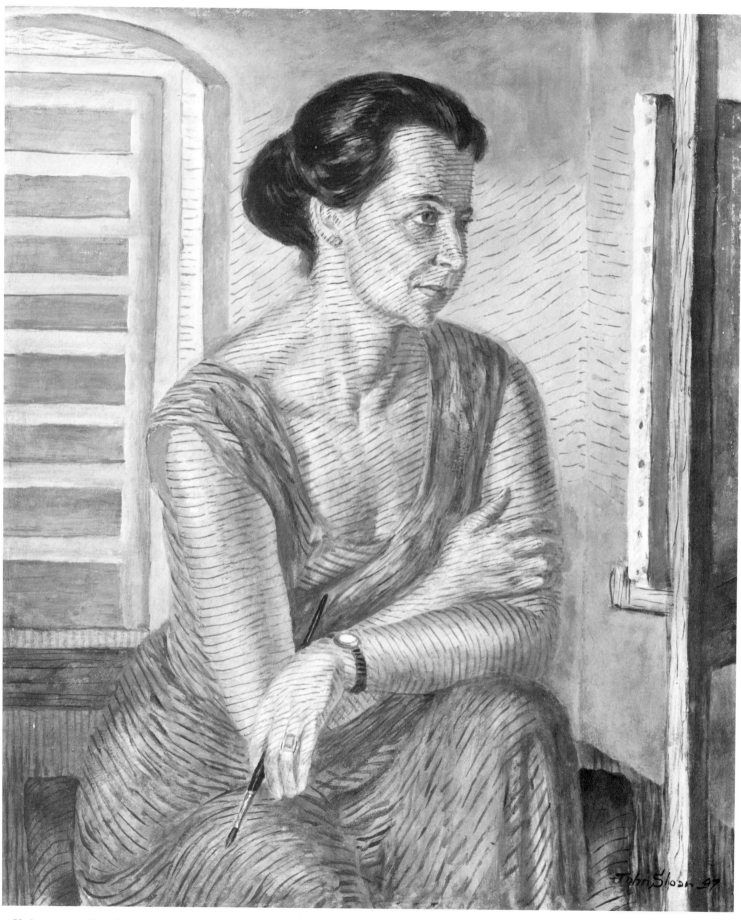

Helen at the Easel. 1947 and 1950. Tempera with overglaze on panel, 24″ x 20″.
The John Sloan Trust, Wilmington, Delaware.

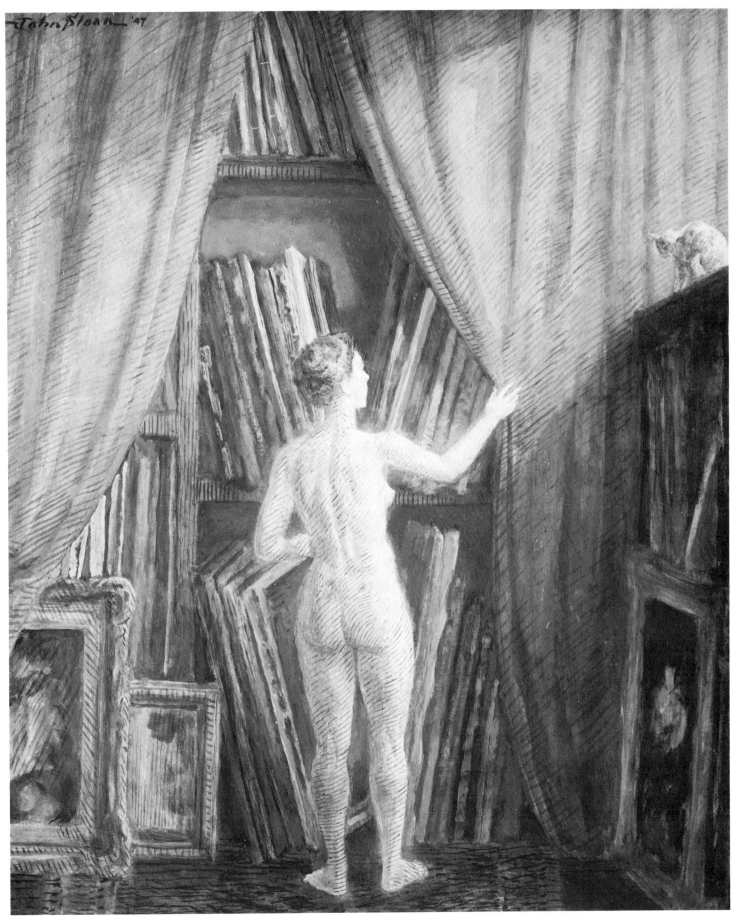

Exploring the Unsold. 1947–48. Tempera with overglaze on panel, 24″ x 20″.
Collection of Phyllis Levy Dumain, New York.

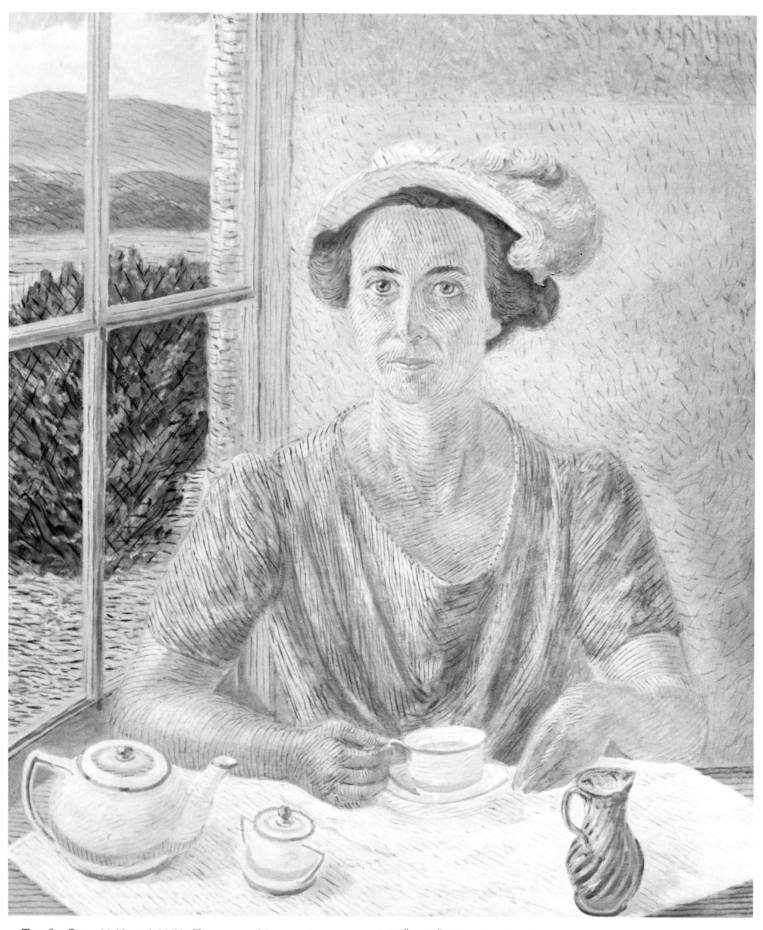

Tea for One. 1948 and 1950. Tempera with overglaze on panel, 32″ x 26″. Private collection.

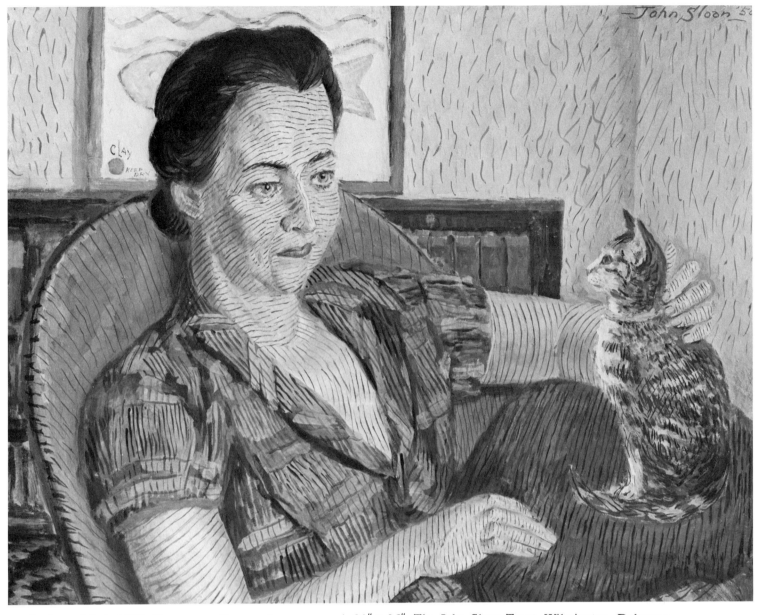

Lady and Cat. 1950. Tempera with overglaze on panel, 20″ x 26″. The John Sloan Trust, Wilmington, Delaware.

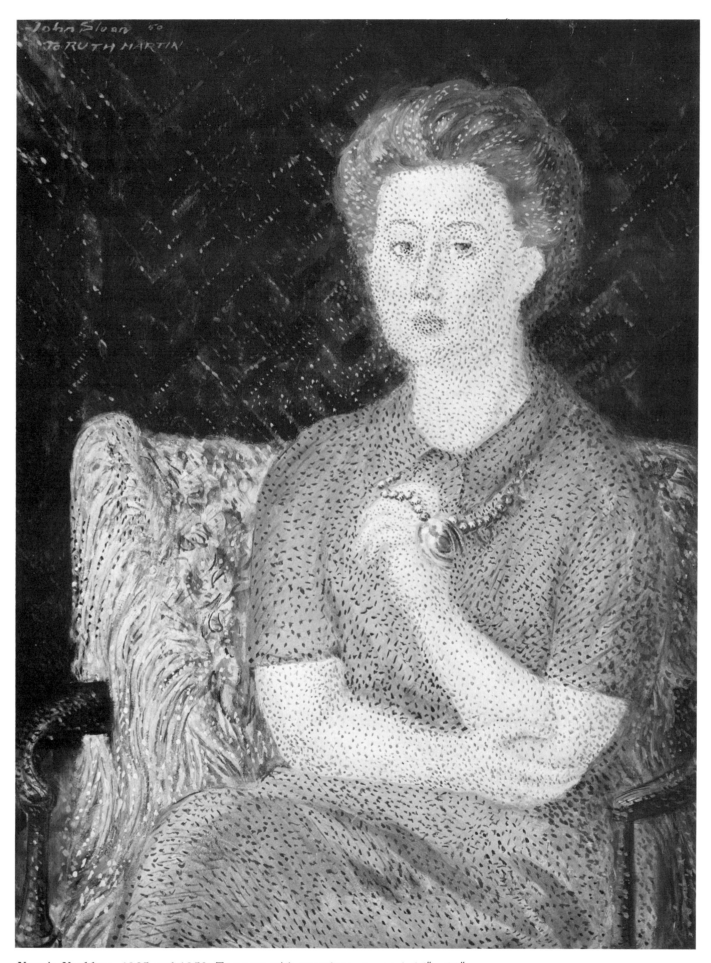

Navajo Necklace. 1935 and 1950. Tempera with overglaze on panel, 26″ x 20″.
Collection of Miss Ruth Martin, New York.

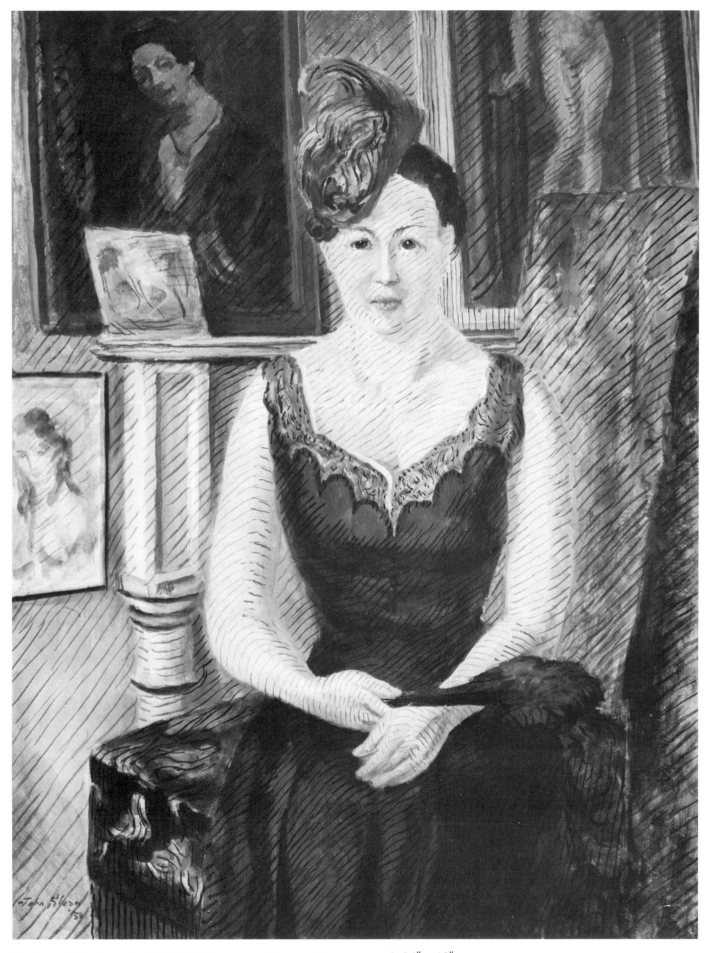

Lady and Rembrandt. 1950–51. Tempera with overglaze on panel, 24″ x 18″.
The John Sloan Trust, Wilmington, Delaware.

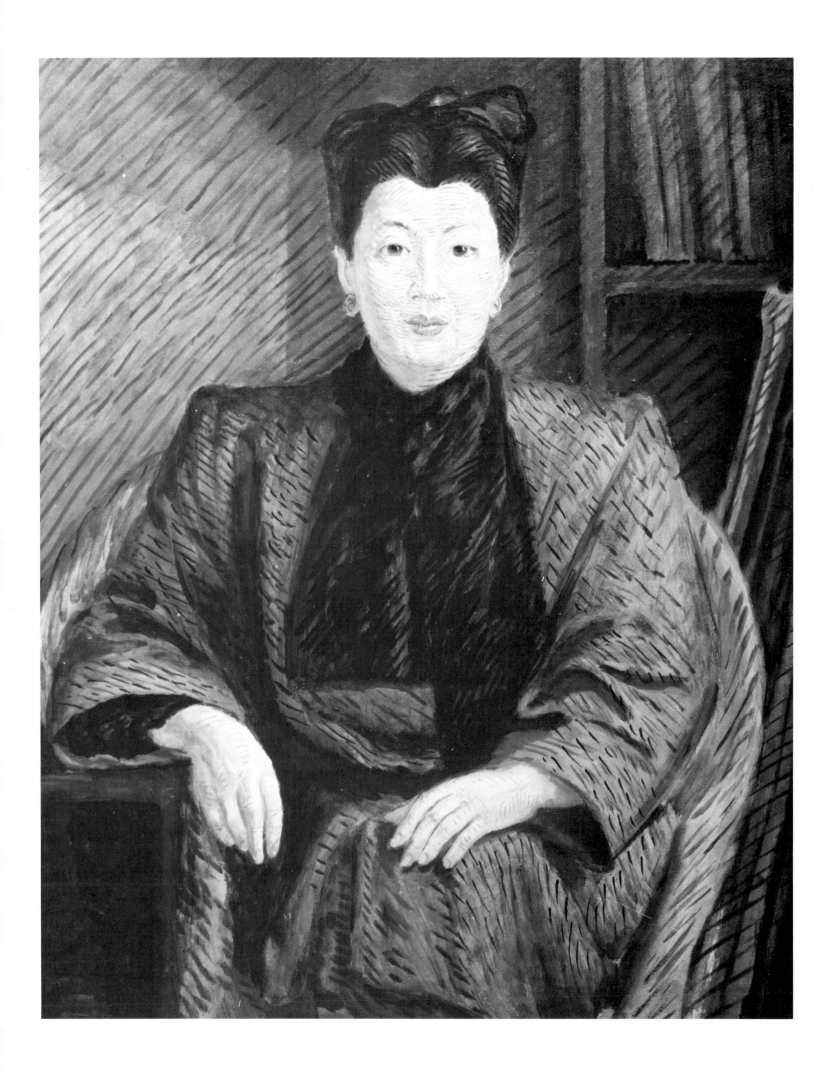

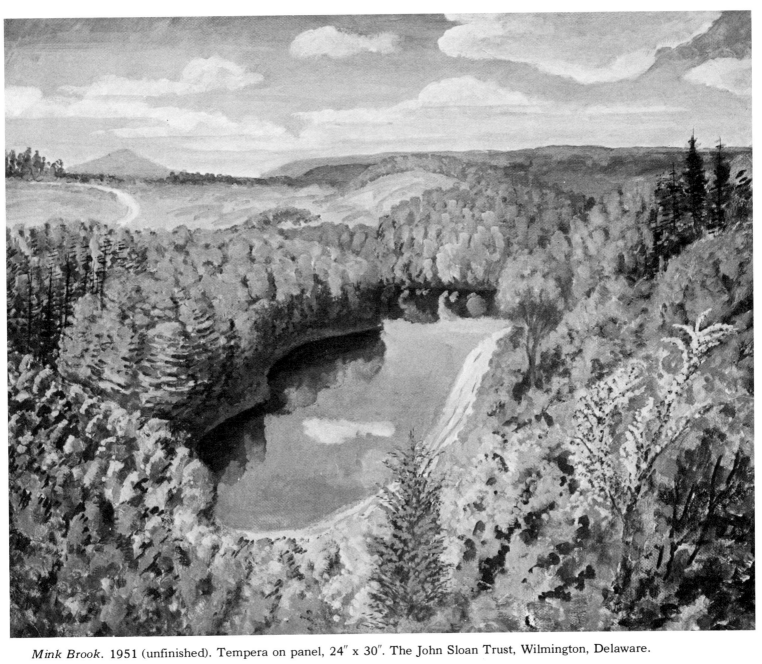

Mink Brook. 1951 (unfinished). Tempera on panel, 24″ x 30″. The John Sloan Trust, Wilmington, Delaware.

Charlotte in Red Coat. 1951.
Tempera with overglaze on panel, 30″ x 24″.
The Whitney Museum of American Art, New York.

ACKNOWLEDGMENTS

This study of John Sloan, like all others of the past thirty years, owes its principal debt to Helen Farr Sloan, who has been a constant help in innumerable ways. Miss Antoinette Kraushaar has been no less patient, understanding, and encouraging. Miss Ruth Martin has been most generous in putting works and interpretations at my disposal. William I. Homer, E. John Bullard III, and Grant Holcomb III have graciously shared the results of their studies, and Frank Getlein and Lloyd Goodrich have also placed me in their debt. Without the cooperation of the collectors and museums that have given permission to reproduce their paintings, it would have been impossible to do justice to the scope of Sloan's work. Finally, coming closer to home, I must acknowledge the help of the staff of the library of the National Gallery of Art and Mrs. Matthew Kaye; and I am eternally grateful to my wife and daughters for sharing in the effort of producing this book.

NOTES

1. Quotations in the first six sections of this book, unless otherwise identified, are drawn from "Early Days: Unpublished Autobiographical Notes by John Sloan," *The Poster Period of John Sloan.*

2. John Sloan, *Gist of Art,* ed. Helen Farr, New York, 1939, p.1.

3. John Sloan, *New York Scene,* July 6, 1906.

4. John Sloan files.

5. John Sloan, "Artists of the Press," in *Artists of the Philadelphia Press,* Philadelphia, 1945, p.7.

6. Sloan, *New York Scene,* November 29, 1906.

7. *New York Sun,* February 3, 1895.

8. Sloan, *New York Scene,* November 29, 1906.

9. *Ibid.,* January 15, 1908.

10. Helen Farr Sloan, quotation from John Sloan.

11. John Sloan, "Robert Henri," in Catalogue of a *Memorial Exhibition of the Works of Robert Henri,* New York: The Metropolitan Museum of Art, 1931, p. xi.

12. From an updated newspaper clipping in the John Sloan files.

13. *Philadelphia Press,* December 8, 1900.

14. Van Wyck Brooks, *John Sloan: A Painter's Life,* New York, 1955, p. 50.

15. Jacob Kainen, Foreword to *John Sloan's Prints: A Catalogue Raisonné of the Etchings, Lithographs and Posters,* by Peter Morse, New Haven and London, 1969, p. 7.

16. See Bullard, p. 206ff.

17. Sloan, *New York Scene,* February 22, 1907.

18. Charles Wisner Barrell, "The Real Drama of the Slums, as Told in John Sloan's Etchings," Craftsman, February, 1909, p. 564.

19. *New York Evening Sun,* February 24, 1906 (review of Pisinger Gallery exhibition).

20. *Ibid.,* April 11, 1901.

21. *Ibid.*

22. Ibid., January 21, 1904.

23. *New York Times,* January 20, 1904.

24. Barrell, "Real Drama of the Slums," p. 562.

25. Art Young characterized the drawings of Sloan and his friends for the *Masses* as "pictures of ash cans" in 1916, but it was apparently not until 1934 that the term "Ash Can School" was introduced into art-historical literature by Holger Cahill.

26. *New York Sun,* December 27, 1906.

27. *New York Evening Sun,* January 23, 1904.

28. Sloan, *New York Scene,* January 8, 1906.

29. *Ibid.,* March 3, 1907.

30. *Ibid.,* March 18, 1907.

31. *Ibid.,* April 11, 1907.

32. *Ibid.,* May 15, 1907.

33. *Ibid.,* January 31, 1908. Sloan's seven entries, as listed in the Macbeth catalogue, were *Easter Eve; Hairdresser's Window; The Cot; Sixth Avenue and Thirtieth Street, 1907; Election Night; Nurse Girls, Spring; Moving Pictures, Five Cents.*

34. *Ibid.,* April 3, 1908.

35. *New York Post,* February 1, 1908.

36. *Philadelphia Press,* February 9, 1908.

37. *New York World,* February 2, 1908.

38. Sloan, *New York Scene,* December 18, 1907.

39. Charles H. Caffin, *Story of American Painting,* New York, 1907, p. 373.

40. Sloan, *New York Scene,* December 11, 1908.

41. *Ibid.,* January 4, 1910.

42. *Ibid.,* January 26, 1910.

43. *Ibid.,* March 9, 1910.

44. Sloan exhibited *Clown Making Up, Pigeon-flying, Recruiting in a Public Square,* and *Three A.M.* He also showed twenty-two etchings and twenty-seven drawings, all but one taken from his de Kock illustrations.

45. Sloan, *New York Scene,* April 1, 1910.

46. *Ibid.,* January 22, 1911.

47. *Ibid.,* February 7, 1912.

48. *Sunday, Girls Drying their Hair; McSorley's Ale House; Girl and Beggar; Portrait of Mother; Night Windows; Anshutz's Talk on Anatomy; The Picture Buyer.*

49. Sloan, *New York Scene,* December 25, 1909.

50. *Ibid.,* March 7, 1907.

51. *Ibid.,* May 27, 1909.

52. Sloan, *Gist of Art,* p. 4.

53. Sloan, *New York Scene,* November 3, 1908.

54. *Ibid.,* April 15, 1909.

55. *Ibid.,* May 5, 1909.

56. *Ibid.,* December 19, 1909.

57. *Ibid.,* October 4, 1909.

58. Sloan, *Gist of Art,* p. 227.

59. Brooks, *John Sloan,* p. 100.

60. Sloan, *New York Scene,* April 20, 1912.

61. *Ibid.,* November 12, 1911.

62. *New York World,* April 7, 1916.

63. Sloan, *New York Scene,* October 24, 1909.

64. Chicago Tribune, February 22, 1914.

65. Max Eastman, *Enjoyment of Living,* New York, 1948, p. 412.

66. *New York Sun,* April 8, 1916.

67. Sloan, *New York Scene,* p. 382.

68. *Ibid.,* March 23, 1912.

69. Brooks, *John Sloan,* p. 123.

70. Sloan, *New York Scene,* July 3, 1911.

71. *Ibid.,* January 16, 1913.

72. Brooks, *John Sloan,* p. 134.

73. Robert J. Cole, *New York World,* January 30, 1916.

74. Sloan, *New York Scene,* April 13, 1907.

75. Sloan, *Gist of Art,* p. 15.
76. Sloan, *New York Scene,* March 9, 1910.
77. Sloan, *Gist of Art,* p. 6.
78. *Ibid,* p. 7.
79. Brooks, *John Sloan,* p. 262.
80. *New York Times,* April 9, 1932.
81. *New York Herald Tribune,* April 9, 1932.
82. *New York Times,* April 12, 1932.
83. *New York Sun,* December 4, 1933.
84. Brooks, *John Sloan,* p. 156.
85. Sloan, *Gist of Art,* p. 147.
86. *Ibid.,* p. 263.
87. Maratta and Henri also worked on geometric systems for ordering paintings; see Sloan, *New York Scene,* July 3, 1911.
88. Sloan, *Gist of Art,* p. 117.
89. *Ibid.,* p. 116fn.
90. *Ibid.,* p. 126.
91. *Ibid.,* p. 16.
92. *Ibid.,* pp. 140–141.
93. *Ibid.,* pp. 110, 114.
94. *Ibid.,* pp. 16–17.
95. *Ibid.,* p. 110.
96. *Ibid.,* p. 38.
97. Dartmouth Catalogue, no. 98.
98. Sloan, *Gist of Art,* p. 49.
99. *Ibid.,* p. 5.
100. *Ibid.,* p. 7.
101. Sloan, *New York Scene,* February 17, 1909.
102. Sloan, *Gist of Art,* p. 6.
103. George Moore, *Modern Painting,* London and New York, 1893, pp. 212–14.
104. Sloan, *Gist of Art,* p. 3
105. *Ibid.,* p. 15.
106. *Ibid.,* p. 198.
107. *Ibid.,* p. 16.
108. *Ibid.,* p. 189.
109. *Ibid.,* p. 19.
110. Lloyd Goodrich, *John Sloan,* New York, 1952, p. 76.
111. Sloan, *New York Scene,* p. xxii.
112. Brooks, *John Sloan,* pp. 216–18.
113. Herbert Faulkner West, *John Sloan's Last Summer,* Iowa City, 1952, p. 17.
114. Sloan, *Gist of Art, p. 44.*
115. West, *Sloan's Last Summer,* p. 19.
116 *Ibid.,* p. 23.

BIBLIOGRAPHY

Writings on John Sloan

BOOKS

Brooks, Van Wyck. *John Sloan: A Painter's Life.* New York: Dutton, 1955.

Brown, Milton W. *The Story of the Armory Show.* New York: The Joseph H. Hirshhorn Foundation, 1963.

Bullard, E. John. *John Sloan and the Philadelphia Realists as Illustrators.* Master's thesis, University of California at Los Angeles, 1968.

Caffin, Charles H. *The Story of American Painting.* New York: Frederick A. Stokes Co., 1907, pp. 378–81.

Cahill, Holger, and Alfred H. Barr Jr., eds. *Art in America in Modern Times.* New York: Halcyon House, 1934, pp. 31–32.

Craven, Thomas. *Modern Art.* New York: Simon and Schuster, 1934, pp. 326–28.

_____*A Treasury of American Prints.* New York: Simon and Schuster, 1939.

du Bois, Guy Pene. *John Sloan.* New York: Whitney Museum of American Art, 1931.

Eastman, Max. *Enjoyment of Living.* New York: Harper and Bros., 1948.

_____*Love and Revolution.* New York: Random House, 1964, pp. 492 and 600.

Gallatin, A. E. *Certain Contemporaries.* New York: John Lane Company, 1916, pp. 23–30.

_____,ed. *John Sloan.* New York: E.P. Dutton & Co., 1925.

Geldzahler, Henry. *American Painting in the Twentieth Century.* New York: The Metropolitan Museum of Art, 1965, pp. 26–30, 224.

Glackens, Ira. *William Glackens and the Ashcan Group.* New York: Crown Publishers, 1957.

Goodrich, Lloyd. *John Sloan.* New York: Whitney Museum of American Art, 1952.

Holcomb, Grant. *A Checklist for John Sloan's Paintings.* Lock Haven, Pennsylvania: Annie Halenbake Ross Library, 1970.

Homer, William Innes. *Robert Henri and His Circle.* Ithaca and London: Cornell University Press, 1969.

John Sloan. New York: American Artists Group, Inc., 1945.

LaFollete, Suzanne. *Art in America.* New York: Harper and Bros. 1929, pp. 304–7, 324–25.

Larkin, Oliver W. *Art and Life in America.* New York: Rhineboat, 1949.

Mather, Frank Jewett, Jr. "John Sloan." New York: *American Art Portfolios,* ser. 1, 1936, pp. 54–58.

_____, Charles Rufus Morey, and William James Henderson . *The American Spirit in Art,* New Haven: Yale University Press, 1927, pp. 153, 268, 317.

Mellquist, Jerome. *The Emergence of an American Art.* New York: Scribner's, 1942, pp. 42, 119, 130–34.

Morse, Peter. *John Sloan's Prints: A Catalogue Raisonné of the Etchings, Lithographs, and Posters.* New Haven and London: Yale University Press, 1969.

Pearson, Ralph M. *Experiencing American Pictures.* New York: Harper and Bros, 1943, pp. 164–68.

Perlman, Bennard B. *The Immortal Eight, American Painting from Eakins to the Armory Show, 1870–1913.* Introduction by Mrs. John Sloan, New York: Exposition Press, 1962.

Phillips, Duncan. *A Collection in the Making.* New York: E. Weyhe, 1926, pp. 51–52.

Rueppel, Merrill Clement. *The Graphic Art of Arthur Bowen Davies and John Sloan.* Ann Arbor, Michigan: University Microfilms, 1956.

St. John, Bruce. *John Sloan.* New York: Praeger, 1971.

West, Herbert Faulkner. *John Sloan's Last Summer.* Iowa City: Prairie Press, 1952.

Young, Mahonri. *The Eight.* New York: Watson-Guptill Publications, 1973.

"Art Students League Mourns Passing of John Sloan." *Art Students League News,* vol. 4 (October 1, 1951), pp. 1–4.

Barker, Ruth Laughlin. "John Sloan Reviews the Indian Tribal Arts." *Creative Art,* vol. 9 (December, 1931), pp. 444–49.

Barrell, Charles Wisner. "The Real Drama of the Slums, as Told in John Sloan's Etchings." *The Craftsman,* vol. 15 (February, 1909), pp. 559–64.

Baury, Louis. "The Message of Bohemia." *Bookman,* vol. 34 (November, 1911), pp. 262–65.

Bohrod, Aaron. "On John Sloan." *College Art Journal,* vol. 10 (Fall, 1950) pp. 3–9.

Brace, Ernest. "John Sloan." *Magazine of Art,* vol. 31 (March, 1938), pp. 130–35, 183–84.

Brown, Milton W. "The Two John Sloans." *Art News,* vol. 50 (January, 1952), pp. 24–27, 56–57.

Cahill, Edgar (Holger). "John Sloan." *Shadowland,* vol. 4 (August, 1921), pp. 10–11, 71–73.

Coates, Robert M. "Profiles." *New Yorker,* vol. 25 (May 7, 1949).

"Dartmouth Shows Fifty Years of John Sloan." *Art News,* vol. 45 (August, 1946), pp. 38–39.

Edgerton, Giles. "The Younger American Painters: Are They Creating a National Art?" *The Craftsman,* vol. 13 (February, 1908), p. 523.

Ely, Catherine Beach. "The Modern Tendency in Henri, Sloan, and Bellows," *Art in America,* vol. 10 (April, 1922), pp. 132–38, 143.

"An Exhibition in Print of the Work of John Sloan." *Arts and Decoration,* vol. 6 (January 1916), pp. 142–43.

Gutman, Walter. "John Sloan." *Art in America,* vol. 17 (June, 1929), pp. 187–95.

Henri, Robert. "The New York Exhibition of Independent Artists." *The Craftsman,* vol. 18 (May, 1910), pp. 162, 168, 172.

Katz, Leslie. "The World of the Eight." *Arts Yearbook,* vol. 1 (1957), pp. 55–76.

Kwiat, Joseph J. "John Sloan: An American Artist as a Social Critic, 1900–1917." *Arizona Quarterly,* vol. X (Spring, 1954), pp. 52–64.

Larric, J. B. "John Sloan—Etcher." *Coming Nation,* no. 69 (January 6, 1912), pp. 3–4.

Mechlin, Leila. Editorial, *American Magazine of Art,* vol. 21 (May, 1930), pp. 282–83.

Morse, John D. "John Sloan, 1871–1951." *American Artist,* vol. 16 (January, 1952), pp. 24–28, 57–60.

Morse, Peter. "John Sloan's Etching Technique: An Example." *Smithsonian Journal of History,* vol. 2 (1967 no. 3), pp. 17–34.

"Notes." *Chap-Book,* vol. 2 (November 15, 1894), p. 40.

Pach, Walter "L'Art de John Sloan." *L'Art et les Artistes,* vol. 18 (February, 1914), pp. 222–26.

_____"The Etchings of John Sloan." *Studio,* vol. 92 (August 14, 1926), pp. 102–5.

_____"Quelques notes sur les peintres americains." *Gazette des Beaux-Arts,* vol. 51 (1909), pp. 324–35.

_____"John Sloan." *Atlantic Monthly,* vol. 194 (August, 1954), pp. 68–72.

_____"John Sloan." *New Mexico Quarterly Review,* vol. 19 (Summer, 1949), pp. 177–81.

_____"John Sloan Today." *Virginia Quarterly Review,* vol. 1 (July, 1925), pp. 196–204.

Penn, F. "Newspaper Artists—John Sloan." *Inland Printer,* vol. 14 (October, 1894), p. 50.

Roberts, Mary Fanton. "John Sloan: His Art and Its Inspiration." *Touchstone,* vol. 4 (February, 1919), pp. 362–70.

Salpeter, Harry. "Saturday Night's Painter." *Esquire,* vol. 5 (June, 1936), pp. 105–7, 132, 134.

"John Sloan: A Great Teacher-Painter Crusades for American Art." *Life,* vol. 7 (December 11, 1939), pp. 44–46.

"John Sloan—Painter and Engraver." *Index of Twentieth Century Artists,* vol. 1, no. 11 (August, 1934), and vol. 2, no. 12, supplements no. 11 and 12.

John Sloan, speech at Art Students League Diamond Jubilee Dinner. *Art Students League News,* vol. 3 (December 1, 1950), pp. 3–7.

Watson, Forbes. "John Sloan." *Magazine of Art,* vol. 45 (1952), pp. 62–70.

Weitenkampf, Frank. "John Sloan in the Print Room." *American Magazine of Art,* vol. 20 (October, 1929), pp. 554–59.

Yeats, John Butler. "The Work of John Sloan." *Harper's Weekly,* vol. 58 (November 22, 1913), pp. 20–21.

Zigrosser, Carl. "John Sloan Memorial: His Complete Graphic Work." *Philadelphia Museum Bulletin,* vol. 51 (Winter, 1956), pp. 19–31.

Addison Gallery of American Art, Phillips Academy, Andover. *John Sloan Retrospective Exhibition,* 1938. (Notes by Sloan.)

American Academy of Arts and Letters and National Institute of Arts and Letters, New York. *Exhibition of Work by . . . Recipients of Honors,* 1950.

Annie Halenbake Ross Library, Lock Haven. *The Early Landscapes of John Sloan,* 1969. Comments and checklist by Grant Holcomb.

Brooklyn Museum. *The Eight,* 1943–44.

Carnegie Institute, Pittsburgh. *An Exhibition of Etchings by John Sloan,* 1937.

Dartmouth College, Hanover. *John Sloan Painting and Prints.* Seventy-fifth Anniversary Retrospective, 1946. (Notes by Sloan.)

Delaware Art Center, Wilmington. *The Fiftieth Anniversary of the Exhibition of Independent Artists in 1910,* 1960.

Hudson Guild, New York. *Exhibition of Paintings, Etchings, and Drawings by John Sloan,* 1916. (Notes by Sloan.)

Kraushaar Galleries, New York. *Complete Collection of Etchings by John Sloan,* 1937. *John Sloan Retrospective Exhibition,* 1948.

Lock Haven State College. Foreword by Helen Farr Sloan. *The John Sloan Exhibit,* 1970.

Macbeth Galleries, New York. *Exhibition of Paintings . . . ,* 1908. ("The Eight")

Metropolitan Museum of Art, New York. *Life in America,* 1939, p. 27.

Museum of Modern Art, New York. *Paintings by Nineteen Living Americans,* 1929–30.

National Gallery of Art, Washington. *John Sloan,* 1971. (Essays by David W. Scott and E. John Bullard.)

Renaissance Society, Chicago. *Retrospective Exhibition of Etchings by John Sloan,* 1945. (Notes by Sloan.)

Smithsonian Institution, Washington, D. C. *John Sloan,* 1961. (Essays by Helen Farr Sloan and Bruce St. John.)

Title III E.S.E.A., Area "J" (sponsor). *An Exhibition of Selected John Sloan Paintings* (and Graphics), 1968. (Introduction and notes by Mrs. John Sloan.)

University of Missouri, Columbia. *A Selection of Etchings by John Sloan,* 1967. (Introduction by Peter Morse.)

Walker Art Museum, Bowdoin College, Brunswick, Maine. *The Art of John Sloan,* 1962. (Essay by Philip C. Beam.)

Wanamaker Galleries, New York. *Retrospective Exhibition: John Sloan Paintings, Etchings, and Drawings,* 1939.

Wanamaker Galleries, Philadelphia. *Retrospective Exhibition: John Sloan Paintings, Etchings, and Drawings,* 1940.

Whitney Museum of American Art, New York. *New York Realists 1900–1914,* 1937, p. 7.

Whitney Studio (Mrs. H. P.), New York. *Exhibition of Paintings, Etchings, and Drawings by John Sloan,* 1916.

Wilmington Society of the Fine Arts. *The Life and Times of John Sloan,* 1961. (Essays by Helen Farr Sloan and Bruce St. John.)

Writings by John Sloan

BOOKS

Introduction to American Indian Art (with Oliver La Farge). New York: Exposition of Indian Tribal Art Inc., 1931.

Gist of Art. Edited by Helen Farr. New York: American Artists Group, Inc., 1939.

New York Scene: From the Diaries, Notes, and Correspondence 1906–1913. Edited by Bruce St. John. Introduction and Notes by Helen Farr Sloan. New York: Harper and Row, 1965.

The Poster Period of John Sloan. Edited by Helen Farr Sloan. Lock Haven, Pennsylvania: Hammermill Paper Company, Lock Haven Division, 1967.

ARTICLES AND INTRODUCTIONS

"Artists of the Press." In *Artists of the Philadelphia Press,* pp. 7–8. Philadelphia: Philadelphia Museum of Art, 1945.

"Art Is, Was, and Ever Will Be." In *Revolt in the Arts,* by Oliver M. Sayler, pp. 318–321. New York: Brentano's, 1930.

"A Tale of Wickedness on Wings" (Illustrated Poem). *Collier's,* vol. 46 (December 10, 1910), p. 27.

Introduction to *Patterns and Ceremonials of the Indians of the Southwest,* by Ira Moskowitz and John Collier. New York: Dutton, 1949.

Introduction to *Vanity Fair,* by William M. Thackeray. New York: Heritage Press, 1940.

"My Recent Encounter." *Creative Art,* vol. 2 (May, 1928), Supplement, pp. 44–45.

"Randall Davey." *New Mexico Quarterly Review,* vol. 21 (Spring, 1951), pp. 19–25.

"The Indian as Artist." *Survey,* vol. 67 (December 1, 1931), pp. 243–46.

"The Process of Etching." *Touchstone,* vol. 8 (December, 1920), pp. 227, 238–40. (Reprinted in Peter Morse, *John Sloan's Prints,* pp. 338–392.)

Sloan also wrote statements for several of his exhibition catalogs and for: The Metropolitan Museum of Art, *Robert Henri Memorial Exhibition,* 1931, pp. xi–xii; and the Whitney Museum of American Art, *Juliana Force and American Art,* 1949, pp. 32–42.

INDEX

Edited by Jennifer Place
Designed by Bob Fillie
Set in 12 point Bookman by Gerard Associates/Graphics Arts, Inc.